winning digital photo contests

Project Manager: Frank Gallaugher
Editor: Derek Doeffinger
Book Design: Sandy Knight
Cover Design: Thom Gaines

Library of Congress Cataloging-in-Publication Data

Wignall, Jeff.
 Winning digital photo contests / Jeff Wignall. -- 1st ed.
 p. cm.
 Includes index.
 ISBN 978-1-60059-475-5 (pbk. : alk. paper)
 1. Composition (Photography) 2. Photography--Digital techniques. 3.
Photography--Competitions. I. Title.
 TR179.W54 2009
 771--dc22

 2009010220

10 9 8 7 6 5 4 3 2 1

First Edition

Published by Lark Books, A Division of
Sterling Publishing Co., Inc.
387 Park Avenue South, New York, N.Y. 10016

Text © 2009, Jeff Wignall
All photography is copyrighted as indicated
Front cover photos: eagle, ©Andrew Thomas; tree in field, ©Heather McFarland;
 man with turban, ©BanHup Teh; baby and jellyfish, ©Michelle Frick;
 airplane, ©Claude Brassard; bridge with horizon line, ©Andre Viegas;
 castle with sundial, ©Geoff Stamp
Back cover photos: fort through window, ©Daniel Kohanski; man with apron, ©Ernie Aranyosi;
 monk photographing monks, ©Paul Hilts; elk, ©Richard Hahn;
 fishnets against sunset, ©Snehendu Kar
Spine photo: red/yellow spiral, ©Cor Bosman

Distributed in Canada by Sterling Publishing,
c/o Canadian Manda Group, 165 Dufferin Street
Toronto, Ontario, Canada M6K 3H6

Distributed in the United Kingdom by GMC Distribution Services,
Castle Place, 166 High Street, Lewes, East Sussex, England BN7 1XU

Distributed in Australia by Capricorn Link (Australia) Pty Ltd.,
P.O. Box 704, Windsor, NSW 2756 Australia

If you have questions or comments about this book, please contact:
Lark Books
67 Broadway
Asheville, NC 28801
(828) 253-0467
www.larkbooks.com/digital

Manufactured in China

ISBN 13: 978-1-60059-475-5

For information about custom editions, special sales, premium and corporate purchases, please contact
Sterling Special Sales Department at 800-805-5489 or specialsales@sterlingpub.com.

winning digital photo contests

Jeff Wignall

LARK BOOKS
A Division of
Sterling Publishing Co., Inc.
New York / London

winning digital photo contests **contents**

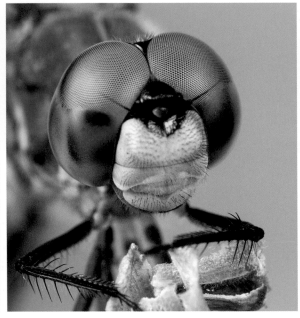

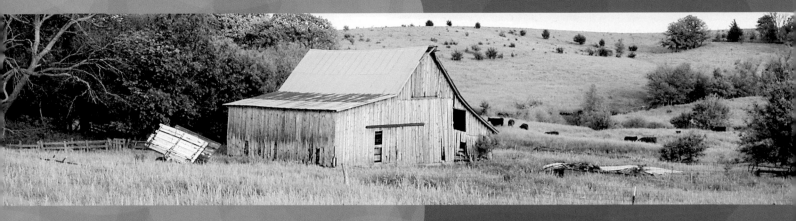

acknowledgments

While my name is on the cover of this book, it took a lot of hard work and cooperation from many people to create it. I want to thank those people:

Derek Doeffinger, editor. Derek helps me to sound like me and there's no better compliment that you can give to an editor.

Frank Gallaugher at Lark Photography Books. Frank climbed and conquered a formidable mountain of logistics to make this book happen and did it with good humor and great style.

Sandy Knight at Hoopskirt Studio for designing a beautiful book.

We could not have created this book without the assistance of the contest sponsors:

Jim Miotke at BetterPhoto.com

Todd and Donna MacMillan at Digital Image Cafe

Eric Cheng and Matt Segal at WetPixel.com

Smithsonian Magazine

John Nuhn at National Wildlife Federation

Marianna O'Brien at Kodak.com

DailyAwards.com

Steve's Digicams

Jason Heller at DivePhotoGuide.com

Jeff Roberts at HFMUS/*Popular Photography* magazine

Kara Goodson at the Photographic Society of America

My three former students for their contributions: Michelle Frick, Tom Callahan, and Cindy Johnston.

Special thanks also to *National Geographic* magazine and Energizer.

I was lucky to interview three extremely talented photographers for this book: Jim Richardson from *National Geographic* magazine (jimrichardsonphotography.com), and amateurs Heather McFarland and Robert Ganz. Robert and Heather are great examples of just how far you can go in winning contests with creative ideas and lots of hard work.

Thanks, as usual, to Lynne for helping to keep me sane as I write.

Finally, grateful thanks to all of the photographers who let us use their contest-winning images. Your photos were the inspiration for this book.

introduction

I first became aware of just how pervasive digital photo contests are while wandering around the Internet doing what a lot of photographers do when they're looking for new ideas or inspiration—sneaking a peek at what others are up to. It seemed like I could barely flip to a photo-related site without seeing another Picture-of-the-Day or annual competition. And I could tell from the number of entries and the amount of related chat in the message boards that the contests were hugely popular.

The more I looked, the more contests I found. There were (and still are) contests for all types of photography: people pictures, close-ups, underwater photography (check out WetPixel.com if you want to see some amazing underwater photos), babies, travel, wildlife, and even UFOs. If people were photographing it (or thought they were), there was a contest for them to enter.

The other thing that struck me about these contests was that the winning photos were incredibly creative and superb in quality. I found myself bookmarking several sites (like StevesDigiCams.com) just to see what fun surprises the next day's winners' page would bring. Whether you're entering them or just admiring the pictures, it turns out that contests can be quite addictive.

Not surprisingly, the boom in digital photo contests coincided with the exploding popularity of both digital photography and photo-related websites. The ability to upload your images with the click of a mouse has made entering photo contests as easy as sending an email. No more hiring labs to make great quality prints, packing them up carefully, writing a check for the entry fee, or driving to the post office to mail them. With digital contests you can upload pictures moments after you've shot them, often with no entry fees involved.

And then there are the prizes. While some of the smaller contests might offer a few minutes of glory or a modest photo accessory, the major contests give out prizes extravagant enough to keep you up at night, including new cameras, exotic trips, and even publication in prestigious magazines. How prestigious? Think about *National Geographic, Popular Photography,* and *Smithsonian*—just to name a few

(check the listing in the back of the book for dozens more). You may also see your winning photos in some other pretty exciting places: win the Kodak Picture of the Day (POTD in contest slang),for example, and your photo will be displayed on a huge digital screen in Times Square. Talk about an ego boost.

But whether you seek fame, publication, or prizes, these photo contests are a lot of fun. They not only give you a way to show off your best photos, but they also challenge your creativity and motivate you to advance your photography to the next level. Just the act of reviewing and editing your photos to find potential winners is an honest self-appraisal that can force you to be more selective. And winning a contest, well, it can literally change your life. Ask Robert Ganz (interviewed on page 152) who won the grand prize of $1,000 in the 11th Annual *Popular Photography* Photo Contest (not to mention being featured on the cover of the magazine).

Just how good are the photos being entered in digital photo contests? Consider this: virtually all of the photos in this book were shot by amateurs and have won some level of photo competition. They were created by photographers just like you—people who have a passion for digital photography and a desire to share their images with the world.

The question that you probably have is: can you learn to take pictures that will win photo contests? The answer is *absolutely.* How? You maybe surprised to read in my interview with *National Geographic* photographer Jim Richardson (who has judged over 100 photo contests) that winning contests is not about impressing anyone or showing off; the secret is to take photographs that move you—that are true to your photographic vision. "Pictures can't be about pictures; pictures have to be about life," he says. "If they are really and truly about life and beauty and understanding and our souls, then they have a pretty good chance in a contest."

In the following pages we'll look at many of the ways that will help and inspire you to create these pictures. With a little luck, other people will share your vision and you'll see your name at the top of the winners' list!

Jeff Wignall • Stratford, Connecticut • jeffwignall.com

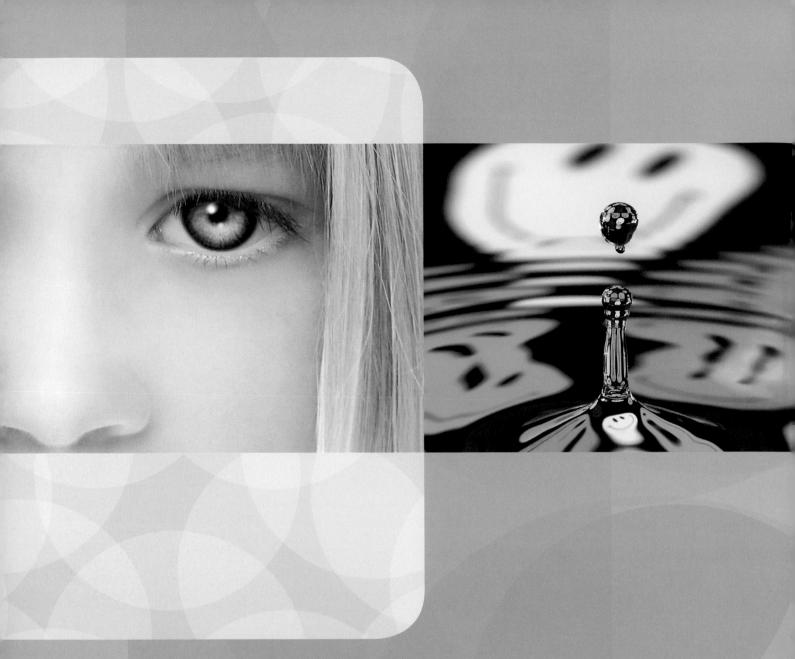

Most contest judges are photo enthusiasts just like you, and they love the look and feel of a well-executed image.

1

pictures
that win

The first question that you're probably asking yourself is: What kinds of pictures win photo contests? No doubt that you're reading this book in search of an answer. More importantly, you're probably also wondering if *you* can take pictures that will win contests. Ahh, yes, self-examination—a good start to any creative endeavor.

The simple answer to the first question, of course, is that *good* photos win contests. No, strike that: *great* photos win contests. And the answer to the second questions is: Yes! Certainly you can take great contest-winning pictures. In fact, my guess is that by the time you've read and digested this first chapter, you'll be well on your way to tasting the thrill of victory.

But back to the first question: What kinds of pictures win contests?

As you look through the photos in this book, one thing you'll notice is that winning a photo contest is not necessarily about having the world's first clearly focused and well-exposed shot of Big Foot. Surprised? Don't be. Just as your mother told you, there's really nothing new under the sun. Most contest-winning photos are pictures of ordinary subjects: kids playing, pets being cute, pretty shots of landscapes and nature—the kinds of subjects you already shoot every day.

That said, there are indeed some common qualities shared among winning photos. And therein, as they like to say in tire commercials, is where the rubber meets the road.

One criterion that winning photos share is technical mastery. This is no time to show your "almost" shots or your near misses. This is the time to strut your technical prowess and demonstrate your mastery of essential camera skills. Far beyond mere technical skill, however, photos that win contests almost always elicit emotion. Surprise the judges. Make them gasp or giggle. Stir up their primal fears (perhaps with a much-too-close photo of a rattlesnake). Astound them with the beauty of exotic destinations or just weave them a spellbinding mood. Do that and you will soon win a contest.

Lastly, the most important ingredient you can bring to your photos is passion. Passion is a hard thing to fake (or disguise); judges recognize when it's authentic and reward it. Photographers that take great photos tend to wear their emotions on their sleeves and it shows. If you are excited about a subject or a moment captured, they will share your enthusiasm.

Sound difficult? You probably think so. But actually it's not terribly difficult. In the following pages I'll show you the specific qualities common to winning pictures, and tell you how to turn ordinary opportunities into contest-winning photos.

So turn the page and let's get started.

engage

Like strangers exchanging glances on a train, a contest judge may have so many images to contend with that they only have a fleeting moment to devote to each photo. In that moment, for your image to stand out from the crowd, it must engage their full attention—and it must do so quickly.

In researching this book I interviewed several prominent photo-contest judges and the one thing they all agreed upon was this: the photos that end up winning the contests were always among those that jumped off the screen (or out of the print pile) during their very first viewing. In each case something about the winning photos—even at a glance— commanded their attention. First impressions matter.

And for any photo—whether it's in a contest or just sitting on your living room mantle—to get noticed, the first thing you have to do is to get the viewer's attention. Demand it. Steal it if you must, but leave no wiggle room for escape. This is no time to be subtle or to coerce a gentle nod of recognition.

Considering the kaleidoscope of visual stimuli that bombards and tantalizes us daily, from cell-phone graphics to giant high-definition TV screens, it's a wonder any individual images manage to penetrate our consciousnesses. But if your photo is going to stand out from the thousands— maybe tens of thousands—of other images in a contest, it must do just that: it must engage the judges.

So how do you craft that mystical moment of instant recognition, that irresistible spontaneously-combusting photo?

There are actually many ways to achieve this, and uncovering them is largely what this book is about. As you'll see in the following pages, it can be done with humor, surprise, beauty, mood, drama, or just with a pair of radiant blue eyes, as Cathy MacMillan's photo to the right shows. My guess is that you were immediately taken with those blue eyes and you won't soon forget them.

Whatever your subject, whatever your approach, as you shoot and edit your photos, ask yourself this: Will this photo grab someone's attention quickly enough to win their further consideration, and will it linger in the viewer's mind?

Engage, Mr. Sulu—engage the viewer.

Technical Note
This symmetrical image is composed of half of my daughter's face, copied and flipped into a mirror image, then painted with corrections (to highlights and shadows) in Corel Painter and Adobe Photoshop.

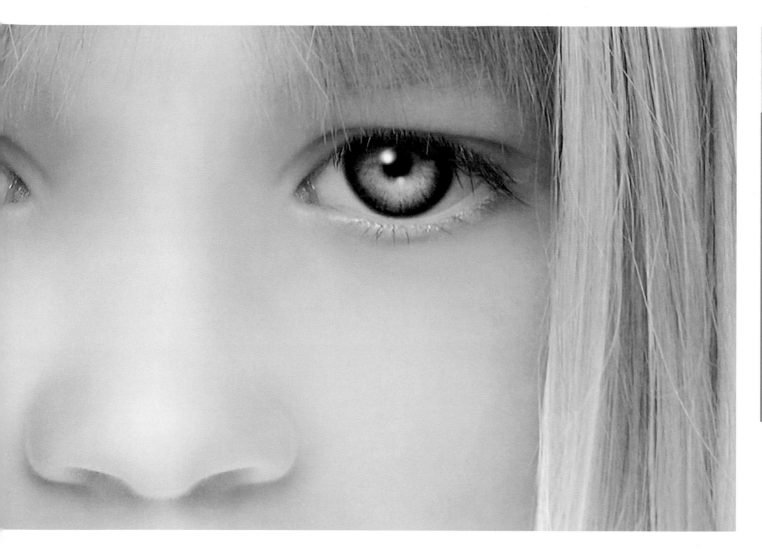

Photograph: ©Cathy MacMillan	Title: Angelic
Contest: Kodak Picture of the Day	
Technical Note: Shot using an Olympus Camedia C-2020 camera.	

❝Join an online community or a local photography club where you can receive (and give) critiques. Critiquing helps you to focus on what you like to shoot and find ways to improve your work. ❞ —Cathy MacMillan

surprise

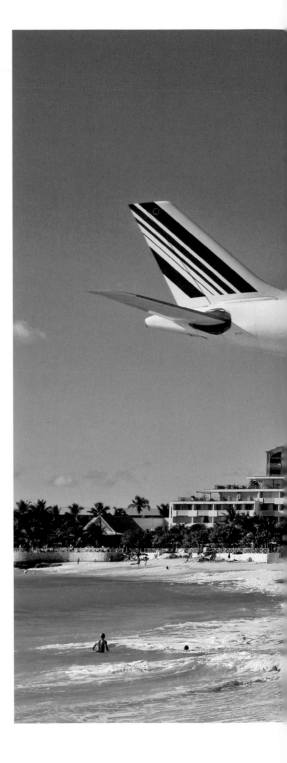

I n a photograph, the element of surprise can be as visceral and startling as when in real life somebody sneaks up behind you in a darkened room and shouts "Boo!" Though hopefully with a photo the surprise will be a bit less jarring to nerves and the judges won't spill their coffee.

Visually surprising someone works because it grabs their attention in the shortest possible time and uses the element of the unexpected to pique curiosity. And in the case of contest judges, since they often move quickly through many photos at a time, the element of surprise can be a potent tool to move your photos to the next level.

How do you make photos that surprise judges? Simple: you find subjects that challenge assumptions and preconceptions in such a powerful and immediate way that they cannot be ignored. Easier said than done—but not at all impossible.

Some subjects originally shocked the photographer as much as they later surprised viewers. In the photo to the right, for example, photographer Claude Brassard used good instincts and a quick trigger finger to capture this jarring coincidence of timing and placement: a huge jetliner seemingly about to use a crowded tourist beach as a runway. Anyone who has ever flown in a plane (or sat on a beach) would have a primal reaction to this photo.

Interestingly enough, however, those who have been to this particular beach on St. Maarten are used to the odd site of jetliners using beach towels as runway markers. In fact, Brassard, who says he was just looking for a photo souvenir of his trip, was able to get several takes as a series of airliners passed overhead: "I shot around 20 frames but was lucky as I got a nice one of Air France; it is one of the biggest planes landing at Juliana airport."

Not all surprises have to be quite so dramatic, of course, and you can even create them yourself: like your daughter pretending to put a frog in her mouth or your pet mouse sleeping with your very tolerant cat. While fabricated to some degree, these kinds of manufactured surprises are just as effective at winning attention.

Whether you stumble upon and capture the unexpected or lend a hand in its creation, remember that the moment must look genuine, be as simple and direct as you can make it, and pluck at universal emotions.

"The most important thing is to have fun."

—Claude Brassard

Photograph: ©Claude Brassard	Title: **Fastest Way to the Beach**
Contest: **Steve's Digicams**	EXIF: **1/800 at f/8, ISO 160**
Technical Note: **Shot using a Sony Cyber-shot DSC-R1 camera at 27mm.***	

*All focal lengths given are real values and are not converted to 35mm equivalents.

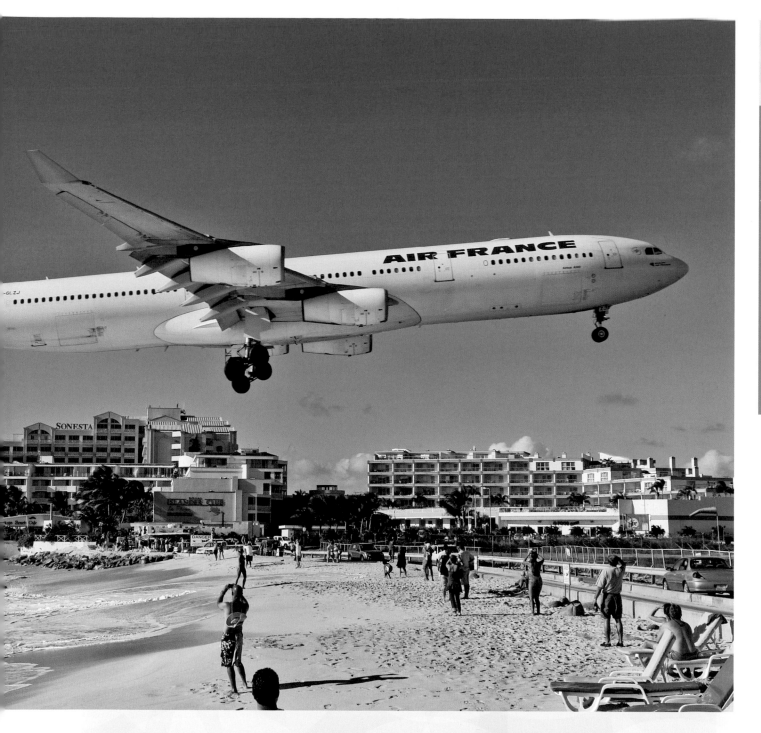

Why This Moment?

"Many tourists try to get this shot, but it's difficult to get decent lighting, a good position for the plane, and onlookers on the beach all in frame at the right moment. Look closely and you can also see the water getting dragged up the beach by the air pressure of the airplane braking." —*Inspiration for* Fastest Way to the Beach

evoke a mood

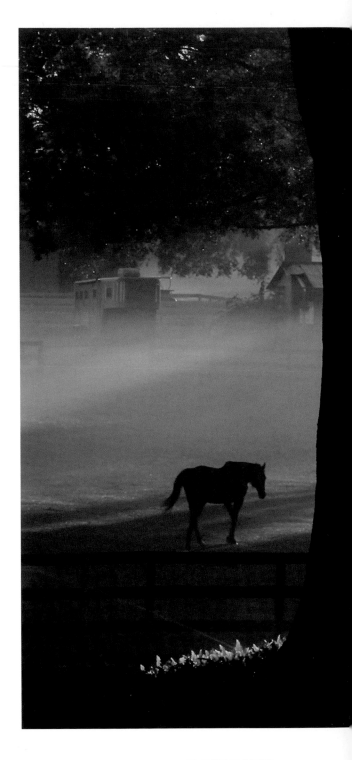

One of the qualities that raises a photograph to a level greater than the sum of its parts is the atmosphere or mood that it imparts. Mood is the emotional flavor of a scene, the ephemeral quality that stirs passions and conjures feelings that the subject alone would not evoke.

Establishing mood in a still photo is no easy task. In a motion picture, the director has more than visual elements to call upon when setting an emotional climate: sound effects (the wind whistling through the trees), the musical score (violins announcing the approaching villain), and even the tone of the actors' voices (is it a whisper or a scream?) are all a part of the mix. In a photograph, however, you're limited entirely to the two-dimensions of the image and whatever visual elements you include.

One way to set mood is by carefully choosing—and limiting—your color palette. To expose the beautiful equestrian scene shown here, photographer Donna Cuic has used the early-morning light to limit the color range to warm shades—browns, yellows, and golds. The warmth of the colors imparts a psychological coziness, a feeling that here, all is safe, inviting, and quiet. Warm tones evoke warm feelings. How different would this scene look if the photographer had shot at twilight and limited the color range to a palette of cold blues and purples? Or the blistering, colorless sun of midday?

Because we all react instinctively to different kinds of weather, the climate of a scene is another important element in evoking mood. Often, in fact, it is a slight shift in the weather that catches our attention and prompts us to consider photographing it. Cuic says that she often drove by this local scene, but it was seeing the early morning fog that inspired her: "When I woke up early that morning and saw that it was a little foggy, I knew I wanted to photograph this field."

As evocative as weather can be, you can't entirely predict people's emotional responses to it. What you perceive as cheerful and bright—a snowy landscape, for example—might be seen as chilling or threatening to someone else. But the odds are that if the weather elicits an emotional reaction from you, it will stir one in others as well.

Photograph: ©Donna Cuic	Title: **Sunday Morning**
Contest: **Kodak Picture of the Day**	EXIF: **1/50 second at f/16, ISO 100**
Technical Note: **Shot using a Canon EOS 10D camera with a Canon EF 28-135 f/3.5-5.6 IS USM lens at 135mm.**	

❝Study photos. What is it you like about them? I really learned a lot by seeing other photos that won. Seeing what others had done always encouraged me and gave me ideas for my own photography.❞ —Donna Cuic

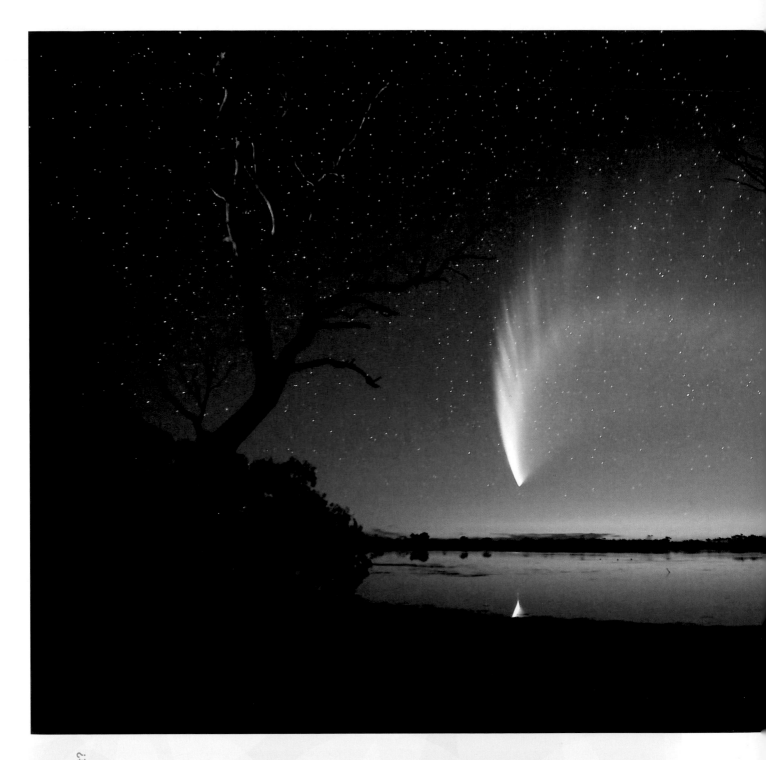

"I shot this about thirty minutes after the sun had set while there was still some light in the sky. I took about twenty exposures from a few different viewpoints, all with shutter speeds of about 30 seconds." —*Inspiration for* McNaught's Comet

reveal rarely seen worlds

One aspect of the camera that has always fascinated photographers is its ability to explore and reveal the myriad unseen worlds that exist all around us. Whether they're the rarely-noticed details at the heart of a flower blossom, comets tracing across the night sky, or the comely face of a dragonfly, things that are rarely seen delight the imagination and compete loudly for our attention. And they win contests.

Photographing these rarely seen worlds, whether underfoot, underwater, or overhead, is a tremendous amount of fun and not as difficult as you might imagine. As you browse through the pages of this book, look at the extraordinary range of unusual subjects that other photographers have captured, and then remember that you and your camera probably have the same capabilities.

Digital cameras excel at close-up photography (see page 119), and even simple point-and-shoot cameras can produce astoundingly good pictures of flowers, insects, and other diminutive subjects with little or no accessory gear. Virtually all digital cameras can also be equipped easily for underwater photography (see page 115).

Even for subjects as exotic as the night sky, all you'll really need is a dark-sky locale, a camera capable of extended exposures, and, of course, some knowledge of heavenly bodies. Because they are so rarely attempted, well-photographed images of sky events like photographer John White's 30-second exposure of Comet McNaught (a sight that won't be seen again for 300,000 years) are certain to attract judges.

In most cases, ideas and opportunities for photographing specialized subjects already exist in your hobbies or your profession. Robert E. Jensen, who shot the vibrant face of the Blue Dasher dragonfly on the next page, is an entomologist by profession and so finding likely subjects is a part of his everyday life. "I am always looking for insects to photograph and I regularly look for dragonflies," he says. He found this specimen while searching for dragonflies along the Los Angeles River in Van Nuys, California.

Don't be afraid to exceed the limits of traditional photography in creating images of these lesser-seen worlds. The odds are that with a little research and ingenuity, you can capture images that are just as fascinating.

> **❝Photography has been a hobby of mine since school and is now an obsession. My advice? Shoot lots of pictures!❞** —John White

pictures that win

Photograph: ©**John White Photos**	Title: **McNaught's Comet**
Contest: **Kodak Picture of the Day**	EXIF: **30 seconds at f/4, ISO 800**
Technical Note: **Shot using a Canon EOS 50D camera with a Canon EF 24-105mm f/4L lens at 24mm.**	

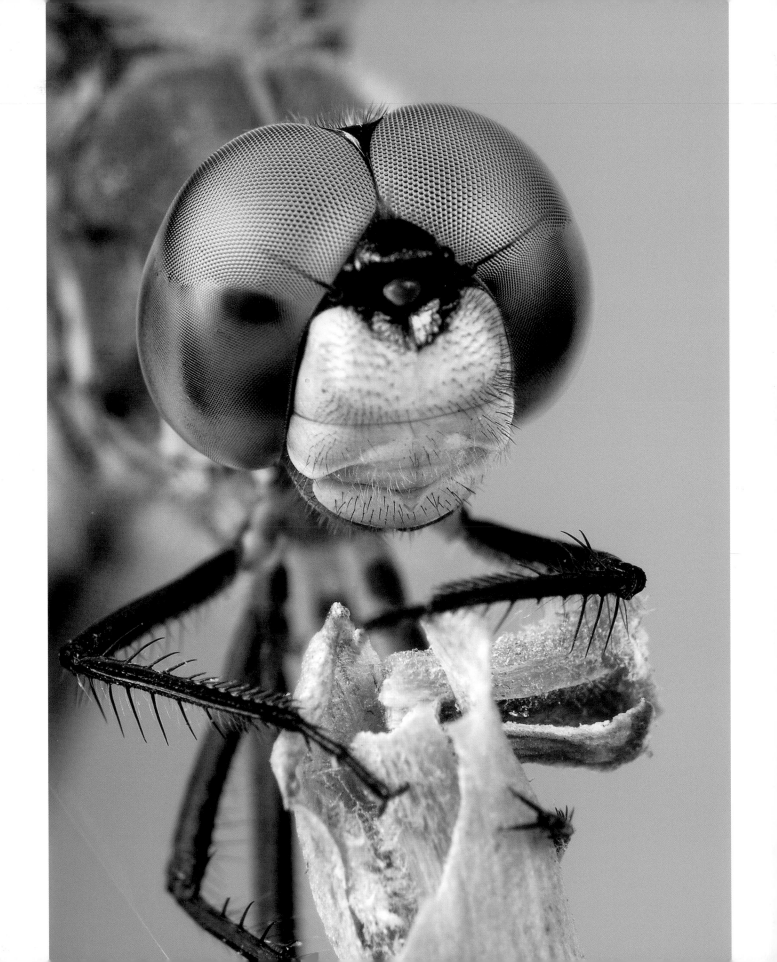

> 66 I was specifically
> looking for
> dragonflies to
> capture a macro shot
> of their compound
> eyes. This one
> was in the perfect
> position, and held
> still long enough
> for me to bracket
> a few exposures
> at different
> focal lengths. 99
> —*Inspiration for*
> **The Eyes Have It**

Above Photograph: ©**Dre Van Mensel**	Title: **Gebandeerde Met Dauw**
Contest: **Festicolor 2009 Belgium**	EXIF: **1/250 second at f/9, ISO 400**
Technical Note: **Shot using a Canon EOS-1D Mark II camera with a Sigma APO 180mm f/3.5 EX DG IF HSM Macro lens.**	

> 66 Listen to other photographers' recommendations and criticism. They can sometimes be painful, but with persistence it's ultimately worth the payoff. 99 —Robert Jensen

Left Photograph: ©**Robert Jensen**	Title: **The Eyes Have It**
Contest: **Digital Image Cafe**	EXIF: **1/180 second at f/32, ISO 100**
Technical Note: **Shot using a Fujifilm FinePix S3 Pro camera with an AF Micro-Nikkor 200mm f/4D IF-ED lens and a Nikon 3T close-up filter.**	

make people laugh

There's probably no more direct or universal way to get someone's attention than to make them laugh. Let's face it: the people judging photo contests are busy, and just as short on time as the rest of us. A quick dash of humor is a welcome release. If you can give someone a good giggle in the middle of a long day, you've made a quantum leap toward winning their approval.

The most prevalent sources of visual humor are simple juxtapositions of seemingly unrelated elements: a one-way sign at the entrance to a cemetery or a dog with his face pressed up against a bakery window. These humorous subtleties exist around us everyday, but it takes an observant (and possibly slightly demented) person to spot them on a regular basis. If you want to improve your odds of finding funny and incongruous scenes, turn the idea into a self-assignment for a few weekends: just look for pairs of things that simply don't belong together.

If you're on a road trip with kids, have them keep an eye out, too. Kids are often a lot better at spotting the subtle absurdities of life than adults (see page 139). Once you're consciously on the prowl for such visual quirks, you'll begin to see them everywhere.

Other things that make people laugh in a photograph are the same things that make them laugh in a verbal joke, like Seinfeldian observations excerpted from the normal rhythm of life. Observation will uncover such moments; camera readiness will capture them.

If you're a bit more ambitious, you might even try inventing a funny scene yourself. Photographer Timothy Toole staged this sympathetic and absurd photo in a fast food men's room specifically for a photo-challenge competition. What makes the shot so convincingly real are the details he added in the setup: the father's look of surprise at being caught on camera and the boy tying up his dad's legs with toilet tissue.

If you have a funny idea, don't be afraid to take the time to stage it. If you think the set up is a funny one, others probably will too. Of course, because no two people are guaranteed to laugh at the same thing, there's always a risk that your humor will fall flat. It's kind of like the old joke: Two cannibals are sitting around a fire eating a clown and one says to the other, "Does this taste funny to you?"

You can't make people taste the humor in your photos or get your sense of humor—the best you can do is to offer up your best recipe for laughs and see if the cannibals taste the humor.

Technical Note
Shot using a Canon EOS Digital Rebel camera with a Sigma 18-125mm f/3.8-5.6 DC OS HSM lens at 21mm.

Why This Moment?

"This was a setup all the way—pretty much a studio-style shot made in an odd location. I snapped a handful of exposures, hoping to catch my kids in the right positions. It was initially taken for a competition on DPChallenge themed 'Your Occupation.' I am a stay-at-home dad so it fit well."
—*Inspiration for* Mr. Mom

Photograph: ©Timothy Toole	Title: **Mr. Mom**
Contest: **Kodak Picture of the Day**	EXIF: **1/25 second at f/7, ISO 400**

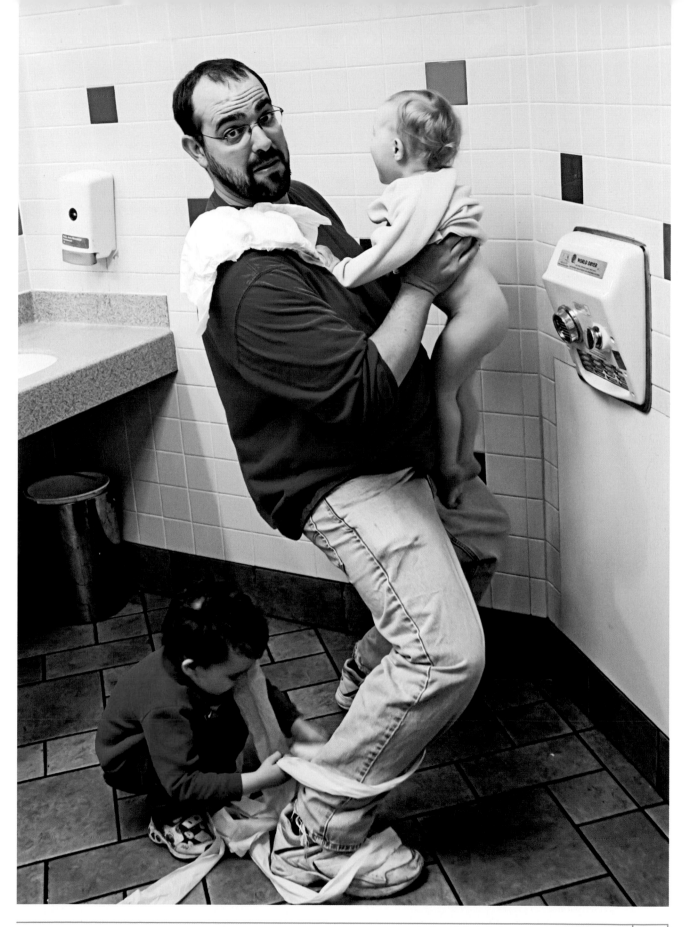

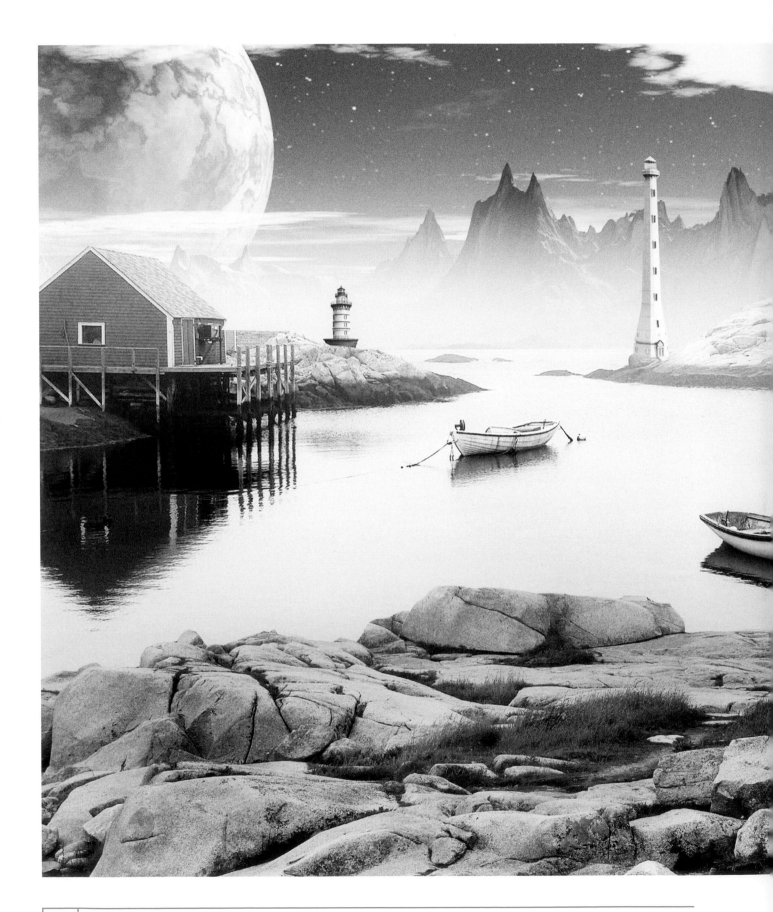

build from your imagination

For many photographers, the greatest untapped source of creative images is the imagination itself. And if there's one thing that digital cameras and image-editing software have created for those visionary pioneers, it's a roadmap to these undiscovered countries of the mind. Even if you hate computers, spend ten minutes sitting next to a friend who can demonstrate the creative power of editing software and you'll be addicted. (I took my first Photoshop workshop in 1993 and more than 15 years later I still spend half my waking hours using it.)

Almost any subject can hold the beginnings of an imaginary landscape, and one of the fun things about tossing off the restrictive bondage of reality is that you can blend bits of the real with pieces of fantasy at will. There are no photography police looking over your shoulder setting speed limits on your imagination or holding up "do not enter" signs at the next creative vortex. And if you create your imaginary worlds well enough, viewers will do double-takes and scratch their heads wondering where the dividing line sits.

Blending the real and the unreal is exactly what photographer David Jackson has done to create what he calls one of his "Alien Landscapes." The bottom half of the photo is a very real view of Peggy's Cove in Nova Scotia. "When I shoot a certain scene I am thinking of the backdrop I will create to make the image an alien landscape," he says. In this case by adding mountains, a night sky, and a planet, Jackson has taken one of the most frequently photographed seaside scenes in North America and transported it to, as Rod Serling of *The Twilight Zone* would say, "…a wondrous land whose boundaries are that of imagination."

Not all contests allow excessive use of image editing, so before you enter a competition (or as you search for new ones) be sure that there is a category for illustrative or highly-edited work. And, of course, it's important to be honest about your photos and be straightforward if you've used extensive editing. If your images happen to include a moon colliding with the foreground and stars in a daylight sky, they'll get the idea.

> **"The key to photo manipulation and 3D rendering is to ensure that the final image remains as photorealistic as possible, even if the scene it presents is a fantasy."** —David Jackson

Photograph: ©**David Jackson**	Title: **Peggy's Cove**
Contest: **Digital Image Cafe**	
Technical Note: **Original photo shot using a Canon Powershot S3 IS camera. Image edited with Artmagic Voyager, Bryce 3D, and Photoshop.**	

pictures that win

showcase your technical skills

Because most judges are professional photographers or involved with photography at a fairly serious level (as magazine editors, for instance), you can win their attention by showcasing your superior technical ability. No matter how jaded they are when it comes to looking at other photographers' work, when a technically superior image crosses their desk, they can't help but examine and evaluate its quality.

Photography is full of mind-bending technical challenges for those willing to attempt them and going down such a demanding path can make it a satisfying—if not somewhat exasperating—hobby. The hummingbird shot here, for example, was made by Tom Callahan, a former student of mine who has spent several years mastering the intricate tasks involved in freezing the wing beats of his tiny subjects. This required not only becoming an advanced amateur ornithologist, but also conquering the complex skill required to set up multiple wireless flash units.

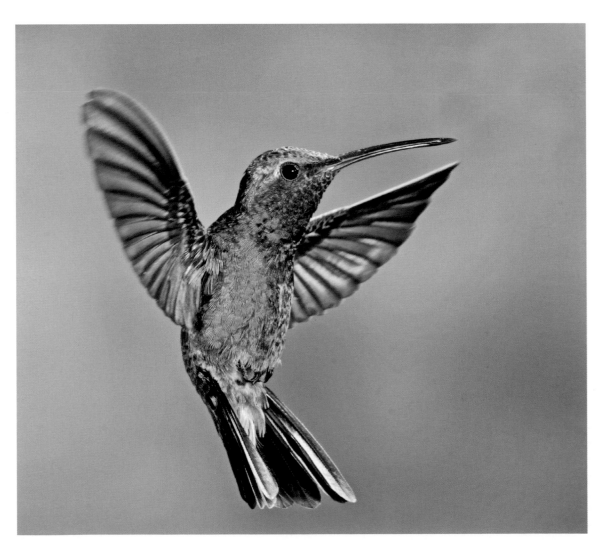

Photograph: ©**Tom Callahan**	Title: **Hummingbird**
Contest: **DailyAwards.com**	EXIF: **1/250 second at f/29, ISO 100**

Remember, though, that such experience is not gained easily and there will be lots of clicks on the trash button along the way. For every acceptable shot that Tom gets, probably a hundred others end in the garbage.

Similar persistence was required by photographer Scott Cromwell in capturing this colorful shot of a single water droplet frozen by high-speed flash. Cromwell spent the better part of a Superbowl afternoon working on it, ignoring most of the game in favor of getting the shot. "This was shot number 414 out of a little over 1,000," he says.

Whether your particular goals happen to be creating larger-than-life-sized close-up photos, capturing great wildlife images, or making beautiful studio portraits, skills matter. The more proficiency that you can demonstrate in rising to a particularly difficult challenge, the more attention you'll receive.

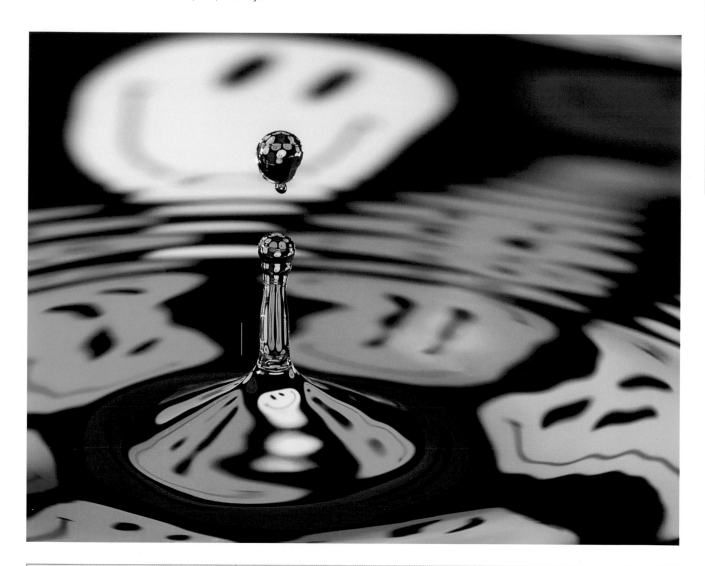

| Photograph: ©Scott Cromwell | Title: **Happy Water** | Contest: **Kodak Picture of the Day** |

Technical Note: **Shot using a Canon EOS 20D camera with a Canon EF 100mm f/2.8 Macro USM lens and both 580EX and 430EX Speedlite flash units.**

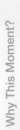

Why This Moment?

66 I rode a camel to the desert sand dunes to do sunset photography but I was not prepared for this magical moment. The gorgeous colors of the sky, the eerie shadows of the dunes, the silhouetted camels and the deafening sound of silence were truly 'peace at sunset.' **99** *—Inspiration for* Peace at Sunset

share exotic journeys

For most of us, travel to exotic and remote locales is largely a daydream, or at the very least a rare occurrence. Still, we all love to see the places where others have been—the firsthand evidence of distant adventures in foreign lands. Contest judges are not exempt from travel envy, nor from the allure of a well-conceived travel photo.

Taking travel photos that promote the fantasy factor may be one of the surest ways to push your entries to the top of the pile. While a rose is a rose is a rose, the Taj Mahal is *always* extraordinary and exciting—even if you've seen a thousand photos of it (like the one on page 174). That brings up the obvious point that the more extraordinary the destination, the more attention photos of it will receive. Although you may not want to plan a trip just for the sake of winning a photo contest, keeping contests in the back of your mind as you travel is certainly good motivation to work hard with your camera.

One of the common bonds that many successful travel pictures share is an ability to immediately reveal a specific location with a bare minimum of visual elements. This photo of camel riders, for instance, couldn't be simpler—two men on camels at sunset in total silhouette—and yet it screams of a Middle East desert. There are no recognizable buildings, no faces, no famous landmarks; yet anyone who has nodded asleep while reading the tales of the Arabian Nights will be swept into the fantasy that the image conjures. The photographer has used the bare number of visual elements to identify a place that many of us have never seen in person, but that all of us have surely imagined.

Elevating any travel photograph from a mere snapshot of a family vacation to an award-winning photo requires finding what professionals call "a sense of place," and it's one of the toughest aspects of travel shooting. Accomplishing it often requires veering off the tourist-beaten paths, away from the traditional landmarks, and peering into the very soul of a place. While some photographers accomplish that by spending all of their travel time counting miles and looking for new views, others find success by planting themselves in one single place—at a sidewalk café in Paris, for example—and waiting for the subject to come to them. Both methods work.

Finally, remember that you don't have to get on a jet and fly for half a day to find a great travel shot. For someone who lives in downtown Tokyo, a northern Michigan barn surely seems geographically distant and culturally poles apart. So even if you're not able to travel to the far corners of the planet, you can turn your own particular corner into an attractive travel destination for others—simply try to look at the places around you as a stranger would and you'll be on the right path.

Photograph: ©Roberta Hamper	Title: **Peace at Sunset**
Contest: **Kodak Picture of the Day**	EXIF: **1/1000 second at f/5.3, ISO 720**
Technical Note: **Shot using a Nikon D80 camera with a Tamron AF28-300mm f/3.5-6.3 XR Di LD lens at 138mm.**	

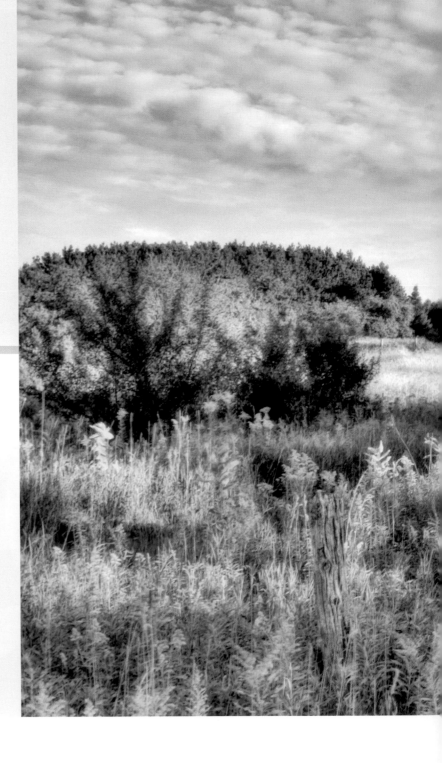

Technical Note

Shot using a Nikon D2x camera with an AF Nikkor 28mm f/2.8D lens. To capture the complete tonal range of the scene, three exposures were bracketed at +/-2 Ev in Aperture Priority mode at f/16. All three were then combined into one HDR (High Dynamic Range) image and tone mapped in Photomatix Pro.

Why This Moment?

"The late evening light creating long shadows among the goldenrod, along with the lovely sky topped off with the beautiful red barn attracted me."

—*Inspiration for* Farm at Late Evening

| Photograph: ©Heather McFarland | Title: **Farm in Late Evening Light** |
| Contest: **Digital Image Cafe** | |

conjure all the senses

There is one huge difference between a photograph and the subject itself and that is, of course, that a photograph is just a visual representation. A photograph of a waterfall isn't wet and a photograph of a snowball isn't cold. Yet when you're out in the world taking pictures, you do continue to experience all five senses.

If you're shooting at a Caribbean beach (lucky devil), for instance, you not only see the ocean waves crashing to the shore, but you also hear the sound of the surf and the cry of the gulls, smell the salt in the breeze, and feel the cool mist on your skin and the sand between your toes. You experience the place with much more than mere sight.

Pity the poor viewer then, looking at your photographs of a rose with no scent to be sniffed, or a cuddly kitten with no soft fur to scrunch. Talk about sensory deprivation! For a photograph to transcend its two-dimensional limitations then, it's up to you to include cues that partially evoke (or invoke) the non-visual. You have to find little tricks to help put the birdsong back on the breeze and the tang back in the lemonade. Easier said than done, but not impossible.

In photographer Kevin Hedquist's close-up of an age-worn hand caressing a violin, the rough textures of the skin and wood compliment the smooth surface of the fingernails; and our brains perceive and feel this delicate tactility without ever touching a thing! By cropping tightly on just the hand and the instrument, Hedquist has heightened our sensual memory of touch. You simply can't look at that photo and not experience the feel of it.

The other senses—taste, smell, sound—are a bit more of a challenge and far less profoundly felt in a photograph, but there are ways to enhance their presence. If you've ever cooked burgers on a backyard grille (that is to say, if you haven't been living in a cave all your life), then just seeing the glow of the coals, the rise of the smoke from the charcoals, and the spritz of juices from the meat will awaken the smells of summers gone by. And if you're sensitive to the sound, just the sight of someone's fingers on a chalkboard will send chills up and down your spine (in fact, just reading this sentence may have already done the trick).

The point is that a photograph is about more than light, shadow, and color; for a picture to really work, to really grab someone's consideration and attention, you have to imbue it with hints of the full sensory spectrum.

Why This Moment?

> The course textures of the hand and violin communicate an intimate relationship—this street performer has spent many years playing his instrument and refining his craft. The moment he positioned his hand near the body of the violin, I knew the scene was complete.
>
> —*Inspiration for* The Maestro

> Get involved in online photo communities. It is a wonderful place to learn, both by having your work critiqued and by critiquing others. —Kevin Hedquist

Photograph: ©Kevin Hedquist	Title: **Maestro**
Contest: **Digital Image Cafe**	EXIF: **1/180 second at f/8, ISO 200**
Technical Note: **Shot using a Pentax *ist DS camera with a Tamron SP AF18-250mm f/3.5-6.3 Di-II LD IF Macro lens and a circular polarizing filter.**	

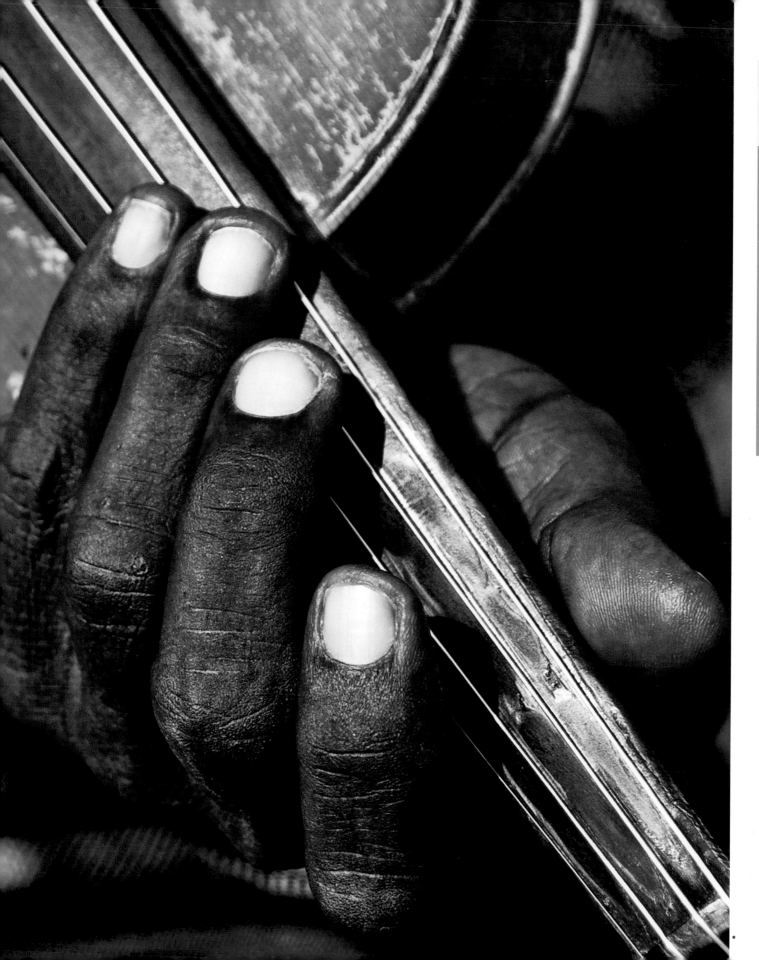

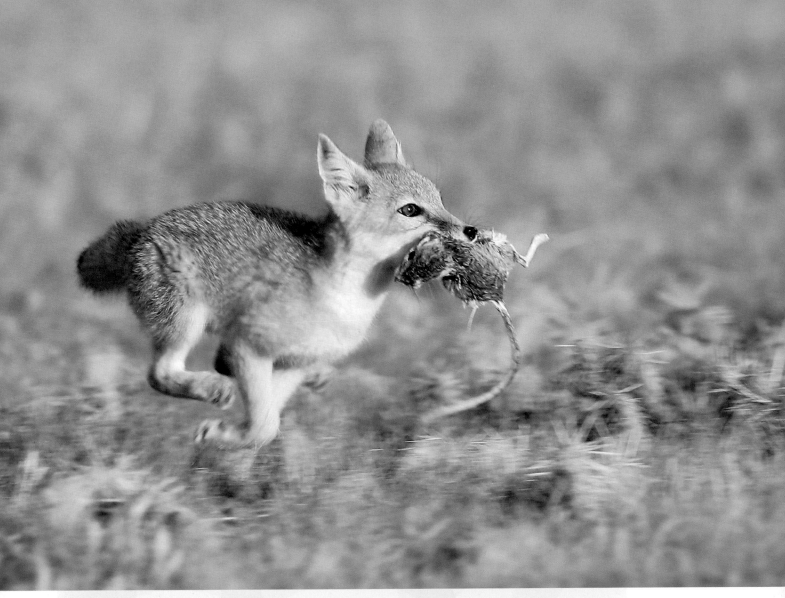

"I had been photographing the den for a couple of weeks and this just happened. As soon as I saw the young fox pounce on the kangaroo rat, I knew she would soon make a run for her den, so I prepared for just that moment." —*Inspiration for* Swift Fox and Kangaroo Rat

Photograph: ©Rob Palmer	Title: **Swift Fox and Kangaroo Rat**
Contest: **National Wildlife Magazine**	EXIF: **1/320 second at f/8, ISO 250**
Technical Note: **Shot using a Canon EOS-1D Mark II N camera with a 500mm lens and a 1.4x tele-extender.**	

shoot on the wild side

Although we certainly share the planet with many more animals than humans, the truth is that our encounters with genuine wild animals (other than the squirrels marauding around the bird feeders) are few and far between. Even the opossum that lives under your back porch is a pretty exotic and scarcely seen neighbor when it comes to actual face-to-face confrontations. The rarity of our encounters with wildlife, and the photographic evidence of them, are what make good wildlife shots another winning subject.

The reason that getting good wildlife photos is such a difficult challenge is that most wild creatures prefer to cavort with their own kind. Also, not unlike most of your human neighbors, animals spend the majority of their waking hours tending to their nutritional needs, commuting around their habitat, napping in a cozy den, and keeping an eye on the kids. Their habitual lifestyle doesn't allow much free time to generously pose for photos. Instead, you have to find ways to observe and photograph them in their daily rituals: hunting, hiding, stalking, flying, swimming, fishing, and dashing home to the crib with a hot meal in tow. (Sound familiar?)

In short, if you want to get good photographs of animals, you have to enter their world because they are surely going to spend most of their life's energy avoiding yours.

Later in this book we'll provide specific tips on breaching their invisible shield in order to get good, close shots of wild animals, but there is one overriding concept that it is fundamental to your task: Getting great photos of wild animals means learning everything you can about their lifestyles. The natural history section of your local library offers a wealth of information on most any wild subject you can imagine (as does the Internet with some good search skills).

While almost all close-up photos of authentically wild animals are interesting, the ones that most often win contests show animals at their most animated and in their most dramatic moments: a cheetah in a blur of motion chasing down prey, bears engorging on salmon in an Alaskan river, or an eagle diving for fish in a mountain lake. While these are visually intense moments for us, they are struggles of life and death for the animals themselves. Capture the essence of these primal struggles in a single frame and judges will have a hard time turning away.

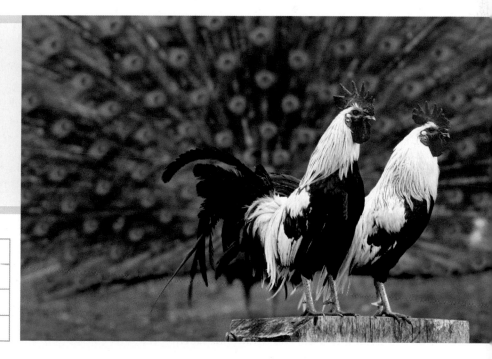

Technical Note
Shot using a Canon EOS 10D camera with a Canon EF 75-300mm lens at 300mm. Color and levels adjustments in post processing.

Photograph: ©Todd MacMillan

Title: **Dos Gallos**

Contest: **Digital Image Cafe**

EXIF: **1/80 second at f/5.6, ISO 100**

interview with

Jim Richardson
National Geographic Photographer

You can read more about Jim and see his work on his website: www.jimrichardsonphotography.com.

Jim Richardson has a career that most photographers can't help but envy. As a freelance photographer for *National Geographic* magazine for more than 25 years (and a contributing editor to its sister publication, *National Geographic Traveler*), he has traveled the world extensively and become one of the *Geographic's* most prolific shooters. Since his first essay appeared in 1984 (on the flooding of the Great Salt Lakes) he has photographed more than 20 other essays on everything from sustainable agriculture to volcanoes of the Great Plains.

Richardson, who has a particular passion for environmental issues, comes from a newspaper journalism background and has also done extensive documentary work. One of his most ambitious projects was a 30-year photographic study of life in the small town of Cuba, Kansas (population 230). It's no surprise that the lure of the small town would appeal to him since he grew up on a dairy farm in Kansas—which is where he first discovered cameras and photography. "I was a kid on the farm with a lot of hobbies," he recalls. "One of those hobbies was photography, and I did lots of experiments including photographing through a microscope and taking pictures through a pair of binoculars held in front of a twin-lens reflex camera."

Still actively shooting assignments, Jim lives in Lindsborg, Kansas and operates Small World: A Gallery of Arts and Ideas, on the town's Main Street. He also teaches photography at workshops around the world and has judged more than 100 photo contests. Most recently he judged the Energizer Ultimate Photo Contest, a major competition sponsored by Energizer and *National Geographic*.

Is judging contests an enjoyable process?

It is, because I get to see the range of photography that's out there—the really great stuff and the not-so-great. You get to look at photos that you just wouldn't see otherwise, pictures that are totally unexpected. It's great fun just to be able to root through those photos and see where people are going with photography.

Do you think that digital photography has helped people to be more creative?

Yes, it certainly has; the creative floodgates have opened. Photographers are able to express what they're after more easily because they're not so encumbered by the trappings of the camera. But also, being able to review images on the LCD is just wonderful. You are able to learn on-the-fly what you're doing right and what you're doing wrong, what's working and what isn't.

Also, with digital photography, each new picture is not costing you more; it's actually spreading the initial cost out over an ever-greater number of pictures. So you feel the freedom to be experimental, to try new things that you might never have tried before.

> **"If you have a reaction to the picture, something visceral and emotional, then you have to think that there's something going on there, even if it breaks all the rules. That's what a picture is supposed to do, to cause a reaction, to get to us."**

Do you think that's true for professionals too?

Yes, absolutely. Even at *National Geographic,* if you were to ask [director of photography] David Griffin, he'd tell you that we're better photographers today then we were five years ago. We're more experimental and we'll take chances and go places we never dreamed we could go before.

What is it that makes a particular photo stand out during judging?

First, I always try to do a scan and go through all of the photos pretty quickly to see if there are things that really just pop out—photos that give you a rush of recognition the instant you see them. Those pictures, whatever their technical qualities, whatever their shortcomings, you give weight. If you have a reaction to the picture, something visceral and emotional, then you have to think that there's something going on there, even if it breaks all the rules. That's what a picture is supposed to do, to cause a reaction, to get to us.

That process of doing a scan helps me to find some of the best pictures and eliminate others—pictures that are simply "me too" pictures. Those pictures may be done well and have perfect exposure, but you realize you've been seeing the same shots for 15 years. I don't care how perfectly it's executed; if I'm jaded to the very approach and the very presentation, it doesn't get nearly the mark up that more inventive photos get.

I had an English composition teacher in high school that used to say that the greatest tool that a writer had was a unique viewpoint. That is so often the case in pictures. There are other pictures that take time to appreciate and their gifts aren't delivered instantaneously, so you don't want to use that barometer all of the time on all pictures. But as you're sitting there doing the initial scan of images, if they can't grab your attention in a second or too, then they probably aren't going to grab your attention at all.

What mistakes do people make with photos they're entering in contests?

One of the greatest sins that you see in photo contests is the overuse of things like the saturation slider. You see that over and over again, people turning up the volume too high. And it doesn't have to be just saturation, either. It can be sharpness, or extreme focal lengths, all kinds of things. They assume that if some saturation is good then more is better, if a wide-angle lens is interesting then a fisheye lens would be even more interesting.

They make the mistake of assuming that it's about technique rather than vision. There's an analogy here to the ballet. Yes, all the dancers have to be technically perfect, but the perfection of the dance won't get to your heart. It may get to your appreciation of perfection, but it won't stir your heart like the agony of *Romeo and Juliet.*

Do you think that trying to win a contest is a good motivator for taking better pictures?

If that motivates people to go out and take pictures, then good. But on the other hand, if having better pictures of their family motivates them, then that's also good. One of the good things about entering a contest is that it gets your pictures out of the hard drive and in front of someone. Getting pictures in front of other people is a good thing because no matter how good your pictures are, a picture that doesn't get seen is essentially mute.

One of the best things you can do to improve your photography is to get your pictures in front of other people where you can see their reaction. I give a lot of talks and lectures where I show my pictures and I always try to watch the reactions when they flash on the screen. There are times when I show pictures that I think are the most wonderful photographs in the world and the people just sit there. But then a certain picture comes along and you see the eyes widen and the people sit up straight. Those are the reactions that you want to see and believe.

That's why sites like Flickr are good, because you have strangers giving you comments and reactions to your photographs. I also think that you have to absolutely discount the opinions of relatives and friends and the people who like you. They're just not objective enough.

> "Pictures can't be just about pictures; pictures have to be about life... then they have a pretty good chance in a contest."

Do you have any tips for helping people decide which pictures are right for entering a contest?

One thing that people can do is go through *National Geographic* or some other magazine, cut out a lot of pictures, and spread them out on the floor with some of their own photos in the mix. Then have someone come in and tell you which pictures don't belong—and tell them to be brutally honest.

You have to find a way to replicate what's going to happen when someone like me, a contest judge, is looking through all of these photos. You can't explain your photos to the judge or point them out. The picture has to do the work.

Years ago I judged a KINSA (Kodak International Snapshot Awards) contest and someone had sent in a picture of a tree. The picture was of the entire tree, but there was an arrow drawn on the photograph pointing to one leaf in the middle. The tag at the end of the arrow said "Hummingbird." It was a pretty humorous photo but I don't think the photographer meant it that way.

Are a lot of contest pictures too predictable?

Yes, I think so. When it comes to photographing the Grand Canyon, for instance, most people go to the south rim and stand at exactly the same place and get the same picture. It's going to be tough for you to get one of those pictures to stand out. But if you were on the north rim at 6 a.m. after it snowed, that picture is much more unusual and judges haven't seen it so much, so it will get attention.

This is exactly the same thing that I go through when I'm showing pictures to picture editors at *National Geographic.* These are people who have been looking at thousands of pictures every day for the last two or three decades. You can't go in there, show them something they've seen before, and expect them to pat you on the back.

What kind of photos make you yawn?

The same old pictures. You can see the photographers who are simply following the rules of what makes a good picture. They've used the rule of thirds, the lighting is perfect, and they've sharpened it exactly. If you're talking about photographing in a pub in Ireland, for instance, you can take a picture of a pint of Guinness sitting on an old wooden bar, and I don't care how sharp it is or how perfectly exposed it is. If it makes me wish I was in that pub having a pint of Guinness, then that's a winning picture.

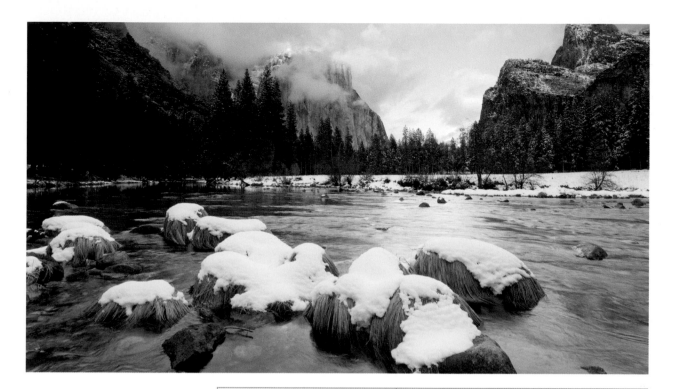

Photograph: ©Doug Steakley	Title: **El Capitan and the Merced River**
Grand Prize Winner of the Energizer Ultimate Photo Contest	

Travel is a common category in contests. What makes a great travel photo?

Fundamentally travel photography has changed. It used to show us places that we were never going to see in person ourselves. We kind of assumed back in the 1950's that very few people were going to actually get to Paris and see the Eiffel Tower. Now everyone travels and travel photography is about being there, what's it like to be there? Your pictures have to provide that visceral sense of what it's like to be in the middle of a place.

My eyes glaze over when I start to see yet another picture of a Tibetan monk in the saffron robes. I've seen enough of that. But if you bring me a picture that makes me feel like I can plop myself down in the middle of a place and get the feeling of what it's really like to *be there,* that's a winning photo. That's what travel photography is all about.

Do you have any advice to photographers that want to win a contest?

I think that trying to make a picture specifically to win a contest is difficult. Almost invariably you're going to end up with a picture that looks like a contest picture and doesn't

have at its heart something that offers real communication that would get to another human being. And it's that "getting to me" as a person, as the judge sitting there, that's essential.

Pictures can't be just about pictures; pictures have to be about life. If they are really and truly about life and beauty and understanding and our souls, then they have a pretty good chance in a contest. If they are simply about photography and about the contest, then they're probably be going to be pretty shallow and transparent. Take pictures of your passions, pursue your love of photography, and the contest prizes will soon follow.

And what is the one thing that photography does best?

It connects us. Good photographs are quantum packets of understanding; they allow ideas to leap from one person to another, almost magically. That is the connection and the link that photography creates as almost no other medium does.

winning digital photo contests: **Jim Richardson** 37

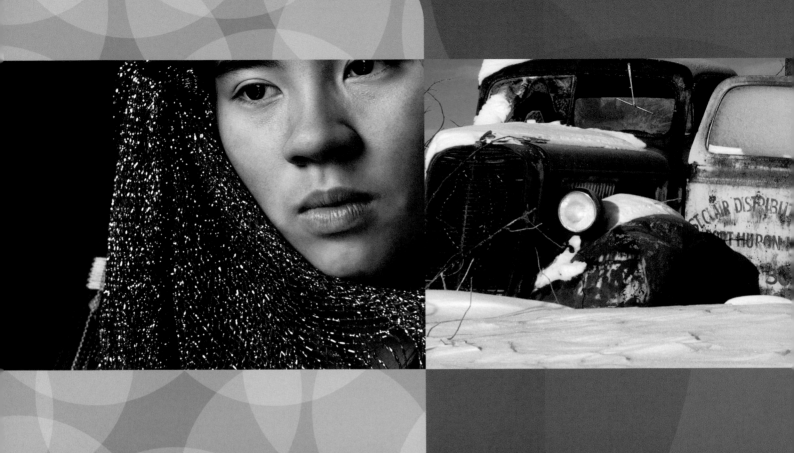

Your mission is to show us the world through *your* eyes using *your* imagination.

2

perfecting
your style

In the early twentieth century a photographer named William "Snowflake" Bentley, inspired by his belief that no two snowflakes were alike, devoted his entire life to photographing them. He produced thousands of images that proved, with photographic certainty, the uniqueness and beauty of each flake that fell on his Vermont farm. There is, I think, a great parallel to draw between Bentley's photos and the creative singularities that define each of our own imaginations.

I've always found it interesting, for example, that while there are probably many thousands of people who contribute photos to online and print photo competitions, each time I look at the winners of various contests, I'm genuinely surprised by both the quality and freshness of those images. How can it be that with so many millions of digital cameras floating around the world that people still have something different—often profoundly different—to say with their shot?

The answer, of course, is that we are each individuals with our own interpretation of the world around us. We each view reality through our own self-fabricated creative goggles (it would be impossible to see any other way); and as long as we have the confidence to stay true to that singular outlook, our pictures will, like Bentley's snowflakes, always be one-of-a-kind.

If you've ever participated in a photo workshop where ten or twenty students went to the same location and aimed their cameras at the same general scene, you've probably been surprised at how different each person's results looked. Some put the horizon high, others put it low; some focused on the foreground, others on the background. You can lead a herd of photographers to the same scene, but you can't make them shoot it the same way.

Although we all see things differently, putting your own visual stamp on the world still takes a lot of work. But that should be work you enjoy. After all, much of the reason that you picked up a camera in the first place was because you felt that you had a slant on the world that you needed to share. Why else would you spend the time, energy, and money that it takes to become a good photographer? And where else would you get the confidence to compete with your photos against other photographers?

Discovering and developing your unique vision is what creative photography is all about: your mission is to show us the world through *your* eyes using *your* imagination. In this chapter we'll look at some creativity-building tools that you can use to invent and enhance your own personal vision.

overstate the everyday

Many beginning photographers believe that the path to success in photography is to find exotic subjects in extraordinary settings. It's hard not to be intrigued by things that are new or foreign to us—a Buddhist monk in a Kyoto temple or a London bobby on the beat. But if your mind is open to it there is fascination also in the familiar, and because these subjects are so commonplace, they have their own intrinsic—almost universal—appeal.

The attraction of this photo by photographer Susi Lawson is that it holds a mirror up to our own lives. It's hard to see the exhaustion in the woman's body language or the utter chaos of the kitchen that surrounds her and not see our own lives and recognize our own kitchens on a bad day (unless, like Andy Griffith, you have Aunt Bee constantly tidying up around you). It's also difficult not to empathize with the woman, who incidentally had just come home from her job and was about to throw a birthday party for one of her four children.

When it comes to photographing everyday scenes, a documentary approach often works best because you're trying to reveal the reality of the scene. In this case the photographer shot only one frame before the magic of the moment was gone. About her photojournalistic angle, Lawson says, "When you are shooting candids you are documenting fleeting moments and expressions that are constantly changing. I took this one shot before she stood up and went back to Mom mode."

To work candidly and spontaneously, you have to be prepared and have the controls on your camera pre-set. On a zoom lens, choose a focal length and, unless you recompose the shot significantly, keep that setting. A lot of great photos are lost by (I'll say this with a nod to Wayne's World) unnecessary and gratuitous zooming. Also, in low light it's far better to bump up the ISO or widen the aperture to your lowest f/stop, rather than turn on the flash. On-camera flash has a way of killing the spontaneity of such moments and is usually the worst possible lighting option.

> **Technical Note**
> Shot using a Canon EOS 20D camera with a Tamron AF28-75mm f/2.8 XR Di LD IF lens at 28mm. Brightness and contrast adjustments, saturation increase, light smudge brush on the skin in Photoshop.

Why This Moment?

> **"**As a single mother myself, I related to the emotion of the moment, which portrays so much about the subject's life. Just as she sat down to rest, one of her children called out for her attention and I snapped the shutter.**"**
> —*Inspiration for* Another Mother's Day

> **"**I prefer to shoot candidly, representing people as they really are. The photos end up with a greater depth and a sense of soul that studio setups lack.**"** —Susi Lawson

Photograph: ©Susi Lawson	Title: Another Mother's Day
Contest: Digital Image Cafe	EXIF: 1/100 second at f/2.8, ISO 1600

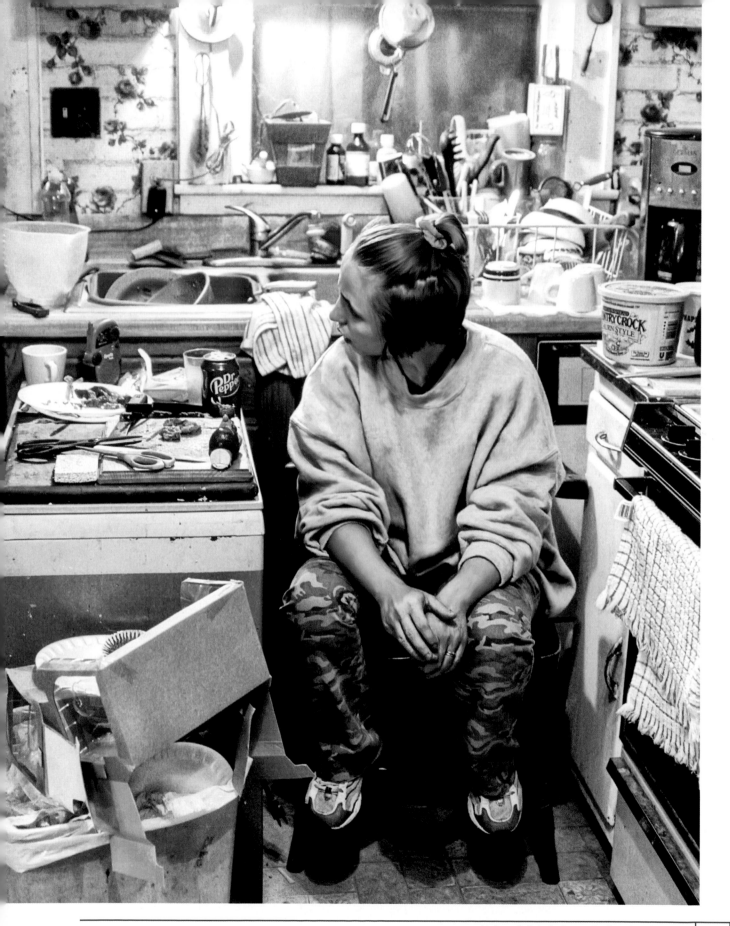

find fresh vantage points

One trait that many creative photographers share is an ability to see everyday subjects from unusual or unexpected angles and perspectives. In fact, it's this very quality that often separates a snapshot from an award-winning photograph, and an average photographer from one who consistently produces imaginative pictures. Revealing common settings or ordinary events from unique viewpoints forces us to re-evaluate both the physical and emotional context of otherwise familiar moments.

To develop an offbeat point-of-view, you need to first sharpen and then trust your visual instincts. If you think something might make a good photo but you're afraid it's a bit too off-the-wall, have the courage to listen to your artist's inner voice. Commit to the instinct and let your results decide. You have to trust that little bell that goes off in your head saying, "This looks like a cool shot."

We've all seen a row of men at a diner counter, for instance, and may have even thought it would make an interesting photo. Usually though we notice the scene when we're sitting in the diner as part of that particular world. What makes this photo on the right a standout is that photographer Brian Lewandowski perceived this very normal moment from an outsider-looking-in perspective, and rather than self-editing or ignoring his instincts, he committed to the

Photograph: ©Stefan Nielsen	Title: **Pink Cadillac**
Contest: **DailyAwards.com**	EXIF: **1/400 second at f/4, ISO 400**

moment. By following through with the idea, he created an image that appeals to your voyeuristic side, yet because it is so ordinary, also feels comforting and real.

Interestingly, while some people may have a genuine gift for consistently seeing old things in new ways (you only have to look at a few of Van Gogh's paintings to realize that he viewed the world from a totally singular perspective), I also believe it's a skill that can be pursued and perfected. In the same way that you can hone your technical skills by practicing them and working toward conscious goals, you can intensify your ability to see the world differently by using self-assignments and exercises to expand your vision beyond safe and familiar viewpoints.

Most people hold the camera horizontally (in landscape orientation) and at eye level—the default position because it's comfortable and convenient. But a little physical effort can radically improve your perspective. Climb a stone wall to shoot downward at a grove of ferns, or sprawl out on the ground to capture a dandelion puff in the breeze. For photographer Stefan Nielsen, capturing the winning image shown left was as easy as leaning in with a medium telephoto lens to isolate this vibrant and graphic detail. You may have seen a pink Cadillac before, but probably not from this dynamic a perspective.

Technical Note
Shot using an Olympus Camedia E-10 camera. Cropped in post processing.

Photograph: ©**Brian Lewandowski**	Title: **Salisbury Stakes**
Contest: **Smithsonian Magazine**	

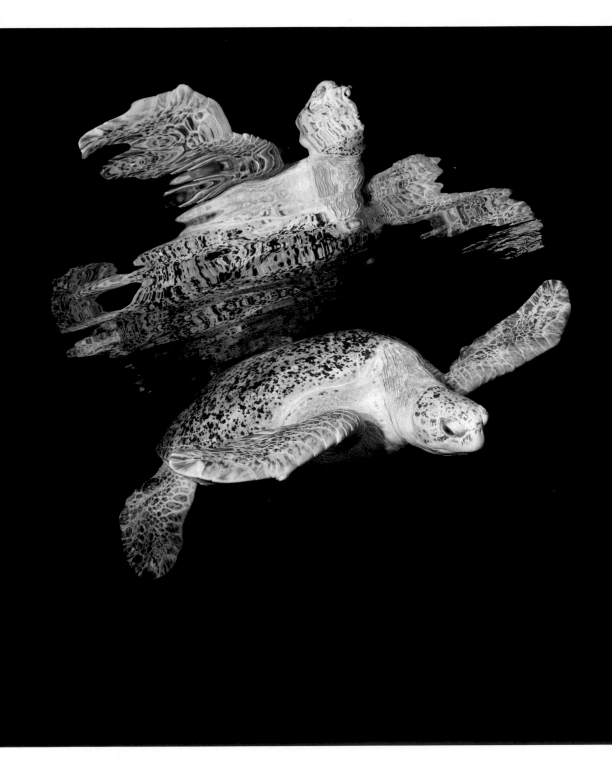

“ The truth is, I did not take only a couple shots; I was literally following the turtle for quite some time. I believe that in order to get the perfect shot, one must be persistent and passionate. **”** —Hermawan Wong

pursue your passions

To find passion in your photography you must also find it in the subjects you photograph. If you have no curiosity about insects or wildflowers there's no way that taking pictures of those subjects is ever going to satisfy your creative drive. You must marry your picture-taking interests to your everyday passions.

In all of the classes that I've taught, both online and in person, my final lesson is always devoted to that very topic: Use your camera to pursue your true passions. With passion comes persistence. Only with that combination will you both develop the skills and devote the time and energy necessary to master photography.

For example, I have always been a very enthusiastic music fan. There is no place I'd rather be than standing beside a stage (with or without a camera) listening to live music. The first serious photos that I ever shot were of live concerts, and I've continued to shoot hundreds more over the years. In order to endure the long hours of standing and kneeling, breathing nightclub smoke, and (at times) having my eardrums stretched to their limits, I depended on my desire to capture the creative energy of a concert with my cameras.

Passion pushes your photography to the next level. It's easy to get kind of good at photographing a particular subject, and if your interest in the subject is pedestrian, that's as far as you'll take it. But if you want to impress your friends and cohorts with your favorite subjects, you'll want to show them progressively more interesting and intense forms of photography. In order to make superb underwater photographs like this one by photographer Hermawan Wong, for example, you would first have to master the skill of diving. It's only natural that you'd want your underwater photo skills (see page 115) to equal your diving skills.

In your own life there must be a passion (or, if you're lucky, several of them) that pulls you out of bed in the morning, keeps you up late at night, and helps you commit the requisite large blocks of time, energy, and money that are necessary for its pursuit. Whether it's gardening or your kids or travel or careening down the side of a mountain in winter on two five-foot fiberglass runners, your enthusiasm will stoke the fires of your photographic ambitions and vice versa. Use the passion.

(see page 115)

Technical Note

Shot using a Canon EOS Digital Rebel XTi camera with a Tokina AT-X 10-17mm f/3.5-4.5 DX AF Fisheye lens and a Sea & Sea DX-400D Underwater Housing. Two Sea & Sea YS-250 Pro strobes provided the lighting.

Photograph: ©Hermawan Wong	Title: **Turtle Reflection**
Contest: **WetPixel**	EXIF: **1/100 second at f/11, ISO 100**

perfecting your style

find beauty where others don't

The old adage that beauty is in the eye of the beholder is certainly true when it comes to finding interesting photo subjects hidden in everyday objects. While most people might drive by this abandoned truck and see it as an eyesore or a roadside blight, photographer Heather McFarland found in it both a strong graphic beauty and a sense of nostalgic charm. By photographing in soft morning light as it emerged from a fresh layer of snow, she created a subtle emotional contrast between the old rusting hulk of the truck and the pristine newness of the snow. (This is one of my favorite photos in the book, by the way.)

The ability to see beauty in the ordinary and find intrigue in the commonplace has many artistic benefits. For one, being able to turn everyday objects into interesting photographs vastly increases the number of subjects you have to photograph. If you can spot inherent mystery or uncover bold graphic patterns in a head of cabbage or a forgotten vase on a windowsill, for instance, you'll never be lacking for fun things to photograph.

More importantly, the challenge and effort involved in probing beyond first impressions to find the inner visual or emotional strength of ordinary places and things forces you to think outside the box. One of the very first exercises that I was ever given in a photo class was very simple: photograph an egg. No other instructions, no guidelines; just come back with an interesting photograph of an egg. The photographs with which we all returned were fascinating and incredibly diverse, and the assignment showed clearly that a subject is as much about what the photographer brings to it as it is about the actual thing itself.

Can you develop this talent? Yes. There are a lot of tricks and exercises you can use to teach yourself to see creatively. In her excellent book *The New Drawing on the Right Side of the Brain* (Tarcher, 2002), author Betty Edwards suggests drawing objects right side up first, then turning them upside down and drawing them again. It's a great exercise for discovering lines, shapes, and patterns that you don't see when your brain is too busy looking at the "normal" or utilitarian aspect of an object. Try it with your camera.

Ultimately, learning to see beauty in the ordinary is about letting go of the internal critic that tells you a subject isn't worthy of the time and energy it takes to photograph it. Turn that voice off. Listen instead to the voice of desire that wants you and your photography to progress toward higher creative ground.

> **"** Old abandoned cars and trucks are some of my favorite subjects. It is getting harder to find them as the old vehicles are restored or fall apart. I think they touch a nostalgic spot in many people's hearts. **"** —Heather McFarland

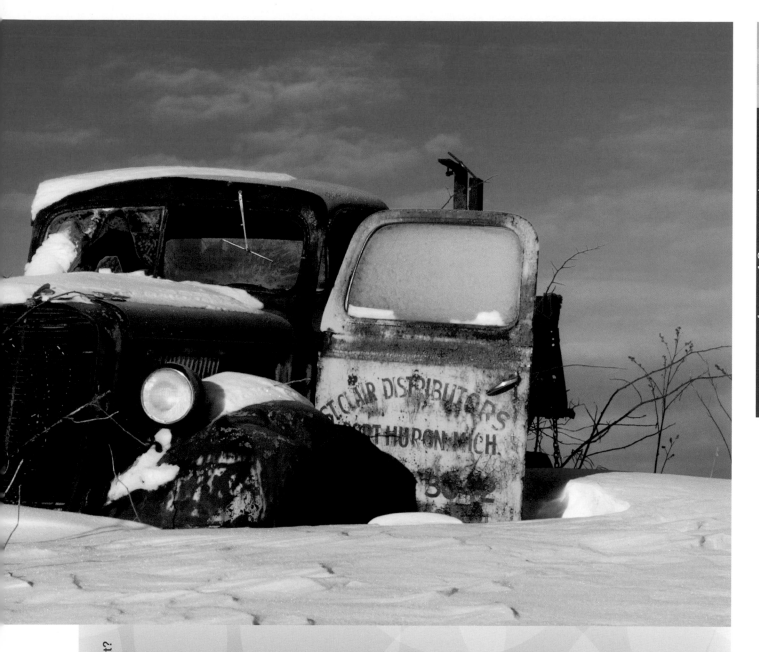

Why This Moment?

 "The morning sun and the fresh snow combined to make this old truck stand out on the top of a hill. The open door and one missing headlight gave the truck a lot of character and the feel of just being driven to the top of the hill and abandoned. **"** —*Inspiration for* **Done Distributing**

Photograph: ©Heather McFarland	Title: **Done Distributing**
Contest: **Digital Image Cafe**	EXIF: **1/100 second at f/16, ISO 125**
Technical Note: **Shot using a Nikon D1x camera with an AF Zoom-Nikkor 35-70mm f/2.8D lens at 44mm.**	

develop a specialty

As your photographic skills grow, you may find yourself gravitating naturally to a few specific subjects, or developing a specialty in one particular type of photography. Devoting much of your time to one style or a single subject might seem limiting at first, but in reality it's a great way to expand both your technical and creative skills. By concentrating on just that one type of subject, you focus all of your energy and talent into a smaller area of expertise, and can then begin to refine and polish your technique.

Having a special interest in one particular area also helps you narrow down the range of contests that you pursue—a good timesaving device. Also, if you're trying to pick up an income or get established as a freelancer, getting known for a specialty can be a good marketing tool. Many professional photographers intentionally limit their work to one or two specialties for that very reason.

Discovering your strong suit in photography happens naturally for some photographers because, as we talked about earlier, they have married their photographic energy to a particular passion or hobby. Others arrive there by sheer process of elimination: they shoot a lot of different subjects at first and gradually leave some behind to narrow down their field of interests. If this starts to happen to you and you find yourself photographing only night scenes or close-ups of bugs, for instance, embrace your good fortune. Work with that subject as long as it inspires you.

Once you have identified your specialty you'll begin to notice new possibilities for subjects and ideas all around you. To make these soulful and intense portraits, photographer Banhup Teh had to go no farther than his own household: the man pictured on the following page is his gardener and the beautiful young woman here is his daughter. Rather than searching the earth for subjects, Teh brought his talents to his own immediate world. Both shots were made by available light—no special equipment required.

Finally, another benefit of having a specialty is that you can (and should) seek out mentors, either in person or through books, magazines, and websites. To truly excel at mastering a particular subject it's very important to know where others have already taken it and to be aware of what's happening in that field. Visit museums and galleries, or just sit on the floor of the library for a few hours studying monographs, and you will see rapid growth in your own artistic ambitions.

Why This Moment?

"I noticed the excellent late-evening sunlight streaming through my bedroom window onto my daughter's face, and instantly saw the moment's photographic value. I work almost exclusively with available light and am always ready for it to inspire me. **"** —*Inspiration for* **Waiting by the Window**

" It is always encouraging to see where my photos stand. I take part in contests mainly for this encouragement—I seldom collect my prizes. **"**

—Banhup Teh

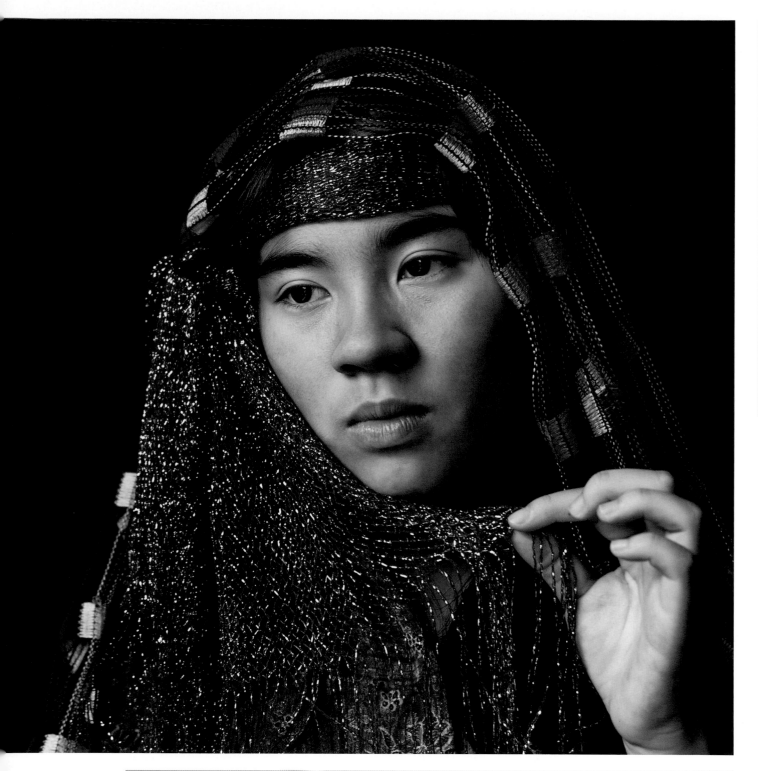

Photograph: ©**Banhup Teh**	Title: **Waiting by the Window**
Contest: **Digital Image Cafe**	EXIF: **1/60 second at f/3.2, ISO 400**
Technical Note: **Shot using a Nikon D200 camera with an AF-S Nikkor 28-70mm f/2.8 IF-ED lens at 28mm.**	

"This was taken in my hall with early morning light coming from the window to the subject's right. While having coffee, I noticed my gardener's wonderful features and colorful headgear, especially cast in the quality ambient light."
—*Inspiration for* Colours

Photograph: ©Banhup Teh	Title: Colours
Contest: Digital Image Cafe	EXIF: 1/50 second at f/3.2, ISO 400
Technical Note: Shot using a Nikon D200 camera with an AF Nikkor 85mm f/1.4D IF lens.	

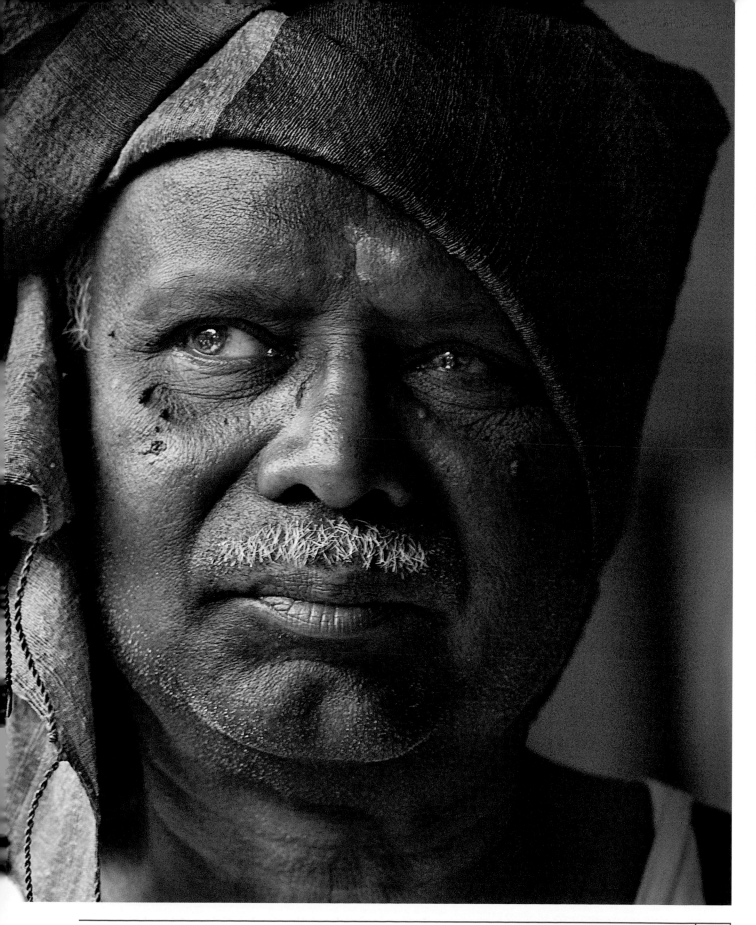

Technical Note

Shot RAW using a Canon EOS 1-Ds camera with a Canon EF 24-70mm f/2.8L USM lens at 42mm. Levels adjustment and sharpening in Photoshop.

Photograph: ©**Michael S. Rickard**	Title: **The Lincoln Memorial**
Contest: **Kodak Picture of the Day**	EXIF: **10 seconds at f/11, ISO 100**

push your limits

To grow as a photographer

To grow as a photographer and to have your photos stand out among other photographers' work, you need to push past your personal comfort zones, both technically and creatively. While getting good at the basics of photography—exposure, sharpness, composition—is vital to learning the craft, it's just as important that you experiment (warning: here comes a trendy phrase) outside of the box. In fact, to unleash your inner artist you may have to put some dynamite in the box and blow it to smithereens.

Some photographers consider the restrictions of normal photography a gauntlet thrown at their feet, and boldly test the boundaries just for the sake of the challenge. For example, while I really don't recommend trying this with your good camera, there is a whole group of photographers out there (look on Flickr if you think I'm making this up) who call themselves camera tossers; and they do just that. They set their camera on self-timer and then quickly toss it skywards so it takes a picture while airborne, hoping to catch both the camera and a unique shot at the same time.

You don't have to go to such extremes to find new creative horizons; just force yourself to photograph in situations where you don't normally take pictures. If you've never taken your camera out after dark and set the shutter speed to 10 or 20 or 30 seconds just to see what happens, try it. That's exactly how photographer Michael S. Rickard got this amazing shot of the Lincoln Memorial. A 10-second exposure and a tripod were all he needed to create this neon stream of taillights flying across the Arlington Memorial Bridge in Washington, DC.

If you ever find yourself asking "I wonder what would happen if…" about a picture-taking situation, there's only one way to find out: try it. By asking and answering that simple question you will propel your vision ahead in creative leaps and bounds, and you (and contest judges) will appreciate the effort.

Photograph: ©**Charles Cleverly**	Title: **Just for Him**
Contest: **Popular Photography**	

perfecting your style

"I felt the Glasgow Show in Scotland would be a fantastic opportunity for quality, original action shots—there are so many opportunities to capture something a little different. After several failed attempts, I decided prefocus on the nearby trees first, then re-frame against the sky where I knew they would pass. The narrow aperture helped in predicting the focus. " —*Inspiration for* Sky Acrobatics

master split-second timing

A good sense of timing is an important quality in a lot of aspects of daily life. Choosing just the right moment to step off the curb and into a crosswalk can be a life or death decision. Knowing the exact moment that a cake is ready to come out of the oven is not nearly as crucial, but nonetheless it's a skill a chef must master. In photography, developing a refined timing instinct is equally crucial to the success of your photos, and timing choices can make or break an image.

In some photographs, like a still life, the only timing to worry about is getting the shot before your lights begin to melt the wax fruit. In other situations, though, timing is everything. To capture this photo of motorcyclists flying through the air at the Glasgow Show in Scotland, photographer Sandy McLachlin's timing had to be perfect. Had the shutter been released a millisecond earlier or later, she would have lost the shot. Mastering timing in sports and other situations is largely a matter of two things:

studying the action and anticipating when the peak of action will happen. Fortunately a lot of fast action subjects, like sports, tend to repeat themselves (kids on skateboards going down the steps at the local strip mall is a great example—security guards running after them is another), and so you have opportunities to study and practice.

There are other situations though where the importance of good timing may not be apparent. In a landscape photo, for instance, waiting for the sun to peek out from behind the clouds and illuminate a lone tree on the hillside might be a critical consideration (see page 75). If you're photographing a swan preening in a nearby pond, choosing the instant when it gracefully tucks its head under a wing is the mark of a great shot.

Whatever your subject, remember that developing a sense of timing is mostly about being aware and knowing when to wait and when to not hesitate. Just ask the skateboarders as they zoom past you, one push ahead of the law.

Technical Note

Shot RAW using a Samsung GX-20 camera with a Tamron SP AF90mm f/2.8 Di Macro lens. White balance and contrast adjustments in RAW processing; levels and curves adjustments, resizing, and Unsharp Mask in Fireworks 8.

> **"**Voting on other photos is a great source of learning as it gets you to analyze the good (and not so good) points of other photographers' images. It's also very inspiring to explore member profiles and top winning images in each category to gain a better understanding of the various aspects required to be successful.**"** —Sandy McLachlin

Photograph: ©Sandy McLachlan	Title: Sky Acrobatics
Contest: DailyAwards.com	EXIF: 1/500 second at f/9.5, ISO 100

listen to the light

No matter what you photograph, you're always capturing the same thing—light. Light is the essence of photography. Whether you're photographing a pumpkin, your Pit Bull "Fluffy," or a Caribbean island from the deck of your cruise ship (lucky you), your camera sees the light rays reflecting off of those subjects. It has no clue as to what the physical subject in front of your lens is. It has only one responsibility (and only one capability): to faithfully record the rays of light that you have pointed it toward.

But light is more than a mere facilitator of photography. When it is well seen and carefully captured, light has the power to be an enchanting, enticing, and exceptional presence in your pictures. The right light can transform the most mundane of objects into rare treasures, and has the singular ability to cast a profound emotional spell over the most familiar of scenes. A butterfly in a meadow is a fairly common site and always fun to photograph, but by photographing it in the amber glow of sunset, photographer Justin Black transformed the moment into an icon of natural beauty. He acknowledges what drew him to make this picture, "What made me notice this butterfly was the beautiful lighting."

Indeed, one of the things that draw many people to photography as a hobby (or a profession) in the first place is a heightened appreciation of the beauty of light. It's probably a quality that you possess. If a single ray of morning light igniting your toothbrush sitting in its holder above the bathroom sink has ever moved you to fetch your camera and record the scene, you are probably already charmed by the power of light. Let your family laugh as you stand there in your bathrobe composing your ode to an underappreciated toothbrush; your awards will vindicate your madness.

Why This Moment?

"This photo was taken in a park near my home, where I enjoy taking photographs of insects. They are challenging just to approach, much less to compose an interesting scene around. This butterfly was not startled by me and the lighting was perfect." *—Inspiration for* **Mystical**

"I started entering competitions at the age of sixteen, with no expectations of winning (my photography teacher needed entries to represent our school). To my surprise I placed in almost every contest I entered. Winning reassured me that I was doing something right, and encouraged me to to continue taking photos." —Justin Black

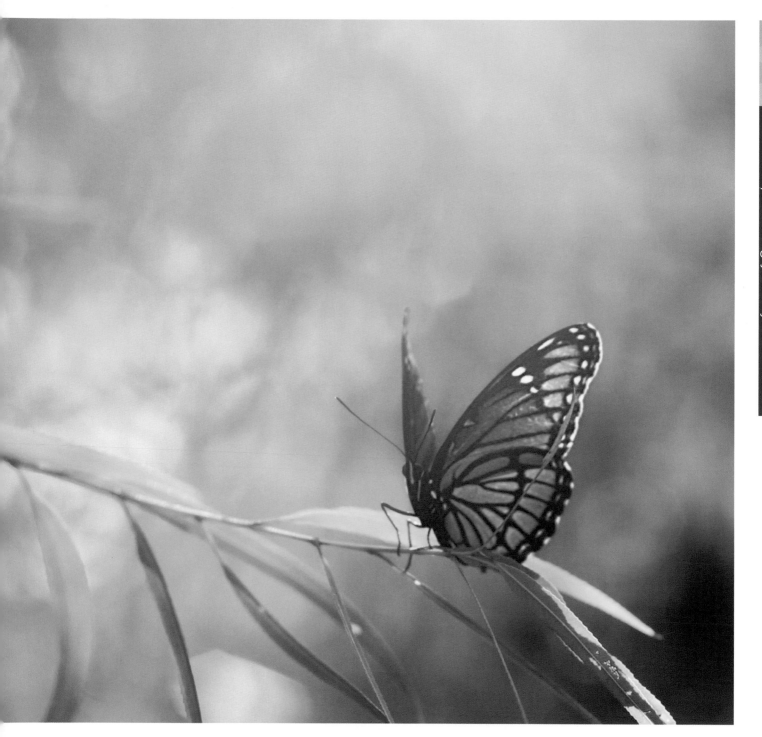

Photograph: ©Justin Black	Title: **Mystical**
Contest: **National Wildlife Federation**	EXIF: **1/800 second at f/4, ISO 200**

Technical Note: **Shot using a Canon EOS Digital Rebel camera with a Sigma 105mm f/2.8 EX DG Macro lens. Custom white balance (4750K).**

Why This Moment?

“I'm always looking for that special look, the perfect moment and eye contact. I loved the way she was peeking over her Mom's shoulder and keeping an eye on me.”

—*Inspiration for* Got my Eye on You

Technical Note

Shot using a Canon EOS 5D camera with a Canon EF 28-135mm f/3.5-5.6 IS USM lens at 75mm. Two-light studio flash setup with JTL 300D Versalights: one softbox, one umbrella. Levels adjustment, red saturation decrease, contrast increase, smoothed the skin in post processing.

Photograph: ©Michelle Frick	Title: Got my Eye on You
Contest: BetterPhoto.com	EXIF: 1/125 second at f/5, ISO 100

amuse yourself

One of the most significant difficulties in selecting photos to enter into a contest is that you probably know next to nothing about who the judges are and what they like to see. You have no way to know if they favor dramatic photos shot in exotic locales or are fans of a more subtle, homespun style of photography. You don't know if their personal preferences are for color images or black and white, for a lot of post-production editing or for none. For that matter, you don't even know if they enjoy looking at photographs (let's play it safe for now, however, and assume that they do).

Fortunately you have a built-in filter for helping you decide which photographs might win contests and appeal to the broadest description of a contest judge: yourself. While the goal in entering a photograph in a contest or exhibition is to win some type of award and get recognition for your vast and remarkable talents, the ultimate and most crucial audience for all of your photographs is, and will always be, you. If you don't think your photographs are interesting, creative, warm, funny, beautiful, dramatic, soulful, inspired, and just plain delightful, it's unlikely that they will move anyone else.

In order to reach those lofty goals, however, you've got to begin by shooting pictures that amuse you. You won't ever reach your true potential as a visual artist if you're photographing things just because you think other people will like them. That's a riddle you can simply never solve and trying to resolve it leads to circular paths with no end. In his short career (which lasted only ten years from first sketch to his untimely death), Van Gogh likely never sat at a canvas and asked himself "What will the dealers in Paris want to see?" Van Gogh was driven—haunted—by a personal vision that not only consumed his every breath but drove him to paint at a relentless and furious pace.

You may never achieve that level of tormented passion, but you must share with Van Gogh and every other master artist the simply stated goal of pleasing yourself. Make yourself laugh. Make yourself cry. Make yourself wonder. Amuse yourself! This will probably mean that on some days you won't find a single thing to photograph—and sometimes that's a good thing. While you don't want to set your standards so high that you never take your camera out of its case, you also want to be selective about the subjects and moments that have meaning to you. Accomplish that and the contest world is your oyster.

"I'm competitive and a perfectionist by nature, so I am compelled to keep on trying. It's a wonderful feeling of validation to receive recognition for my work."
—Michelle Frick

Photograph: ©Greg Tucker	Title: **Mother's Embrace**
Contest: **Nature's Best Magazine**	

The success of a landscape photo depends
not on the type of place you photograph,
but rather on your ability to reveal the soul
of that place.

3

creating
landscapes

Step out your front door some morning, aim your camera up the street, and snap a quick picture. What have you just done? Exactly the same thing that photographers have done since the invention of the medium: you've photographed a landscape. Your photo probably won't contain purple mountain's majesty or granite cliffs beside the ocean (unless you live on a *really* nice street), but it will do what all landscape photographs are meant to do—it will describe a place. In this case, *your* place.

The types of places that landscape photographs can describe are as varied as the planet itself. While many of us tend to associate the word "landscape" with nature and wilderness photography, you can also take wonderful landscape photos in a city park, a school playground, a crumbling factory row, or even your own backyard. The great photographer David Plowden (www.davidplowden.com), one of my personal heroes, has created some of the world's most important and interesting landscapes out of subjects as diverse as rural railroad stations, small town streets, industrial harbors, and abandoned bridges. His urban venues are every bit as dramatic and beautiful as nature's because he has peered into each of them with genuine curiosity, reverence, and an unrelenting sense of wonder.

The success of a landscape photo depends not on the type of place you photograph, but rather on your ability to reveal the soul of that place—to show us (and hopefully a few contest judges) why this place moved you enough to photograph it in the first place. Ultimately, landscapes reveal not just where or what we photograph, but who we are. While one photographer might portray the streets of Manhattan as an oppressive concrete canyon, another might choose to animate the same streets with romance and infinite possibilities. Likewise, you can approach the same subject in several different ways, depending on your mood or your goals on any particular day.

Whatever your subject or approach, when you put your eye to the viewfinder four challenges face you: choosing a physical vantage point; deciding how much (or how little) of the scene to include; selecting lighting suitable for your subject; and whether to treat your subject realistically or as an abstract (or somewhere in between). These are decisions that you have to make each time you attempt to describe a place and make it your own.

In the following pages we'll look more closely at the situations you may face and how other photographers turned those choices into winning pictures.

the classic composition

A good landscape tells a tale. But like most tales, it's up to the storyteller—that's you—to engage and enthrall the audience. The stories your landscape photos tell can fall into several genres: the most desirable being the authentic, novel image that richly characterizes its landscape while totally captivating its viewer; the most common being the awe-inspiring but tired postcard knockoff that rhapsodizes beauty without giving personal insight; and the most unlikely and difficult to achieve being the humorous photo that narrates a funny story or situation. The latter is difficult simply because landscapes don't easily lend themselves to guffaws—though odd urban juxtapositions can easily elicit giggles (think of a large ice cream cone sign positioned above a group of overweight folks exercising in the park).

Whatever tale you decide to tell, recognize that all landscapes present you with design challenges. Their vastness forces you to carefully coordinate the foreground, middle ground, and background into a coherent story consistent with the theme you've chosen. Tossing together a random smattering of elements—a barn here, a silo there,

some trees over there—isn't likely to impress a judge's discerning eye. You must carefully arrange your images to demonstrate that you knew precisely what you were doing. In other words, prove to them that you've got a plan.

Just how much you emphasize each of the three regions in a particular design is a decision you'll have to make for each scene—that's one of the toughest concepts to master in landscape photography. (You thought this was going to be easy?) In some cases, like photographer Judy Corbin's tranquil lake shown here, the foreground is relatively tiny: a small sapling at the edge of the vast body of water. But it's the very smallness of that carefully chosen foreground object that emphasizes the expanse of the middle ground's lake, and the great distance to the background trees.

Eventually, coordinating the various elements of a landscape will become second nature. You'll instinctively balance them into an effective design. But until that happens, you need to consciously identify the major elements of the landscape in front of you and practice arranging them until they come together to form a compelling composition. The good news is that it won't be long before you can compose landscapes quickly and confidently.

Why This Moment?

66 Lac Beauvert [Beauvert Lake in Jasper National Park, Canada] had me awestruck and I just wanted to be able to convey what it did for me. The peace and serenity of the place is amazing, especially first thing in the morning. 99
—*Inspiration for* A Slice of Heaven on Earth

Photograph: ©Sue Green	Title: **Night Must Fall**
Contest: **DailyAwards.com**	EXIF: **1/6 second at f/22, ISO 50**
Technical Note: **Shot RAW using a Canon EOS 5D camera with a Canon EF 24-105mm f/4 IS USM lens at 50mm.**	

Photograph: ©Judy Corbin	Title: **A Slice of Heaven on Earth**
Contest: **DailyAwards.com**	EXIF: **1/180 second at f/8, ISO 200**
Technical Note: **Shot using a Pentax *ist DL camera with an smc Pentax-DA 18-55mm f/3.5-5.6 AL lens at 18mm.**	

strike a visual balance

In the same way that you wouldn't cluster all of your knick-knacks at one end of a mantle and leave the other end completely bare, it's important to distribute the various elements in your landscapes so they appear harmonious and visually balanced.

Visual balance in a landscape (or any type of photo) doesn't require a symmetrical distribution of weights and shapes within the frame, as much as an aesthetically pleasing arrangement of them. I'll resort to a playground analogy: if some kids on either side of a seesaw are equally balancing their weights to remain perfectly horizontal, that's not nearly as engaging as another, more entertaining arrangement—a giant football player whose feet remain on the ground while on the other end three little kids are stuck up in the air. Beyond shapes and sizes, the tones of your subject are equally if not more important to achieving harmony across the photograph. Offsetting light areas of visual levity (lighter tones and pastel colors) against heavier areas (darker tones and shadows) is the Feng Shui of landscape composition.

To keep these heavy areas from weighing a photo down too much, you can balance a large bright area with a smaller dark one. Or try to balance opposing dark areas to create a sense of buoyancy across the frame. In this moody Quebec lake scene, photographer Suzanne Lestage carefully arranged the dark areas (the dock in the lower right and the trees in the upper left) at opposite diagonals. Not only are the weights of the heavy areas evenly distributed over the image, but also, even though they are smaller, the darker corners balance out the large light area of the water.

As with creating classic compositions, visual balance is often as much about instinct as about following traditional rules and arrangements. When you're confronted with a scene that has conflicting dark and light areas, experiment with different arrangements of its elements until a pleasing harmony emerges.

Why This Moment?

"The mysterious mood created by the light and fog on the lake struck me that early morning. The mood only lasted about five minutes—just long enough to take four or five shots."
—*Inspiration for* Mystic Blue

Technical Note
Shot using a Nikon N80 camera with an AF Zoom-Nikkor 28-105mm f/3.5-4.5D IF lens and Ektachrome film. Mounted on a tripod, with a Cokin P173 Varicolor blue/yellow filter attached.

Photograph: ©Suzanne Lestage	Title: Mystic Blue
Contest: Smithsonian Magazine	EXIF: 1/30 second at f/5.6, ISO 64

communicate a sense of scale

When you photograph a common object—a deck chair, a bicycle, or a basket of apples—it isn't important to include indicators of relative size, because we're already familiar with the approximate sizes of such objects. Landscapes, on the other hand, are rarely so familiar that their huge dimensions are self-evident. Even with familiar views of the Grand Canyon or Grand Tetons, viewers can't readily grasp the enormity of the subject unless you've included a visual measuring stick.

Remote, unpopulated areas like mountain ranges and scenic panoramas particularly need at least one object of modest size in order to communicate a sense of scale. In photographer Ted Lee's haunting shot of the Li River in the Guang Xi Province in China, it's the boat that reveals the mountains to be vast, soaring, and imposing. If you doubt the importance of the boat, put your finger over it. What happens? The mountains shrink, the grandeur diminishes. Even though we don't know the precise size of the boat, its presence reveals the expansiveness of the surroundings. Lee, who photographs this area near Guilin, China about once every six months, says he waited patiently for the boat (and the ripples) to complete the scene.

To exploit scale and size, choose familiar markers of a known size. Including a saguaro cactus in a desert landscape, for example, is only somewhat useful because not everyone has seen one in person—not to mention that their height can range from 2 to 30 feet (0.6–9 m) or more. But put a person in that same scene and the scale is abundantly clear, as we all know the approximate size of a human being.

When you want to veil the dimensions of a landscape, keep in mind that the reverse of this concept is also true. If you consciously remove all objects of known size you can eliminate scale from the scene and create a more abstract landscape.

Why This Moment?

66 Several factors attracted my attention: the mountains, the mist, the boat, and the ripples. The movement implied by the ripples was very important; without it the photo would have been too static. 99

—*Inspiration for*
A Boat in Misty Mountains

66 Learn more about your subjects before your shoot—prepare! 99 —Ted Lee

Photograph: ©Ted Lee	Title: **A Boat in Misty Mountains**
Contest: **Smithsonian Magazine**	EXIF: **1/60 second at f/11, ISO 400**
Technical Note: **Shot using a Canon EOS 40D camera with a Canon EF 28-135mm f/3.5-5.6 IS USM lens at 100mm.**	

"This scene usually includes apartment buildings in the background, but with fog rolling in, coupled with a recent snowfall, the scene became a tranquil, serene landscape."

—*Inspiration for* Winter Solace

Technical Note

Shot using a Canon EOS 20D with a Canon EF 17-40mm f/4L USM lens at 17mm, and a neutral graduated filter attached. Minimal post processing.

Photograph: ©Craig Doros	Title: **Winter Solace**
Contest: **Digital Image Cafe**	EXIF: **1/125 second at f/8, ISO 200**

the minimalist approach

There is a temptation when photographing landscapes to indulge in everything that appears in front of you. In the same way that some of us grab a smattering of everything at the all-you-can-eat buffet, a gorgeous landscape tempts you to stuff too much into a single frame. When faced with a surplus of exquisite scenery, it's hard to remember that less is more; so most photographers just pull out the wide-angle lens and embrace everything they see.

But with great landscape photos, as with a healthy diet, less is almost always more. Unless it is supremely well organized, clutter annoys the heck out of judges. Whether you're entering a contest or a local juried show, judges seek a clean image with a purposeful design that showcases what's important. The simple fact that you took a risk and built your designs out of fewer components is enough to impress most judges.

Often the most powerful landscape photos feature only a few distinctive elements that are representative of a larger and more complex whole. By including fewer objects, you free the eye to explore while also emphasizing the objects that remain. On the left, Craig Doros' splendid and uncomplicated image reveals only four elements: the water, the trees, the snowy background, and the sky. To add any more elements—a fourth or fifth tree, for example—would diminish the design and detract from its impact. Notice, too, how the still waters emphasize the sky area to reinforce the feelings of tranquility and simplicity.

Try to think of landscape compositions from a Zen perspective: what you leave out is just as important as what you include. As you compose a scene, take a moment to ask yourself what can be eliminated without upsetting the balance or significance of your shot. Do you need the park bench? Is the rock outcropping really necessary? Once you've analyzed the scene, either use your zoom lens to tighten the frame and exclude those superfluous elements, or just move around the scene until you find a cleaner design.

Simplifying is not just about fewer objects, either. Often you can simplify a scene by reducing the number of colors or tones. It's interesting to note, for instance, that most formal Japanese gardens have few bright colors because tradition holds that color distracts from the tranquility and design of the garden as a whole. Look at how few tones photographer Mark Tkach included in his pastoral landscape—essentially just three horizontal stripes of saturated colors; yet each gains in strength precisely because of the limited palette.

Not all landscapes are meant to be composed in such a minimalist style, of course; but even when a scene requires more complexity, a "keep it simple" philosophy acts as a good clutter filter.

Photograph: ©**Mark Tkach**	Title: **Maryland House**
Contest: **Smithsonian Magazine**	EXIF: **1/500 second at f/11, ISO 400**

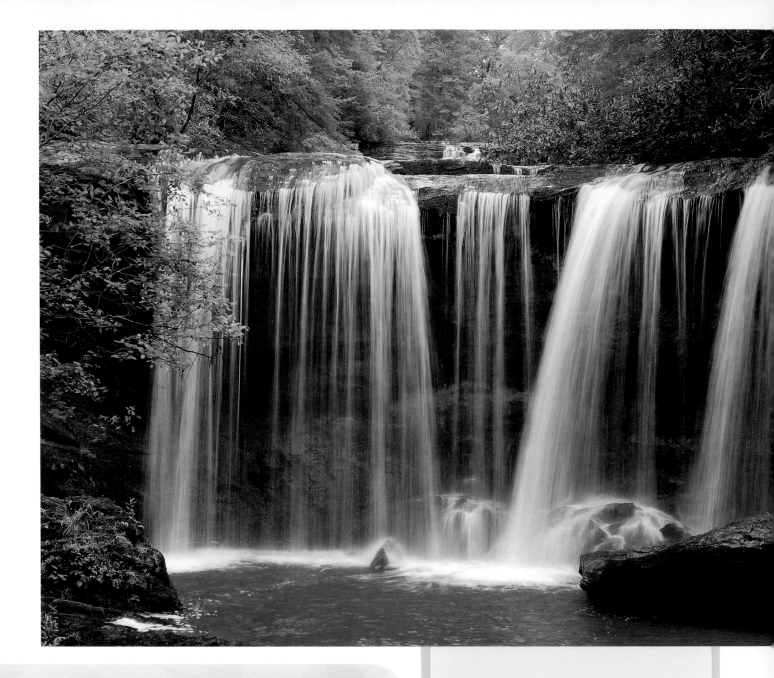

❝I arrived at the falls to find the skies mostly clear, with just a few small clouds. Bright sunlight shining on a waterfall does not make for a good photograph. I set up my tripod and camera and just hoped for a friendly cloud. About 20 minutes later, a small cloud passed over the sun, diffusing the light. The cloud was only over the sun for about 15 seconds, during which time I was able to get off three exposures.❞

—*Inspiration for* Brasstown Falls

Technical Note

Shot using a Nikon D70 camera with a Sigma 17-70mm f/2.8-4.5 DC Macro lens at 34mm. A polarizer and 2-stop neutral density filter were attached. RAW conversion was done with Nikon Capture 4 software; minor additional corrections in Photoshop Elements 5.

the landscape in motion: long exposures

Waterfalls are a favorite subject for me and many other outdoor photographers. Their nature (running water) is so obvious that it may deceive you from exploring a subtle but potentially evocative trait common to many landscapes: motion. Just pause a moment and consider the movement within various landscapes: windblown wheat fields rippling to the horizon, waves exploding on rocks, streams surging down hillsides, clouds sailing across the sky, snow blowing across a road. Although the land itself may not often move (and when it does, run for cover), parts of the land are in constant motion. Capturing that movement in a still photograph can be a challenge that, when met, will definitely catch the judges' eyes.

Whenever motion stirs a scene, you can exploit it as a valuable and unexpected visual element in your pictures. By using slow shutter speeds to include evidence of that movement (i.e. motion blur), you add to your landscape an extra level of realism, as well as a sense of elapsed time. Exaggerated subject movement in a still photo has an undeniably captivating effect.

The trusted technique for capturing or embellishing motion is simple and requires only two ingredients: a long shutter speed and a steady tripod. The optimal shutter speed depends on how fast your subject is moving and how much blur you want to create. A slow moving stream, for example, might require an exposure of several seconds to capture the blur; while a faster-moving subject like a rushing waterfall or crashing storm surf will show motion effects with a much shorter exposure time. Because the water over this waterfall was both substantial and fast-moving, photographer Cliff Berinsky was able to create a beautifully sylvan, silky flow using a relatively short shutter speed (1/5 second).

If you're new to the technique, experiment by taking a series of exposures of increasing duration and see what happens. Don't be afraid to take bold steps either, trying exposures of a minute or more if it seems like the result might be interesting. There is no right or wrong shutter speed, and you will get a variety of different effects with each different exposure. Just be sure to close down the aperture at longer shutter speeds; if your camera has a Shutter Priority mode, use it and the camera will automatically close the aperture as you lengthen the shutter speed.

In some bright conditions the shutter speed can't go low enough to capture motion effects without resulting in overexposure, even with the smallest apertures and lowest ISO values set. In this case, use a polarizing filter when you need a shutter speed just a stop or two slower, or a neutral density filter (often referred to as ND filters) when you need a shutter speed four, five, six, or even ten stops slower. (Probably the most useful ND filter is a four- or six-stop version.) These filters reduce the intensity of the light without altering the color of the scene. To keep your image as sharp as possible, however, keep in mind that it's better to use one dense filter than to combine several.

> **All judges, like all people, view the photos with their own collection of biases. When it comes to photos, the old adage of "to thyne own self be true" definitely applies. Strive to make your photos a reflection of your personal vision, not your perceived vision of a judge. If your photographs please you, they are sure to please others.** —Cliff Berinsky

Photograph: ©Cliff Berinsky	Title: Brasstown Falls
Contest: Digital Image Cafe	EXIF: 1/5 second at f/14, ISO 200

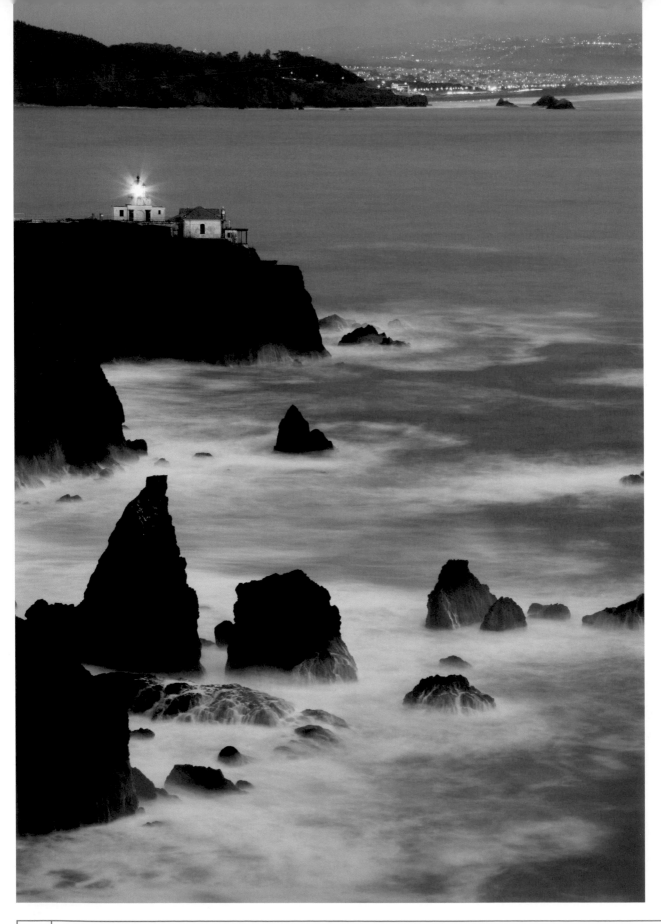

see the color of light

Light's most subtle quality is also its most evocative—color. If you can unleash the subtle effects of the color of light, you can mesmerize judges with a seductive whisper rather than a desperate shout. The color of light changes throughout the day—from the first rosy sprays of dawn, through the clear white light of midday, to the golden moments of the late afternoon that bathe your landscapes in brassy hues.

As profound and dramatic as these colors may be in photographs, we rarely take note of them in person—partly because they occur so gradually, and partly because our visual system adjusts to them automatically. Just like your digital camera, our eyes and brain have their own auto white balance function that instantaneously compensates for color casts—even radical shifts in the existing light like a quick transition from blue shade into brilliant sunshine. At all times our visual system strives to present us the world as if it were bathed in the neutral white light of midday.

The automatic white balance function in your camera, however, doesn't have to be on at all times. Experiment with creative white balance settings and you'll soon see the wide spectrum of light all around us. If your camera produces RAW files, then you have complete freedom to try different white balances in post processing. In either case, if you want to capture the true color of a scene, you should set the white balance mode to sunlight (about 5600K).

The color of true daylight can profoundly impact the mood of a landscape. In photographer Travis Novitsky's beautiful twilight scene of Point Bonita in the Golden Gate National Recreation Area shown here, the rich blue light of late evening has created an ethereal and mystical, yet welcoming light—exactly what the photographer was after. "I wanted an image that portrayed the lighthouse as being a safe haven from a rough sea," says Novitsky, "and the conditions on this evening were perfect for that type of shot."

If you want to demonstrate to yourself just how substantial the gradual shift of daylight is, try finding an interesting landscape and then spend an entire day taking one photograph every fifteen minutes. In a twelve-hour day you will shoot around 50 photos of that same scene and, while you might be bored silly by the end of your experiment, you will certainly see and experience the wide variety of daylight's possibilities.

Why This Moment?

"I spent three days in and around the Golden Gate Nation Recreation Area as part of a photography road trip. In search of an interesting perspective of the lighthouse, I climbed to this cliff, where the foreground of waves crashing against the rocks and the city lights in the background really caught my eye. The dark skies and late evening hour added to the mood of the shot." *—Inspiration for* **Point Bonita**

Technical Note
Shot using a Canon EOS 20D camera with a Canon EF-S 17-85mm f/4-5.6 IS USM lens. Brightness and contrast adjustments in post processing.

Photograph: ©Travis Novitsky	Title: **Point Bonita**
Contest: **Digital Image Cafe**	EXIF: **10 seconds at f/16, ISO 100**

dramatic moments

I f there is one thing at which nature excels, it's creating intense and often unexpected moments of visual drama. Any time that one natural force clashes with another—unstoppable storm waves beating against an immovable rocky shore, for example—dramatic scenes are bound to result. The more extreme the environment, the more explosive and dramatic those moments can be. Of course, it's difficult to predict exactly when or where such moments will occur, but in some respects they do announce their arrival. Dramatic skies can appear almost daily with the coming and going of the sun, and there's no denying that sunrises and sunsets (see the following page) are among nature's most awesome and frequently photographed displays.

Unfortunately, even if you anticipate the arrival of these wild and unabashed incidents, their fleeting nature leaves but a few precious seconds to capture them. Heather McFarland had but mere seconds to capture this isolated tree spotlighted by a ray of sun against a brooding autumn sky. "I had to wait quite a long time for a break in the clouds to light up the tree and foreground," she says. "Once the morning sun broke through I had to shoot as fast as possible. I was able to take about eight shots before the light vanished."

Such success depends on preparation; and that means more than just having your camera beside you in the car. You must have the ISO set, the correct lens mounted (if you're shooting with an SLR), the scene metered, and the correct exposure dialed in. You also have to compose quickly, almost on an instinctual level. I can't tell you the number of times I've wanted to toss a camera into a nearby lake because I hesitated just a second too long while composing and missed the moment. When it comes to dramatic moments—work fast; it's better to get a slightly off-kilter composition than to miss your opportunity entirely.

Technical Note
Shot using a Nikon D1x camera with an AF Zoom-Nikkor 80-200mm f/2.8 ED lens. Curves adjustment in post processing.

❝Learn how light affects different subjects and scenes. I sometimes have to wait several weeks for the right lighting conditions for a subject that I have staked out.❞ —Heather McFarland

Photograph: ©Heather McFarland	Title: Solo Performance
Contest: Digital Image Cafe	EXIF: 1/20 second at f/22, ISO 125

sunsets and sunrises

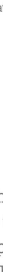

Gifts from nature at the beginning and end of each day, sunrises and sunsets are not only intensely beautiful and inspiring to witness, but they're also downright fun to photograph. No other event in nature so colorfully and spectacularly transforms a landscape—certainly not on such a predictable schedule. And from a purely selfish photographic standpoint, no matter how the rest of your shooting day has gone, it can always be rescued by a great sunset.

If the essence of sunrises and sunsets is color, then let's turn up the volume. You can emphasize their brilliant colors by contrasting them with a simple, yet well-defined foreground. Strong shapes with interesting lines work best because anything you place in front of a sunset usually ends up in a silhouette that hides the subject's colors and textures. Begin scouting for locations ahead of time so that once the sky show starts, you can concentrate on capturing the image. One trick a lot of pros use (especially when traveling) is to carry a pocket compass and map so that they can roughly predict the directions of sunrises and sunsets (east and west, respectively).

Although the skies can reverberate with color on almost any day, sunsets often excel before or after a storm; and the more tumultuous the weather, the more colorful and flamboyant the skies will be. Usually these scenes provide you with a lot of exposure latitude. If you overexpose slightly you'll end up with more pastel colors; if you underexpose, the colors grow more saturated. But do be careful that dark areas in the foreground don't merge into one another. If they do, shift your position slightly and increase exposure a bit to keep the foreground elements distinct.

Remember, too, that the focal length of the lens you use will have a significant impact on the size of the sun: the longer the focal length, the more it magnifies object size, and the larger the sun will be. Using a long lens also compresses the distance between foreground and sky, intensifying the sunset even more. By using a 35mm-equivalent focal length of 300mm, photographer Snehendu B. Kar exaggerated the size of the sun in this spectacular sunset over the Arabian Sea.

And by the way, judges see a lot of sunrise and sunset photos, so delivering that extra level of creativity or impact will command much more attention.

Why This Moment?

" Cochin in the Kerala State in India is famous for its gorgeous sunsets on the Arabian Sea. The combination of sunset and the fishing nets was irresistible. One without the other would not have made such a good shot. "
—*Inspiration for* Cochin Sunset

" Choice of an interesting subject, waiting for the decisive moment, correct exposure, appropriate equipment, and processing techniques are all important. Luck plays a much smaller role than it is credited. "
—Snehendu Kar

Photograph: ©Snehendu B. Kar	Title: Cochin Sunset
Contest: **Popular Photography**	EXIF: **f/16 at ISO 200**

Technical Note: **Shot using a Nikon D200 camera with an AF-S DX VR Zoom-Nikkor 18-200mm f/3.5-5.6G IF-ED lens and a Hoya polarizing filter.**

stormy skies

You've heard me say it once, but because it's so true and important, here it is again: One of the best times to photograph any landscape is just before or immediately after a big storm. As the skies begin to darken, the storm clouds swallow the sun, transforming even the most bucolic landscapes into a climatic and often climactic battleground. Images captured in this threshold between the tranquil and the tumultuous forces of nature often elicit intense emotional reactions of fear, wonder, and awe.

When it comes to encountering storms, most of your photo opportunities will be by chance—unless you're a storm chaser (and good luck with that). But there's always some warning that the weather is about to change, and the key is to quickly make use of this time to scout for a simple but interesting foreground that thematically complements the approaching storm. As photographer Connie Bagot's dramatic scene shows, you can exaggerate the intensity of a storm by contrasting it with a particularly pastoral foreground.

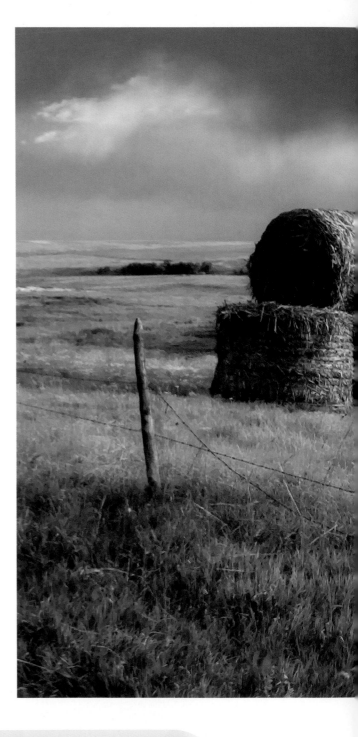

One of the technical challenges of photographing at the fringe of a storm is adjusting for the drastic light loss in the foreground as the skies darken. The problem is that if you increase the exposure to capture foreground detail, you reduce the drama of the skies; and if you lessen exposure to darken the skies, you lose foreground information. The best solution is so use a graduated neutral density filter, which can darken the skies in the top half of the frame but leave the foreground unaffected. An alternative is to take readings of both sky and foreground, and then use your manual exposure mode to set the exposure midway between the two. When using this approach, I tend to favor exposing for foreground detail knowing that I can darken skies in post processing, though that's not necessarily always the best compromise.

Departing storms are easier to shoot partly because you won't be dodging rain as much, and because you've likely had time to prepare while sheltered indoors. Storms that break up early or late in the day often lead to exciting skies with long rays of sunlight piercing the breaking clouds.

Why This Moment?

“The stormy light attracted me immediately. And it doesn't last long, so I went to the nearest subject that I could think of (I had shot these bales before). Out of thirty shots from various angles and distances, this was the only one that worked— and it was a winner!” —*Inspiration for* **Hay Bales on a Stormy Day**

Technical Note

Shot RAW using a Canon EOS D60 with a Canon EF 14mm f/2.8L USM lens. Raw processing in Adobe Camera Raw. Further processing in Extensis Intellihance Pro.

Photograph: ©**Connie Bagot**	Title: **Hay Bales on a Stormy Day**
Contest: **Digital Image Cafe**	EXIF: **1/60 second at f/8, ISO 100**

electrical storms

Lightning bolts slashing through the sky can instantly transform the most innocent and idyllic settings into a violent, primal landscape. As dangerous and fear provoking as they are to witness in person, a lightning landscape is almost impossible to turn away from—a desirable quality when you're trying to snag the interest of a contest judge. The more intense the storm, the more electrifying your photographs will be.

Lightning storms are relatively easy to photograph, provided you do it from a safe distance—photographer Jeff Neima shot this scene from his front porch. Photographing lightning during the day, while possible, is largely a matter of luck and good timing: simply find an interesting foreground with a lot of open sky and try to time your exposures for the peak of a lightning burst. It does take a pretty quick trigger finger, but fortunately most storms will give you several attempts at a good shot.

Nighttime exposures are much easier to control because you can leave the shutter open and wait for the lightning to write its own pattern across the sky. To do this you'll need a tripod (again, from a safe distance—you don't want your tripod conducting anything) and a camera that has a B or "bulb" setting. It's also helpful if you have manual focus so that you can set the focus at infinity, where the sky is always sharp.

Getting the exposure is relatively simple: with your camera set to a low ISO and an interesting foreground pre-framed, simply open the shutter and wait for a lightning bolt to cross the frame. Once you think you've captured an interesting pattern, close the shutter. Neima used a 15-second exposure for this winning image. Using his hands as an umbrella, he shielded the lens from the rain. "The photo was taken as the storm approached our neighborhood," he says. "I had taken about ten failed shots before this final, successful one."

Obviously you can't predict the exact strike location, but by aiming a wide-angle lens at the most active area, your odds greatly improve. By the way, when the scene includes artificial lights, I open the shutter but cover the lens with a piece of black cardboard to keep things dark until the instant lightning flashes. Then I snap away the cardboard to capture it. Since most flashes last a few seconds, I can usually uncover the lens quickly enough to grab most of the lightning streak.

Why This Moment?

" I've always been captivated by both landscape photography and the beauty of lightning. It was the challenge of capturing lightning bolts that made me try for this shot. **"** —*Inspiration for* Lightning

" Any camera can take good photos. It's how and when you shoot that determines the picture. **"** —Jeff Neima

Technical Note

Shot using a Casio Exilim Pro EX-P700 on a cheap, but sturdy, plastic tripod. No post processing.

| Photograph: ©Jeff Neima | Title: **Lightning** |
| Contest: **Steve's Digicams** | EXIF: **15 seconds at f/8** |

Photograph: ©Deborah Lynn Reeder	Title: **Peyto Lake**
Contest: **Steve's Digicams**	EXIF: **1/400 second at f/8, ISO 160**
Technical Note: **Shot using a Sony Cyber-shot DSC-R1 camera at 14mm.**	

the idealized wilderness

Some wild landscapes are so spectacular that good photographs of them inevitably idealize the natural world. Like archetypal views burned into our collective unconscious, even snapshots of such places turn into familiar icons of a country, a region, or a particular national park.

In many respects, however, the extreme beauty and overwhelming grandeur of such places can be a double-edged sword. On the one hand, these landscapes are celebrated precisely because of their unimaginable perfection. Ansel Adams' career was never hurt by the fact that he chose the majestic beauty of Yosemite as his lifelong theme. It's hard to imagine he would have become quite so famous by making a lesser landscape his life's passion. Indeed, when you begin with such an intensely attractive and alluring setting, you've already got one foot in the winner's circle.

On the other hand, because we see so many great photos of these places, we inevitably develop a certain degree of visual indifference, even resistance, to them—what people in the advertising business call "ad blindness." Well-trodden landscapes eventually become invisible to us because our imaginations are saturated by overindulgence in their ubiquitous beauty. Blame the calendar displays at your local bookstore.

Overcoming that familiarity-breeds-invisibility obstacle is a tough cookie not only because you're pitting your (admittedly impeccable) skills against the best nature has to offer, but also because a lot of other photographers have beaten you to the subject. In order for your photographs to compete with the many views already stored in a judge's mind, they have to be either very different or truly perfect—or both. In other words, from composition to execution your images must compete with the best of the best. For instance, photographer Deborah Lynn Reeder's stunning image of Peyto Lake, while a relatively familiar view, succeeds nonetheless because it meets the very high standard for success: classic wilderness + flawless technique = the idealized image.

One trick that you can borrow from professional travel shooters when it comes to capturing such perfect views is to scour the postcard racks before you shoot. While copying exactly what others have done flies in the face of genuine creativity, studying what's already been done is informative and certainly helps set your own creative and technical bar higher.

Why This Moment?

"The lake is a bright, milky-turquoise color, which I had never seen before. I found out later it is because glacial rock flour flows into the lake, and these suspended rock particles give the lake the turquoise color." —*Inspiration for* Peyto Lake

"Shoot what you love whether you win contests or not. This is only the second time I entered a contest and it's my first win." —Deborah Lynn Reeder

the rural landscape

Despite the fact that it's disappearing so fast (or perhaps because of it), the rural landscape continually lures photographers to its forgotten byways. Even though most of us experience its charms only on vacations or weekend drives, there is something eternally calming and restful about scenic views of farms, small towns, and country roads. Just thinking of a covered bridge spanning a rambling river in Connecticut during your morning commute is enough to settle your blood pressure and send your daydreams to a sweeter, gentler place—if only until the guy behind you in the traffic jam honks his horn.

Photographs of rural landscapes make judges pause not only because of their idealized emotional simplicity, but also because of their honest, rustic beauty. There's no denying the inherent photogenic attraction of a quaint farm, a field full of cows, or even just a row of wooden mailboxes next to a dirt crossroads. No one, especially not over-worked magazine editors or website contest judges, is immune to that kind of rose-tinted tranquilizer.

The key to capturing winning photos of rural scenes is to spin them with as much Norman Rockwell-like purity as possible. In other words, remove all signs of the modern world and isolate the elements that magnify the scene's simplicity. Photographer Neil Wetherbee found a superb perspective from which to capture this little hamlet in a single frame, and the trees of the foreground combine with the overall mist to abstract the subject as an island out of time.

Due to their romanticized nature, rural landscapes look best when further accented by the soft, slanting gold light that bathes the countryside early and late in the day (see page 75). Try expanding the peaceful spaciousness by using a wide-angle lens set to a small aperture which will keep more detail in focus by expanding the depth of field. It helps to incorporate depth cues in the frame, such as the linear perspective of a rusted barbed-wire fence receding into the horizon.

Remember that everyone looking at your rural landscapes wants to believe in the myth that we still live in a simpler time, so sell that vision and you'll have a winning landscape.

Technical Note

To improve the composition, the image was flipped in post processing .

| Photograph: ©Neil Wetherbee | Title: **Misty Morn** |
| Contest: **Photographic Society of America** | |

urban landscapes: the night skyline

Say what you will about high rents and rush hour traffic, the night skyline of a big city exhilarates the eye and makes a spectacular photo subject. Illuminated by the glow of countless flickering lights and shimmering rectangles of glass, a nighttime metropolis is visual poetry at its best. And as formidable a task as photographing such a scene might appear, it's fairly straightforward—particularly if you know a few tricks that pros use.

One of the biggest secrets of photographing the city at night is that the best time to shoot such scenes isn't really at night, but rather in the hour or so after sunset. By this time the lights of the buildings have just begun to turn on, yet there is still a gentle blue light filling the sky. That blue light helps give definition to the shapes of the buildings, and keeps exposure times shorter if you don't have a tripod. A tripod is *always* a good idea when shooting night scenes, however, because it opens up a whole range of exposures that even cameras with high ISO settings and anti-shake technology don't provide.

Also, working when there is still some light from the open sky reflecting on the building facades makes setting the exposure much simpler because the light is more equally balanced. Once the sky has gone completely dark, the huge increase in contrast between the bright lights and the surrounding darkness makes achieving a good exposure problematic.

One solution to the contrast problem, however, is to use a technique known as HDRI or High Dynamic Range Imaging, which is exactly what photographer Emin Kuliyev used for this urban landscape of Manhattan (shot from Brooklyn with the Manhattan Bridge in the foreground). The HDRI technique (see page 29) lets you combine several different exposures in post processing so that you can open up shadows and keep highlights from burning out. To read more about this interesting and useful technique, see *The Complete Guide to High Dynamic Range Digital Photography* (Lark Photography Books, 2008) by Ferrell McCollough.

Skylines are best viewed from a distance. That means you need to prowl the perimeters to find a good vantage point. Views that include water (like Chicago from the shore of Lake Michigan or San Francisco from across the Bay) are especially pretty because the reflections add an extra layer of light and color to the foreground.

Finally, it's a good idea to begin scouting your night shots in daylight so that you have time to experiment with various camera positions and lens choices before the sun begins to set. Twilight only provides you with about 30 minutes of premium shooting time, so it's important to have your compositions and camera settings lined up and ready to go.

Photograph: ©Emin Kuliyev	Title: **The Bridge**
Contest: **Popular Photography**	EXIF: **f/14 at ISO 100**

❝Never give up.❞ —Emin Kuliyev

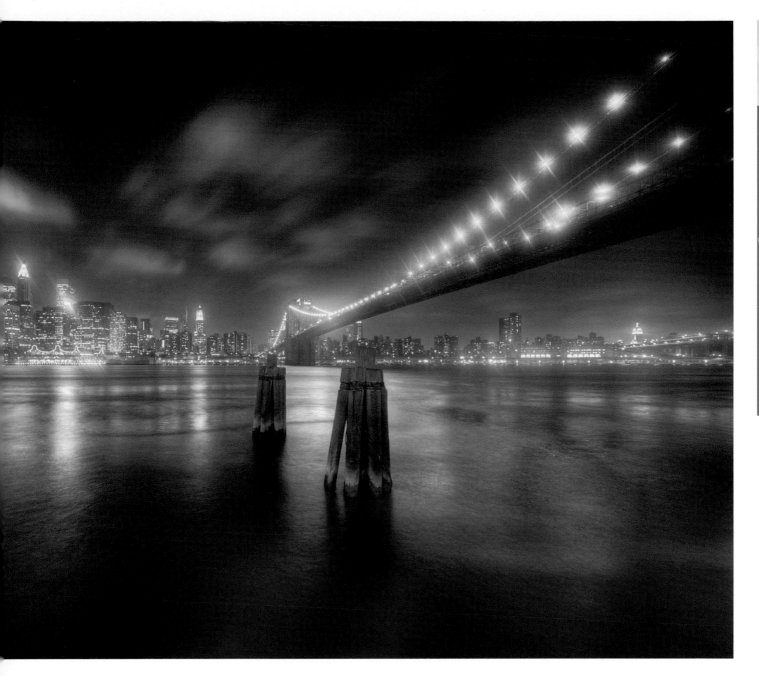

Technical Note

Shot RAW using a Canon EOS 5D camera with a Sigma 12-24mm f/4.5-5.6 EX DG HSM lens, mounted on a carbon fiber tripod. Three separate RAW images, taken at varying shutter speeds, were combined into an HDR image using Photomatix software.

Heather McFarland
photographer

'd like to introduce you to Heather McFarland. She's an exceptional photographer and an extraordinary contest-winner. If you visit some of the sites where her winning pictures are displayed, you will find them swamped with accolades.

In 2000, Heather retired from her 20-year career as a System Engineer at Kmart, to spend more time with her husband and son. It was about that time that her interest in photography blossomed. Now living in northern Michigan, she takes full photographic advantage of the rural locale's abundance of picturesque scenes.

As I started researching photo-contest winners for this book, I kept coming across these beautiful landscape and nature images; and in the information field for each photo, Heather's name kept appearing. She's won grand prizes in several contests, and placed first, second, or third in many others (not to mention honorable mentions, editor's picks—the list just goes on and on). Needless to say, she knows the world of photo contests inside and out.

"Your personal vision is what you should think about when out shooting. When you love what you capture it will show in your photographs!"

| Above Photograph: ©Heather McFarland | Title: Making the Rounds |

| Photograph: ©Heather McFarland | Title: Sunset Stalkers |

When did you get started taking pictures? Was it a serious endeavor from the beginning?

It started casually in the late 1980s; I began to get serious about photography when I purchased my first digital camera in 1999, then even more serious when I got my first D-SLR in 2001. The instant feedback and results from camera to computer really captivated me in a way that film did not. I was able to cut out the middleman of film developing and be in control of the complete photographic process from the click of the shutter to the final image.

When did you first start entering your photos into contests and why?

In 2002, after I'd had a D-SLR for a while. I thought that the photos I was taking were as good as those I had seen winning at these new contests. So I entered my images and started to win right off the bat. That was a big boost to my confidence, which just made photography more exciting for me.

What attracted you to photo contests?

The exposure it gave to my work. Also, being a highly competitive person, I use photo contests to motivate me to improve my photography. From those first few wins, I started to measure my work against the top winners in each contest and worked harder to equal and surpass them all.

How many photo contests have you won?

Many Photos of the Day at three daily contest sites (Digital Image Cafe, BetterPhoto.com, and ShutterBugs.biz). Lots of them have gone on to win Best of Category or Photo of the Month honors. At two online contest sites, I have the most Photos of the Day wins. I have also won at many other monthly contest sites and local print competitions.

What's the biggest prize you've won?

An all-expenses-paid, five-day photo safari to Utah and Arizona with Tawayama Safaris. I won this in an Apogee Photo Magazine contest called Reflections. (You can read an article written by Heather about this trip at www. apogeephoto.com/nov2003/tawa1.shtml)

Why do you think you've had such success at winning? What's your secret?

One of the reasons, I feel, is that I shoot many different subjects and styles. Some photographers shoot only landscapes, or people photos, or wildlife images; I shoot anything and everything. From scenic photos and architectural shots, to still life and macro work, to action and sports. I also very much enjoy turning images into digital art using different post-processing techniques and third party filters. Diversifying how and what you shoot really improves your overall photography skills, and it opens up more subjects and categories for you to enter, which gives you more chances to win.

> **"There's no secret to success, I don't think. Hard work and quality images are the hallmark of any good photographer, and that work will translate into contest wins."**

I also shoot more than most people probably do; besides gardening and spending time with my family, I dedicate most of my free time to taking pictures. There are stretches when I shoot everyday. I am also able to get out and shoot during the golden hours [the first and last hours of sunlight each day] and whenever any type of photogenic weather or lighting occurs. So having a large quantity of high quality images also helps to win many contests. Overall, it boils down to the fact that great photographs are going to get noticed, and great photographs will win contests!

Do you think about contests when you're out shooting?

No, I don't think about contests at all unless it's for a specific monthly theme. I shoot first and foremost for myself—what I like, when I like to. I feel that if you only shoot to win contests in the styles or the subjects you think will win, then you are doing yourself a disservice. Your personal vision is what you should think about when out shooting. When you love what you capture it will show in your photographs!

Do you always have a camera with you?

I never leave home without it. My camera bag weighs about 30 pounds (14 kg), but I am just conditioned to grab it whenever I leave the house. You never know what you might see on a trip into town, and you never know what lens you will need! So it all goes with me wherever I go.

What are you favorite subjects?

I used to enjoy shooting architectural abstracts and cityscapes when I lived near a major metropolitan area. However, since moving to northern Michigan five years ago, I haven't had any urban subjects to capture. I only have small northern towns, rural landscapes, lakes, rivers, and woods. I don't get to travel very often so all of my images are taken within a 100-mile radius of my home. That forces me to search the back roads and two-tracks in order to find new subjects; but hunting for subjects is half the fun for me anyway! I get to enjoy all four seasons (sometimes all in the same weekend), which can always make an often-visited subject or location look totally different. The beauty of autumn and winter make them my favorite times to shoot landscapes.

I also really enjoy macro work. Using my AF Micro-Nikkor 60mm f/2.8D lens to capture spiders, butterflies, bumblebees, or just a beautiful blossom in my extensive perennial gardens is one of my favorite photographic activities. Getting really close to these tiny subjects opens up a completely new world that many people don't see. All in all, my favorite subject is the one I'm shooting at any given moment!

Do you sell your photos to earn a living?

I sell a few prints here and there from my website (www.HKMPhotos.com), and have a couple of marketing deals; but I do not make a living as a photographer.

What advice would you give to photographers who want to enter contests?

Make sure you know the rules of each contest site. For instance, some contests only allow "natural looking" images to be entered, while others give greater leeway in post processing, granting photographers more artistic freedom. You should also know the resubmission time frames on each contest site. Entering a previously submitted image before it is allowed again will be noticed by the judging panel, who may then overlook or ignore it the next time around. On the other hand, if you can resubmit images after seven days, enter your best shots repeatedly. I have had images go on to win monthly honors that initially took over a year to win just a Photo of the Day.

Remember that at most of the larger daily contest sites, there are hundreds of entries submitted into each category every day, and the judges must go through them all

to select that one image that speaks to them. Don't give up on images that you feel strongly about—enter those as many times as is permitted. At most daily contest sites, the judging panel changes each month, or even during the month. A different set of eyes may be looking at your work each time you enter it.

How do you prep or process your photos in image-editing software before you submit them to a contest?

Each image will be unique in what type of processing should be performed. I try to shoot during the golden hours and in the best light possible, in order to capture a good tonal range up front. These images generally don't need much more post processing than a curves adjustment. However, many photographs will be taken in less-than-perfect lighting conditions and will benefit from more extensive editing.

I also inspect images for tiny flaws before submitting them. On any given day, your image will be up against many other outstanding ones, so something as small as dust spots, halos from over-sharpening, or uneven horizon lines may keep your image from winning. When it comes down to a judge choosing a winner out of two or three equally fine images, it can all boil down to the tiny details.

Do you plan to keep entering contests in the future?

I certainly do. I feel it keeps me competitive and gives me incentive to go out and shoot every chance I get. Contests still make me stretch my photographic knowledge and skills in order to keep growing as a photographer.

interview

| Photograph: ©Heather McFarland | Title: Rainy Day Blues |

Few moments in photography are as exciting as getting that first close, clear photograph of a wild creature—whether it's an elk on a mountain ridge or just a bunny enjoying a grassy brunch on the back lawn.

wildlife, birds, and close-ups

4

Based on the sheer number of wildlife photos you see in books and magazines, you'd think that every creature in the wild had its own personal paparazzi following it around. "Over here, Miss Deer! Please, the camera loves you!" The reason for so many wildlife photos, of course, is that people share a universal and insatiable sense of wonder about the other creatures on our planet. Inquiring minds need to know.

Although you've grown up with amazing photos of cheetahs, elephants, and lions in magazines like *National Wildlife, Natural History, Ranger Rick,* and even in your local newspaper, the publication of such photos is a relatively recent development (from a historian's perspective). The first wildlife photos published in a periodical, in fact, are credited to U. S. Representative (and early conservationist) George Shiras, who had a portfolio of 74 images published by *National Geographic* magazine in 1906. Since then photographers have used their cameras to relentlessly pursue the mysteries and lifestyles of the creatures that inhabit our forests, jungles, oceans, and even our cobwebby attics.

Few moments in photography are as exciting as getting that first close, clear photograph of a wild creature—whether it's an elk on a mountain ridge or just a bunny enjoying a grassy brunch on the back lawn. There is something magical about connecting—in a very up-close and personal way—with a wild animal. It's one thing to see a hummingbird whiz by a foxglove stalk like an acrobatic pilot on steroids, but wow, what a thrill to capture that instant forever at 1/4000 of a second! And seeing your first bear in the wild may be a soul-expanding (not to mention boot-shaking) experience—but what fun to relive and share that encounter over and over again in a photograph.

While the pursuit of great wildlife photos may seem an elusive and intangible goal to you now, as you'll see in the following pages, it's something anyone can accomplish with a camera, a bit of knowledge of their subjects, and some patience. In this chapter we'll take a look at some of the more popular wildlife and close-up subjects and show you how to turn your daydreams into reality.

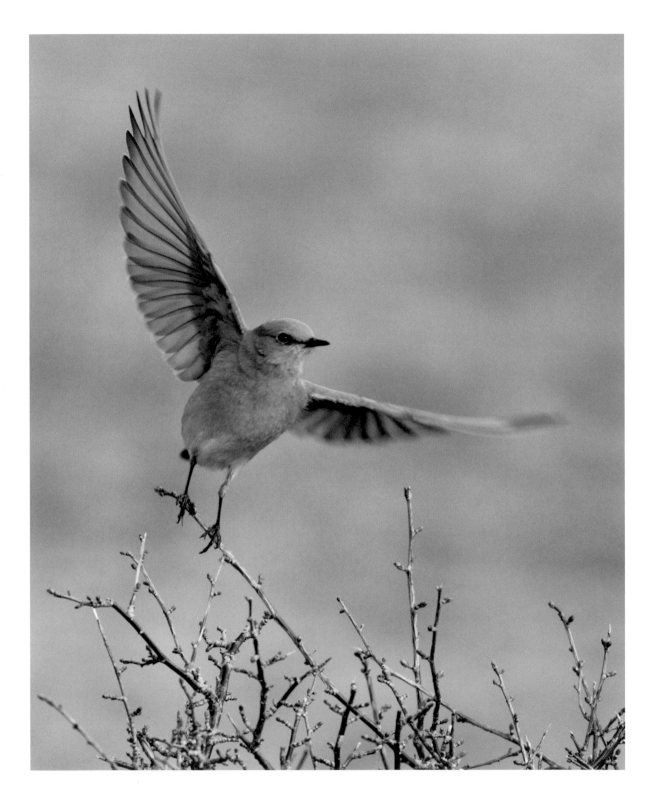

| Photograph: ©Richard H. Hahn | Title: Bluebird Grace |
| Contest: DailyAwards.com | EXIF: 1/800 second at f/5.6, ISO 400 |

songbirds

Cherry-red cardinals, lemon-yellow goldfinches, bluer-than-blue bluebirds—like winged sprites dipped in finger paint, songbirds are our most familiar and colorful wildlife companions. And while we cohabit with them at close proximity on a daily basis, getting good photos of them is a challenge. The reasons are fairly obvious: songbirds are timid; they often blend in with their surroundings; they're small; and, of course, they can fly away. Still, getting a good shot of a songbird is not as tough as it seems, especially if you begin to think like a bird.

For one, if you were a bird, getting food would be high on your list of daily chores. One trick that many experienced bird photographers use is to put a bird feeder near a window and lure the birds close with daily feedings. If you hang a black cloth over the open window and cut two small viewing slits (one for you, one for your lens), you can often get very close shots of birds feeding. If you want an even more natural shot (minus the feeder), try mounting a small branch or twig near the feeder by clamping it to an old light stand or step ladder. The birds will get used to resting on the branch between rounds at the feeder and you can shoot them looking very natural. Gradually snip the branch smaller to restrict where the bird lands so that you only need focus on one particular spot.

Birds also like to splash around in water and quench their thirsts, so putting out a birdbath is a great idea. Once the birds get used to coming to that bath on a daily basis (you have to keep the water fresh), you can sit quietly in a nearby lawn chair and they'll largely ignore you. Most beginning wildlife shooters think that the solution to getting close-up shots of songbirds is to own really long (and often really expensive) telephoto lenses. But that's thinking like a consumer, not like a bird. Instead, draw the birds close and get them used to your presence, and you can get excellent shots with a moderate telephoto or zoom lens.

It's tougher to photograph songbirds in the wild, but with patience and a really long telephoto lens (okay, when they're in the wild you can think like a consumer) you can succeed. As with photographing any bird or animal, the keys to success are persistence and behavioral knowledge of your subjects. If you spot a bird landing repeatedly on one shrub, for example, it may be nesting there or it may have found a good food source. If you set up nearby and remain very still (or use a pup-tent as a blind) you can often predict where a bird will land. As random as their behavior might seem, birds are creatures of habit and will return to the same areas over and over. If they think this is a great shrub, so should you.

Whatever means you use to get close, try to photograph birds doing something other than just sitting there. Photographer Richard Hahn's beautiful photo of a mountain bluebird in Colorado's Rocky Mountain National Park is not only close and sharp, but he's also managed to capture the bird with its wings fully extended. Getting the shot wasn't an easy chore: "It had long been a goal to photograph this bird in flight. But they are fast," he says. "It was part luck and part planning to capture this bird with its wings extended." On this particular day Hahn managed to get 28 frames of bluebirds, but only this shot captured the fleeting, mid-air moment.

wildlife, birds, and close-ups

"Wildlife photography requires patience, persistence, and luck."

—Richard Hahn

> **Technical Note**
> Shot using a Canon EOS 5D camera with a Canon EF 400mm f/5.6L USM lens. Exposure and saturation adjustments; cropped in post processing.

hunt the hunters

Whether it's an osprey scooping a fish out of a river or an owl swooping down on silent wings to snare an unsuspecting mouse, snagging a good shot of a bird of prey at work is rarely an unplanned or casual event. The devoted photographers who consistently get exciting shots have almost always invested a lot of time and energy in the study and observation of their subjects, and the mastery of their camera gear. The effort invested, however, is well worth it because the results—moments of life and death for the prey—are nothing less than thrilling.

Finding birds of prey is, again, a matter of knowing their habits—like what time of day they're active and where they like to hang out (i.e., wherever the hunting is good). If you happen to live near a lake, a river, or a protected wildlife area, finding subjects will be easier. Many state parks have wildlife viewing areas, and you can probably find one within a short drive, regardless of where you live. Photographer Bob McRae's amazing shot on the next page of an osprey with a fish in its talons, for example, was shot at the E. E. Wilson Wildlife Area in Oregon's Willamette Valley, an area known for its plentiful birds of prey. Just becoming familiar with an area and its raptor residents will substantially increase your odds of getting great shots.

It also pays to keep in touch with other birders and to check the local Audubon Society's (www.audubon.org) rare bird alerts for your area. Photographer John Zimmerman captured this exciting moment of an owl catching a mouse because he heard there was a great grey owl near his home in Montreal, Canada, and he went looking for it. Having your gear ready when you arrive is very important. "When I arrived I saw the owl in a tree. As I was watching him the mouse came out of nowhere," he recalls. "I had just enough time to get my camera ready when the owl started to fly." Incidentally, John is the president of the Montreal Camera Club, and belonging to such organizations can be a great way to find out about hot spots for birds and other wildlife in your area.

To catch a bird of prey at the moment of truth you really have to be very comfortable with your equipment. In most cases you are better off using your camera in either its Shutter Priority or Sports/Action exposure modes. In these modes you can select a fast shutter speed (in the latter the camera will do this for you) so that you can freeze the action. (By the way, a few cameras like Nikon's Coolpix P90, will set themselves to the action mode automatically if they detect that you're shooting an action subject.) Also, if you are using a D-SLR that has a continuous-focusing option (as opposed to single-shot), this allows the camera to continually update focus as you track your subject. In the single-shot mode, the shutter will only fire once you've achieved perfect focus—tough to do with moving subjects.

Getting shots of birds of prey is not something you will be successful with every time you go out, but each experience is something you can build on. Persistence, luck, and readiness will provide great rewards.

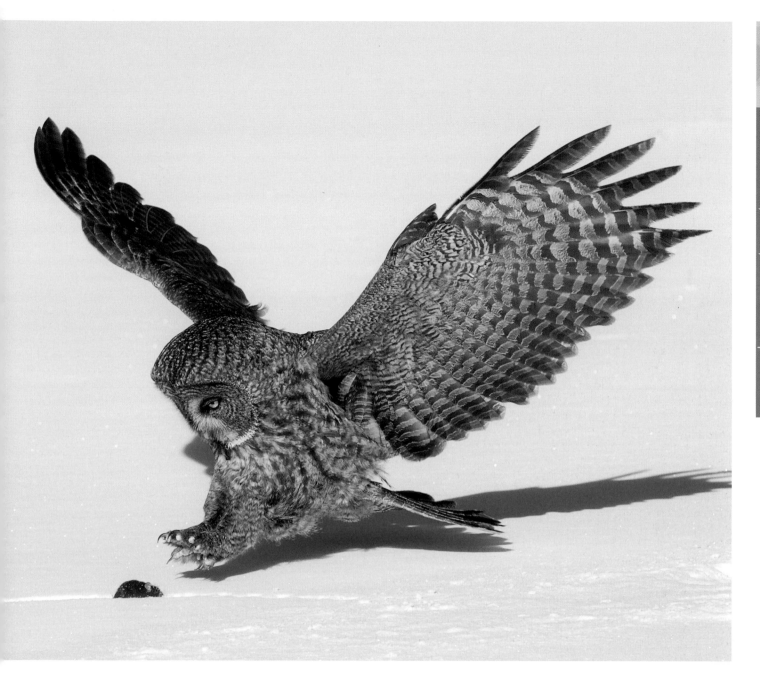

66Winning is always encouraging. I have been lucky to have won many contests including five additional Kodak Picture of the Day awards.99

—John Zimmerman

Photograph: ©John Zimmerman	Title: Making the Grab
Contest: **Kodak Picture of the Day**	EXIF: **1/2500 second at f/8, ISO 400**
Technical Note: **Shot using a Canon EOS-1D Mark II camera with a Canon EF 70-200mm f/4L IS USM lens at 200mm.**	

Technical Note

Shot RAW using a Canon EOS-1D Mark II N camera with a Canon EF 500mm f/4L IS USM lens and a Canon EF 1.4 Mark II tele-extender, mounted on a Gitzo tripod with a Really Right Stuff ball head and a Wimberley Sidekick. Exposed in RAW format. Saturation, contrast, and curves adjustments; noise reduction in post processing.

❝ My objective was to photograph an osprey coming toward me out of the water with a fish in its mouth. This was exactly the moment I'd been waiting for. ❞ —*Inspiration for* Fly Fishing

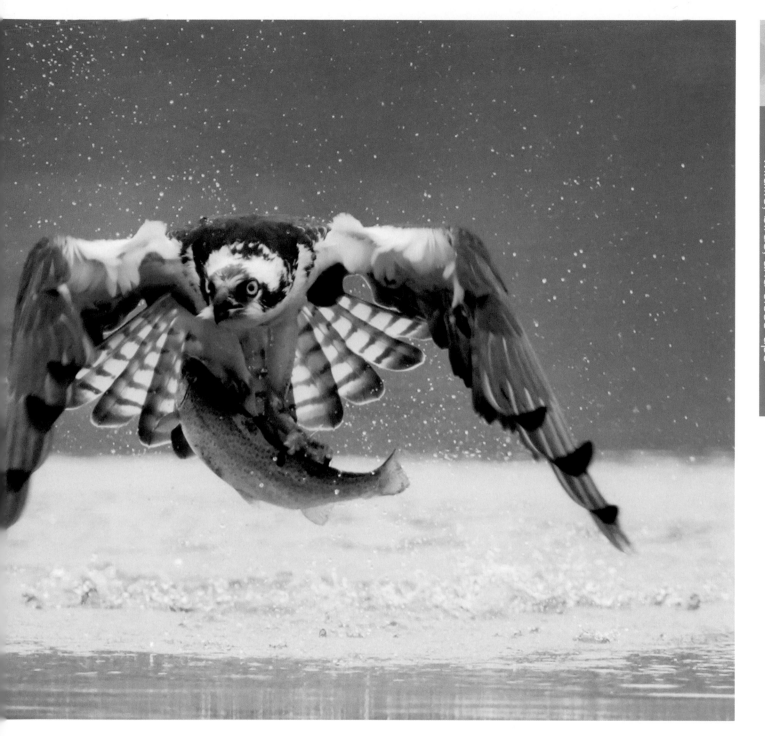

| Photograph. ©Robert McRae | Title: **Fly Fishing** |
| Contest: **Digital Image Cafe** | EXIF: **1/1250 second at f/5.6, ISO 800** |

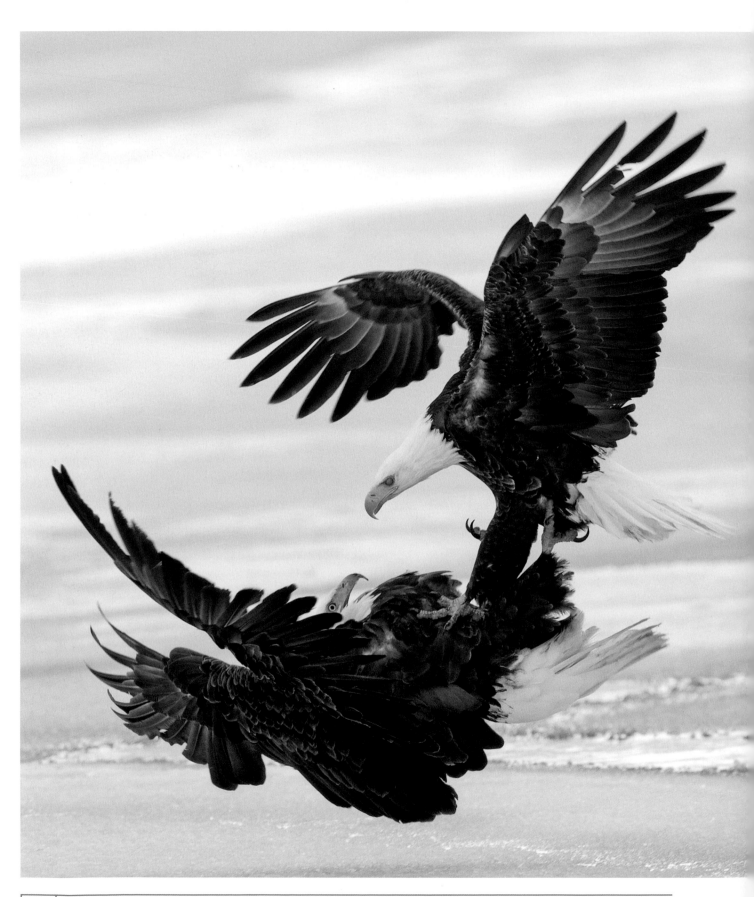

winning digital photo contests

mating rituals, and battles of life and death

Eagles in an epic struggle, battling above a frozen river, eyes and talons locked in fierce combat; or avocets flirting innocently in the tide, sharing an intimate gesture in an age-old mating ritual. Images like them sell millions of nature calendars every year. And if you can capture photos like these, you'll fan the flames of your own fame. These are the shots that elevate bird photos from backyard snapshots to images that define the perpetual struggle of life and death, and the search for love in the natural world.

The secret to capturing images like these is, interestingly enough, the answer to an old joke told by photojournalists: when asked how great, seemingly impossible moments were captured, they often responded: "It's just a matter of f/8 and being there." (Only photographers get that joke, by the way.) The point is that photographing such iconic moments is not about which brand lens you use or a particular shooting philosophy; it's about being in the right place at the right time with the right equipment turned on to the right settings, and finally, the right frame of mind. Then when the right moment happens, you'll be ready.

Having your equipment ready is simple enough: your camera should be turned on and set to the appropriate exposure and autofocus modes, batteries charged, memory card installed, lens mounted and set at a suitable focal length. Anticipating, or even predicting, animal behavior is the tougher—and more important—requirement. And that's where the great wildlife photographers (the legendary shooters like Art Wolfe or Frans Lanting, for example) separate from the pack: they've spent lifetimes studying animal habits, rituals, and lifestyles. So must you if you are to work at this elevated level of wildlife photography.

When it comes to bird habitats and habits, there is no dearth of knowledge available; just browse the Internet or your local library's natural history section. Then put your book knowledge to work in the field by spending free weekends visiting wildlife refuges, state parks, and other sanctuaries. Take part in wildlife walks on Saturday mornings and you'll be surprised how much you'll learn (and how much some of your neighbors already know).

If you have the time (and the means) available, consider also taking a wildlife photo vacation or an organized tour to more exotic locales. The back pages of photo magazines like *Outdoor Photographer* are brimming with ads for exciting trips to exotic places, all led by wildlife photography experts. Nothing will speed up the learning curve like a good mentor.

Technical Note

Shot using a Canon EOS-1D Mark II N camera with a 500mm lens and a 2x tele-extender.

Photograph: ©**Rob Palmer**	Title: **Battling Eagles**
Contest: **Photographic Society of America**	EXIF: **1/800 second at f/6.3, ISO 400**

Why This Moment?

"I am a Ph.D. biologist who happened to do my dissertation on this species (about five years before this photo was taken). Although I have many shots of other frog species in this [mating] position, I had only seen green frogs in this position maybe once or twice ever—so I knew this was a pretty unique photo situation." —*Inspiration for* Green Frogs

Above Photograph: ©**Victor Lamoureux**	Title: **Green Frogs**
Contest: **National Wildlife Magazine**	EXIF: **1/125 second at f/5.6, ISO 400**
Technical Note: **Shot using a Canon EOS 20D with a Sigma APO 180mm f/3.5 EX DG IF HSM macro lens.**	

Technical Note
Shot using a Canon EOS-1D Mark II N camera with a 500mm lens and a 1.4x tele-extender.

"To be a wildlife photographer you have to spend as much time in the wilds as possible and know your subject...I have over 27,000 images in my database." —Rob Palmer

Left Photograph: ©**Rob Palmer**	Title: **Mating Avocets**
Contest: **National Wildlife Magazine**	EXIF: 1/1000 second at f/10, ISO 400

Above Photograph: ©Tom Callahan	Title: **Hovering Female Anna's Hummingbird**
Contest: **DailyAwards.com**	EXIF: **1/200 second at f/10, ISO 100**

Technical Note: **Shot using a Canon Rebel XT, a Sigma 70-300mm lens at 300mm, and 4 Nikon Speedlight SB-26 flash units.**

hummingbirds in flight

If shooting large birds like eagles, owls, and ospreys in flight is too meek a challenge for you, perhaps you'd like to up the ante and try your hand at photographing the speediest and most miniscule of flying marvels: the hummingbird. Hummers, as birders often call them, are so fast (and so tiny) they often zip past you and wave goodbye before you even realize you've seen one. If that doesn't make the challenge enticing enough, consider this: they can also hover, fly backwards and, if the mood strikes them, fly upside down. (And you thought your cat could do tricks.)

Getting a good, sharp photo of a hummingbird in flight is a complex pursuit that often takes years to master (during which time you will groan in exasperation more than you have since your first geometry quiz). Let's start with the most elemental problem: first you have to find (or attract) birds to photograph. Hummingbirds are fairly widespread in the United States (areas like the southwest are particularly rich), and the best way to lure them to your yard is by either planting shrubs and flowers on which they enjoy feeding or setting up hummingbird feeders. I do both. Hummingbirds need to eat twice their weight in nectar daily (imagine how many cheeseburgers you'd need to put away to equal that little accomplishment), so if you offer them a free and convenient meal, your odds of having enthusiastic subjects will soar.

As with songbirds, getting a close-up shot of a hummingbird means that you must try to narrow down their range in order to give yourself sufficient shooting opportunities. Clustering a few feeders or several attractive plants in one corner of your garden helps. To keep up with the rapid movement of a hummingbird, set your camera's autofocus mode to continuous (if available).

If you're hoping to freeze a hummingbird's wings in mid-beat (as in both shots shown here), you'll need to use either flash or a very fast shutter speed (1/2000 second or faster). Most serious hummingbird shooters use multiple accessory flash units (either wireless or hard-wired) so that they can not only freeze the wings, but also create pleasant, natural-looking lighting.

Tom Callahan used four wireless flash units set up near a feeder in his Phoenix, Arizona backyard (where he regularly photographs hummers) to freeze the wing beats of an Anna's Hummingbird. "I used a wireless setup with four accessory flash units," he says. "Three flashes were aimed at the bird and one on the background, and they were set off by the camera's built-in flash." All four flash units were set to 1/16 power, because the lower power creates a shorter flash duration, which is needed to freeze the bird's motion.

Why This Moment?

❝I noticed the water droplets forming and hoped to time the falling drops with the arrival of a bird. Fortunately, when the hummer nudged the flower with its bill it knocked off a few drops. Temporarily startled, the bird backed away and I was able to capture the peak of action with the bird and water droplets simultaneously caught in mid-air.❞ —*Inspiration for* Hummingbird Drops By

Bottom Left Photograph: ©**Greg Tucker**	Title: **Hummingbird Drops By**
Contest: **Digital Camera World Magazine**	EXIF: **1/250 second at f/16, ISO 100**
Technical Note: **Shot using a Nikon D200 camera with an AF Zoom-Micro Nikkor 70-180mm f/4.5-5.6D ED lens at 180mm.**	

animals at the zoo

Lions and tigers and bears—and gorillas—oh my! You probably won't find any of these at your backyard feeders, but you will find them hanging out at the local zoo. And while photographing zoo animals may be a bit less thrilling than shooting animals in the wild (though it is considerably safer), it's still the best opportunity that most of us will get to approach many rare and exotic (and often endangered) species. Better still, they are there waiting for you whenever the mood strikes you to photograph animals.

Zoo photography is surprisingly good practice for photographing in the wild since it will teach you a lot about patience, telephoto-lens technique, and just how difficult it is to get great animal shots even in a very controlled circumstance. Some challenges of zoo photography—like finding lighting with a pleasing quality and direction—are similar to those you'll face in the wild. Zoo residents are a bit less afraid of human beings, which is helpful when it comes to getting good photos (and surprising, considering the hundreds of school kids—and their parents—that bang on their cages and make silly faces at them all day).

The artificial environment of zoos also presents its own unique set of challenges, especially if you're trying to present the animals in a natural state. Mesh fences, moats, walls, partially hidden doors, litter, tossed treats of food flying through the air, and, of course, the hordes of people are just a few of the many man-made distractions that you must hide or obscure if you don't want your photos to scream "animals in captivity!" Carefully choosing a viewpoint is paramount to hiding these indicators. But you can use a few other zoo photo tricks. One of them is attaching a telephoto lens set to a fairly large aperture, such as f/4. A long lens set to a large aperture not only helps isolate animals, but if you place the lens against a mesh fence (which is sure to obstruct your view) its magnification and shallow depth of field also make the mesh disappear.

Feeding time is a particularly good time to shoot zoo animals because they wake up and become animated. The iconic American Bald Eagle, shown on the next page, "had just finished eating its lunch of raw meat and was very active and vocal," says Photographer Andrew Thomas.

Also, if your goal is to get good photos (as opposed to just enjoying the zoo), consider visiting often or buying a season's pass, so that you can get to know individual animals. Then just plant yourself in one location for an hour or two while you wait for the winning moments. "Patience is a must and I am always looking for a unique perspective where the subject tells a story," says photographer Jeff Robinson, who made the regal portrait of a lion on the next page at the Fort Worth Zoo. "I'm a member of the zoo and I go there often to visit the lions."

Finally, silly as it seems, photos of animals are very appealing when they show human-like traits. Who can resist that ecstatic grin in photographer Emin Kuliyev's family portrait of gorillas at the Bronx Zoo?

❝I live near the Bronx Zoo and spend all my free time there. To catch the right moment, sometimes I have to wait for hours (with the camera in my hands, of course); for example, lions sleep almost 16 hours a day! When I shoot the gorillas, I try to explain that they think the same way as humans, with the same behavior.❞ —Emin Kuliyev

Photograph: ©Emin Kuliyev	Title: **Family**
Contest: **Popular Photography**	EXIF: **1/100 second at f/5.6, ISO 1600**
Technical Note: **Shot using a Canon EOS 5D camera with a Canon EF 70-200mm f/2.8L IS USM lens at 70mm.**	

Photograph: ©Andrew Thomas	Title: **Screaming Eagle**
Contest: **Kodak Picture of the Day**	EXIF: **1/400 second at f/11, ISO 400**
Photographer's Website: **www.andrewthomasphotography.com**	

Technical Note

Shot using a Canon EOS Digital Rebel XT camera with a Canon EF 70-300mm f/4-5.6 IS USM lens at 300mm. Levels and curves adjustments; sharpening and cropping in post processing.

Why This Moment?

"The adult male lion was looking upward and it gave me a sense that he, like most of us, has dreams, too!**"**
—*Inspiration for* **Day Dreaming**

Technical Note
Shot using a Canon EOS 30D camera with a Canon EF 100-400mm f/4.5-5.6L IS USM lens at 400mm. Post processing in Photoshop Elements 6.

"Follow your passion and you will be amazed at the results that you are able to achieve.**"**
—Jeff Robinson

Photograph: ©Jeff Robinson	Title: Day Dreaming
Contest: Digital Image Cafe	EXIF: 1/80 second at f/8, ISO 200

wildlife from cars

Even in sanctuaries where birds and animals abound and are accustomed to humans, getting close to them remains your biggest challenge. Because most animals see us as predators (you'd hide too if you were being stalked by something huge that could eat you for a snack), you have to use some clever tricks to get within a frame-filling shooting distance. Interestingly enough, many animals ignore automobiles, letting you approach quite close while enjoying the comfort of your car. Fortunately, too, the roads in many wildlife sanctuaries let you drive to populated feeding and breeding grounds where you can not only shoot to your heart's content, but even lean back and take a nap whenever the action is slow.

The key to using your car as a blind is to find an active area, and then turn off the car and settle in while the wildlife comes to you. The longer you and your car remain motionless, the more comfortable the birds and animals become. Once I reach a sanctuary (and before I head out on the sanctuary drive) I mount my camera in a rear window so I don't have to make a lot of commotion when I arrive at my destination. Upon arrival at my shooting location, I sit still for a few minutes, and then quietly slip into the back seat. Even if they fly off temporarily, shore birds like egrets and herons tend to return over and over again to a rich feeding area (what might look like a small tidal puddle to you or me).

I shot this photo of the great egret on Blackpoint Wildlife Drive at the Merritt Island National Wildlife Refuge in Titusville, Florida. By remaining in the car, I was able to approach within about 20 feet (6 m). Had I gotten out to set up a tripod along the road (which I sometimes do), it would have taken much longer for the birds to accept my presence. I was able to photograph this bird for more than an hour from the rear seat of my car without it taking any notice of me. And more importantly, the sanctuary is full of alligators, so had I been outside the car my concentration would have been divided, to say the least.

The main problem shooting from a car window is steadying a long lens. I use a simple but effective support: a rolled up sweater, bunched atop the open window frame, with my camera and lens securely nestled into it. It works great with lenses up to 200mm. But if you're using a very long lens (300mm or longer) then you need a rigid camera support. Several companies make "window pods" that are designed specifically for this purpose (check out the Groofwin Pod at www.rue.com); if you do a lot of this kind of shooting, they're a worthwhile investment.

Photograph: ©Jeff Wignall	Title: **Great Egret Fishing**
EXIF: **1/200 second at f/5.6, ISO 100**	

toward perfection:
fine-tuning the animal portrait

Getting your first close-up photograph of a wild animal is kind of like getting your first kiss; you're often so flustered (not to mention grateful) at the opportunity and so satisfied by the conquest that you lose all critical perspective. You've got the shot, and there's no denying the evidence. But once the initial thrill has subsided, in order for your photography to grow you must apply a more discerning eye to your images, and find out how you can fine-tune the quality to a higher level.

The first set of criteria for masterful wildlife photos is, naturally, technical. Is the photograph perfectly sharp, or (as with that first kiss) did you get shaky hands and sweaty palms? Is the exposure dead-on? Did you have the white balance set correctly, and were you using the optimum ISO and file size? For your photos to compete with photos from other more experienced wildlife shooters, they must be technically flawless. Anything less than a perfect execution gives a contest judge an excuse for moving on to the next image.

Just as important as technique, however, are aesthetics. Your animal photos must be beautiful. Even though your subject is probably moving, wary, far away, and just as nervous as you are, you have to find a way to slow your pulse enough to compose an interesting, if not elegant image. You must be hyper-aware of the animal's environment and its visual surroundings so that you can quickly—almost instinctively—design an image that is not only a great natural history example but a classic, winning photograph.

Very often, creating a beautiful wildlife portrait means patiently waiting for the perfect moment—and giving up shots even if the animal is close enough for an acceptable documentary photo. In his notes for this superb photograph of an elk shot in Colorado's Rocky Mountain National Park, photographer Richard Hahn lists these factors that made him shoot at this precise moment: "Bright overcast sky, calm winds, no harsh shadows, animal in perfect position, and in a good pose." Though he shot 32 images of the animal that day, he says that only two were what he calls "special" images.

And it's the *special* images that you're after. So while it's exciting to get close to a wild animal—especially one as beautiful as this elk—it's vital that you bring all of your photographic skills to the table. Do that and judges will find it impossible to turn away from your photos.

Here is a checklist of important considerations:

✓ Is the background simple and unobtrusive?

✓ Does the animal's pose look natural and refined?

✓ Have you restricted depth of field in order to isolate the subject?

✓ Is the animal positioned in the frame in an interesting way?

✓ Does it seem alert and attentive to its surroundings?

Photograph: ©Richard Hahn	Title: **Solitary Survey**
Contest: **DailyAwards.com**	
Technical Note: **Shot using a Canon EOS 5D camera with a Canon EF 400mm f/5.6L USM lens.**	

Why This Moment?

"The bull elk was in its velvet phase and summer chocolate coat—always a great subject. He was standing on a ridge with the valley behind, creating nice bokeh."
—*Inspiration for* Solitary Survey

underwater photography

If, like in the Beatles song, we all lived in a yellow submarine, we would probably all have wonderful photographs of the beautiful riddles of life that lie beneath the sea. As it is, however, the undersea world remains a largely uncharted and esoteric wonderland, recorded only by those devoted enough to plunge beneath its surface with cameras in tow. The photos they return with are often filled with intense colors, rarely seen creatures, and unfathomable natural mystery. And that is why photos taken underwater are so striking and so popular in photo contests.

Most serious underwater photographers are also experienced SCUBA divers who are so enthralled with what they find in the depths that they are compelled to return to the surface with evidence. But you needn't rush out to get SCUBA certified in order to capture your own fascinating underwater images (though you can get "resort certified" at many beach resorts—a much faster track to diving); there are many extraordinary subjects in shallow waters within reach at almost any beach. All it takes is a bit of inexpensive snorkeling gear to find them. You can even find some great underwater subjects trapped in tidal pools and attached to rocks at low tide at your local beach.

To take underwater photos you will definitely need either a camera that is capable of going beneath the waves, or a waterproof underwater housing to protect your terrestrial camera. There are many new underwater digital point-and-shoot cameras on the market, and housings are not expensive—plus you can often rent or borrow them at beach resorts or hotels. If you're going on a diving or snorkeling vacation, many resorts loan or rent good-quality underwater cameras, as well.

The biggest technical challenge of underwater photography is the lack of light. Seawater sucks up light like a photon vacuum cleaner, and most of the color spectrum along with it. In shallow waters (depths of less than 10 feet, 3 m) you can still use sunlight and the colors will remain vibrant, especially in clear-water areas like the Caribbean. But once you go beyond those depths (or are working in murkier waters) flash is your only reliable light source. For that reason virtually all deep-water images are made using flash. Since a lot of underwater photography is essentially close-up, using flash is convenient and provides all the light you need.

Prepare your camera gear with plenty of memory and battery power before you head out for your dive or snorkel excursion, because returning to shore (or a boat) to replace either can be pretty inconvenient. You may also be restricted in what settings you can change once the housing is in place, so ask a companion or instructor for advice on which exposure modes and flash settings to use.

There are several good sites on the Web about underwater shooting (www.wetpixel.com is a popular site) that feature technical articles, forums, and product reviews. A few nights of research and reading will increase the quality of your images substantially.

Why This Moment?

" I set off on the dive knowing I wanted to capture the unusual circular pattern of the Christmas Tree worm. They are very skittish animals, so I got to take just a few shots. " —*Inspiration for* Christmas Tree Worm

Photograph: ©Carl Bosman	Title: **Christmas Tree Worm**
Contest: **Our World Underwater**	EXIF: **1/60 second at f/14, ISO 100**

Technical Note: **Shot using a Nikon D2x camera with an AF Micro-Nikkor 60mm f/2.8D lens. Cropped in post processing.**

Technical Note

Shot using a Canon PowerShot A95 camera with waterproof housing. Levels adjustment; cloned out floating debris in post processing.

"Bring plenty of memory with you. Trying to nail the focus with such a small depth of field while being pushed around by heavy currents meant I had to take a lot of shots."

—Mark Roberts

Photograph: ©Mark Roberts	Title: **Partners in Crime**
Contest: **Steve's Digicams**	EXIF: **1/60 second at f/2.8, ISO 400**
Photographer's Website: **ReflectiveDreams.com**	

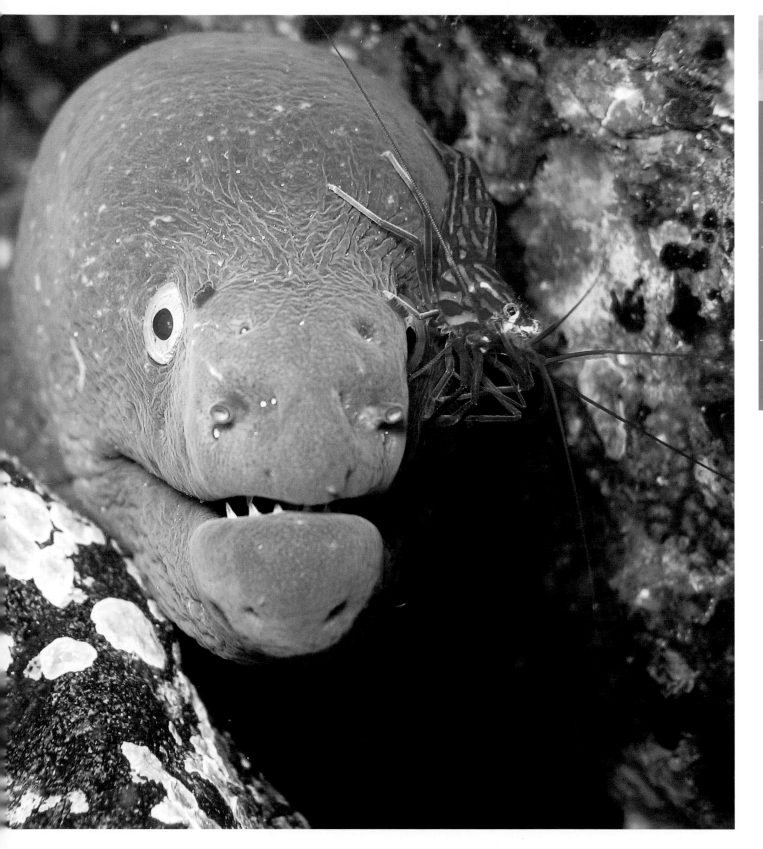

close-up photography: insects

They're creepy, they're crawly, they bite and sting, buzz and flutter, they eat your flowers, and even get into your picnic lunch. Wow, talk about no manners. It's no wonder most non-photographers dislike bugs. But with a good macro lens, bugs (insects, if you insist) can be one of the coolest things since soft ice cream—and a good bug photo is twice as sweet.

Fortunately, the world is chock full of bugs (just lift up a rock in the garden if you doubt it) that are waiting to be immortalized, if not in Disney's next big animated bug flick on the silver screen, at least on your computer screen.

Assuming that you are not a bug-o-phobe, getting great shots of insects is pretty easy and a lot of fun. And as much as most people generally dislike insects in person most of us are fascinated by them in photographs.

The primary difficulty in getting good macro shots of bugs is just getting close enough to make your subjects recognizable in the picture. As you can see in both Justin Black's photo on the right and Michelle Frick's on the next page, your subjects need not fill up the entire frame. A contrast in color or a very simple background is often enough to focus attention on the tiny quarry. In Frick's shot, the fingers also provide a good sense of scale.

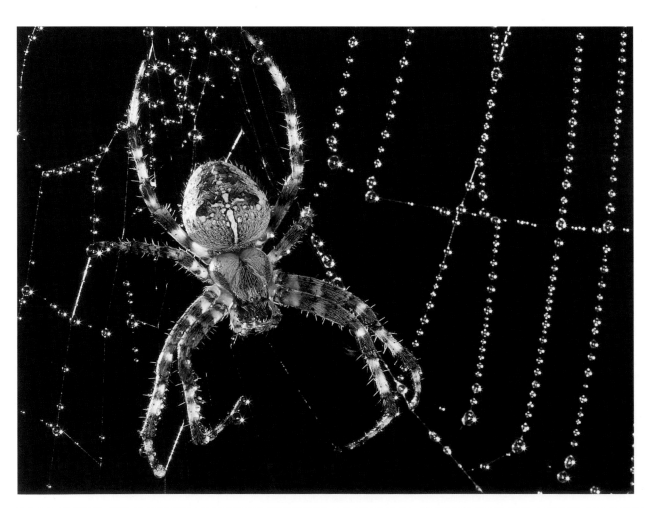

Photograph: ©Robert Ganz	Title: Casting Pearls
Contest: Steves Digicams	EXIF: 1/200 second at f/10, ISO 400
Technical Note: Shot using a Canon EOS 10D camera with a Canon EF 100mm f/2.8 Macro USM lens and fill flash.	

Interestingly, you don't need a lot of expensive gear to take good close-up photos. Many point-and-shoot cameras have extremely good close-up capabilities because of the relationship between their lens' optical designs and the small size of the digital sensor. These two things in combination provide a very short minimum-focusing distance (often an inch or a couple centimeters) and a much larger depth of field—perfect for tight close-ups.

If you're shooting with a D-SLR camera you have even more options, including: high-quality macro lenses (designed specifically for close-up work), extension tubes (which reduce the minimum focusing distance and increase magnification), and lens-bellows (an adjustable accordion-like device that goes between the lens and camera body to provide the greatest magnification of these three options).

The major obstacle you'll face when taking close-up pictures is the extremely shallow depth of field, which makes it difficult to focus sharply on your subjects. In close-up photography, the depth of field is typically around only an inch (2.5 cm) or less. It can be maximized by using a very small aperture, such as f/16 or f/22, but even then you may not be able to get the entire subject in sharp focus. Keep in mind, however, that while the depth of field may be thin, it still covers the entire frame; so positioning the camera back parallel to the subject helps more of it fall into focus. Had this spider on the left been shot head-on, probably only its face would have been sharp; but because photographer Robert Ganz chose a top-view angle, the entire body remains within the depth of field.

Holding the camera by hand, even in a rock-steady grip, can cause the subject to go in and out of focus as you try to firm up your position (just think how hard it is to thread a needle). That's the main reason why I like to use a tripod when taking close-ups. With the camera locked into position on the tripod, I don't have to worry about it wobbling around and losing focus on the critical areas of the subject.

Another advantage of a tripod is that you can offset the drawback that occurs when you use extension tubes, bellows, and macro lenses, as they all reduce light reaching the sensor and force you to use a slower shutter speed. Of course, a high ISO and an image-stabilized lens might allow a shutter speed fast enough for sharp pictures;

but if you're going for a winner, you should avoid the "mights" and "maybes" and get the best picture possible—in other words, use a tripod.

More serious close-up shooters like Ganz (see his profile on page 152) often use electronic flash. It provides plenty of light for small close-ups and also enables you to use smaller f/stops to get greater depth of field. As this spider photo demonstrates, flash also helps illuminate subtle color patterns and provides some sparkle to things like dew drops on a spider's web. To soften the light of the flash in close-up work, use a diffuser (see www.lumiquest.com for inexpensive solutions) or just wrap a white handkerchief over your accessory flash unit.

| Photograph: ©Justin Black | Title: Lady Bug |
| Contest: National Wildlife Magazine | |

| Photograph: ©**Michelle Frick** | Title: **Little Ladybug** |
| Contest: **BetterPhoto.com** | EXIF: **1/125 second at f/2.8, ISO 100** |

Why This Moment?

"My daughter's nickname is Katiebug; she's always loved bugs and all living creatures. Knowing that I love ladybugs, she was anxious to show me her newest little friend that she had just rescued from the pool. So I grabbed my camera to make sure we didn't lose the moment."
—*Inspiration for* Little Ladybugs

Technical Note

Shot using a Canon EOS 5D camera with a Canon EF 100mm f/2.8 Macro USM lens. Levels adjustment; saturation and contrast increase; cropping in post processing.

"I wanted a nice, soft background for a macro shot, so I framed an already-opened flower behind this budding one. The colors in the out-of-focus area harmonized nicely with the subject." —*Inspiration for* Poppin Poppies

Photograph: ©Robert Ganz	Title: Poppin' Poppy
Contest: Canadian Geographic Magazine	EXIF: 1/400 second at f/5.6, ISO 200
Technical Note: Shot using a Canon EOS 10D camera with a Sigma APO 180mm f/3.5 EX DG IF HSM Macro lens.	

close-up photography: flowers

Flowers are probably the most popular subjects for close-up photography—and well they should be. They are easily accessible and naturally beautiful. Also (with a few exceptions), flowers don't bite, sting, pinch, or fly away, making them a far more cooperative subject for close-up photography than bugs.

One of the challenges presented by photographing flowers is coming up with a fresh approach. *Everyone* photographs flowers, and for your photos to stand out in that vast bouquet you must demonstrate not only top-notch technical skills, but an imaginative and creative vision as well. The photos that will catch a judge's attention are not seed-catalog shots that merely document a flower, but rather images that are dramatic, perhaps even whimsical or abstract.

While sharpness is always a worthy goal, don't be such a slave to the quest for a sharp image that you ignore other creative options. If the breeze is shaking the flowers around, try using a slow shutter speed (1/4 second or slower) to capture an impressionistic blur. Often restricting depth of field so that only a tiny portion is sharply focused—a single rose petal, for example—can lead to a much more romantic look. Also, try using an out-of-focus cluster of blossoms to frame a sharply focused flower.

If your goal *is* to capture the clarity and detail of a flower blossom, however, pay special attention to the background. Simple dark backgrounds work best to show off a flower's colors, shapes, and textures. To photograph the bleeding hearts shown here, for example, I hung a sheet of black fabric over a lawn chair a few feet behind them and then exposed just for the flowers. What I wanted to show was the unique heart shape of the tiny blossoms, and the contrast against the pure black background revealed that perfectly.

Lighting is also critical when it comes to flowers. While bright sunlight is appealing because it ignites colors, it's also very contrasty and tends to wash out lighter tones and delicate transitions. Instead, work on overcast days, early mornings, or late evenings when the rays are less intense and warmer in tone. If the flowers you're photographing are partially translucent, then backlighting works nicely because it provides colors with a soft glow. Use exposure compensation to add an extra stop of exposure to backlit subjects.

Finally, consider documenting a flower's life cycle. All flowers go through a fascinating metamorphosis from emerging shoot, to swollen bud, to open blossom, and eventually to withered corpse. In his sci-fi-looking shot of a poppy blossom unfurling from its coarse shell, for example, Robert Ganz reveals a moment of transition that most of us never see—or at least never notice.

Photograph: ©**Jeff Wignall**	Title: **Bleeding Hearts**
EXIF: **1/60 second at f/18, ISO 200**	
Technical Note: **Shot using a Nikon D70s camera with an AF-S VR Micro-Nikkor 105mm f/2.8G IF-ED lens and fill flash.**	

suburban wildlife

Considering the fact that we've practically erased their natural habitats, it's no surprise a lot of animals share our suburban spaces with us. And while it may be frustrating (and a bit embarrassing) to lose a battle of wits over garbage can rights with the local raccoon posse, it's kind of fun to have wild animals to photograph in your own yard. In my little backyard in Connecticut, for instance, I have regular visits from rabbits, opossums, skunks, snakes, raccoons, red fox, gray squirrels, and the occasional wild turkey brigade (not to mention the mice that winter in the garage).

Getting natural-looking photos of your backyard menagerie is largely a matter of spending enough time around them that they begin to ignore you. The bunnies in my yard, for example, will happily munch dandelions for hours within a few feet of my camera if I just lay there quietly and talk with a soothing voice (my 20 years as a radio announcer finally pays off). Some animals will even perform tricks if you reward them with snacks; all it takes is a handful of peanuts to get squirrels to strike funny poses for you all day long.

One clever idea that you can borrow from pros is to use a wireless remote camera trigger so that you can photograph animals up close while you remain at a distance. Remotes are inexpensive (some cameras come with them, accessories run under $25) and typically work within a 15- to 20-foot (4 m) range. By placing your camera on a tripod near an old stump, for example, and baiting the stump with a hidden walnut, you can sit across the yard and fire photos of a squirrel without it being any the wiser. If you're using a D-SLR camera you can also switch the lens to manual focus, then pre-focus on an exact spot and fire when your quarry enters that area.

If the idea of working remotely appeals to you there are also remote infrared motion sensors that will trigger your camera's shutter release when something crosses into its target. Light triggers, for instance, use an infrared beam that fires the camera when the beam is interrupted. If your yard is on a deer path, for example, you can aim the trigger at the path, and when the deer break the beam they take an instant self-portrait. Just do some online searching and you'll find a number of manufacturers; generally the equipment is not terribly expensive. Imagine, not even a skunk in the dead of night will escape your camera.

Photograph: ©Robert Ganz	Title: **Fairway Bunny**
Contest: **Digital Image Cafe**	EXIF: **1/200 second at f/5.6, ISO 400**

Technical Note: **Shot using a Canon EOS 10D camera with a Canon EF 300mm f/4L IS USM lens and a 1.4x tele-extender.**

Photograph: ©Robert Ganz	Title: **Three Squirrels**
Contest: **Canadian Geographic Magazine**	EXIF: 1/320 second at f/4.5, ISO 1600
Technical Note: **Shot using a Canon EOS 10D camera with a Canon EF 300mm f/4L IS USM lens.**	

Why This Moment?

" I was doing dishes in my kitchen and looked out the window and saw the squirrels chasing each other around the tree. I grabbed the camera and a long telephoto lens, went outside on the deck, and got off a few shots as they tussled on a branch before they took off. I have never seen anything like it since. "
—*Inspiration for* Three Squirrels

We photograph people more than
any other subject because our strongest
desire is to slow, if not to hold onto,
the pageant of faces and moments
that make up our lives.

5

people

I magine how different life must have been before George Eastman popularized the snapshot with his introduction of a re-loadable roll film camera in 1888 ("You press the button, we do the rest"). No photos of summers at the lake to look back on with fondness. No stiff-shouldered portraits of your grandparents in front of the fireplace. No photos of your kids being born or posing awkwardly in formal outfits before their prom. Unless one of your siblings was a talented quick-sketch artist, the family album was mighty thin indeed and the faces of your past were just a memory.

Today, of course, just the opposite is true. Taking pictures of people is far and away the most popular and universal reason most of us own a camera. So popular is the habit of photographing people that camera engineers have invented a feature called Face Detection so that the camera automatically recognizes when your subject is a fellow human being. And so pervasive is the camera these days that people are even saying "Cheese!" to other people's telephones (try explaining that little techno-merge to your great grandparents).

Taking pictures of people is so pervasive because people are the most important parts of our lives. Whether it's a snapshot of one of your kids pouting or a formal portrait of a close friend, these moments and faces represent the true wealth of our lives. We also use cameras to document our ceremonies and rituals, both common and rare, and to share our jobs and our hobbies. A few of us even use cameras to reach back into and recreate the past.

We photograph people more than any other subject because our strongest desire is to slow, if not to hold onto, the pageant of faces and moments that make up our lives. Perhaps the great *National Geographic* photographer Sam Abell said it best in the introduction to his book *Stay This Moment:* "Photography, alone of the arts, seems perfected to serve the desire humans have for a moment—this very moment—to stay."

In the following pages we'll look more closely at ways that you can use your camera to stay the moments of your own life, creating compelling portraits that will engage and relate to contest judges the world over.

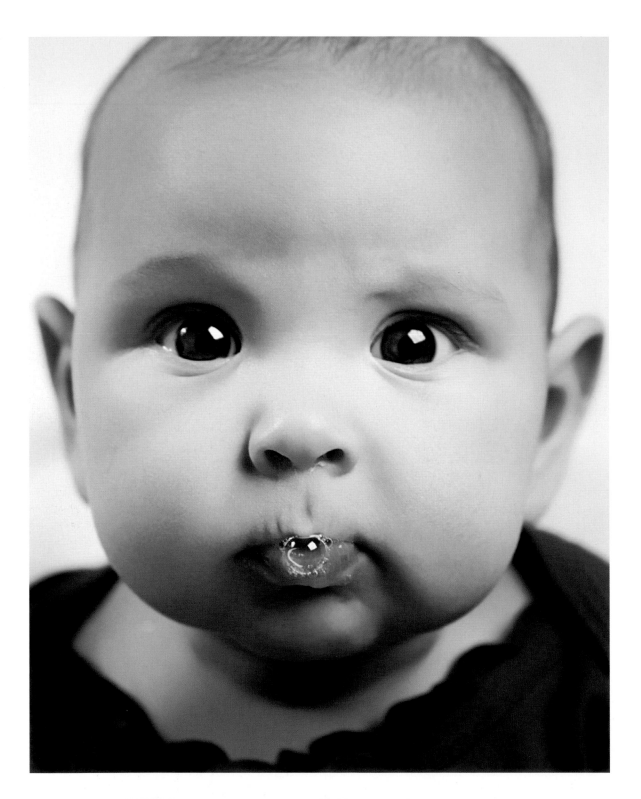

| Photograph: ©Michelle Frick | Title: **Baby Bubbles** |
| Contest: **BetterPhoto.com** | EXIF: **1/125 second at f/5.6, ISO 100** |

faces

Whether it's your neighbor leaning over a fence or a stranger on the street, the first thing we look at when we approach another person is their face. Sure, if you're an expensive shoe kind of person you might look at their feet first to see if they're out-styling you. And if you're a jewelry person (or checking if they're single) you might glance quickly at their hands. But pretty quickly we all zero in on the face.

Faces are where we carry and display our emotions, and unless you've got a really good poker face going, it's very hard to disguise your true emotional state. Happy people smile, confident people beam, sad people frown, and babies, well, as you can see here in Michelle Frick's intense and somewhat silly portrait, babies can wear some pretty goofy looks. You can't buy that kind of cuteness anywhere except the baby store.

Pictures of faces are most powerful when they dominate the frame. Any extra millimeter of space that you let creep into your composition begins to dilute the impact of the portrait. The problem is that between the time you spot an interesting face and raise your camera to capture it, the facial expression changes—usually into one of self-consciousness. For that reason, if you're trying to catch candid facial expressions it's important to have your camera in an autoexposure mode, and to work quickly while remaining as casual as possible. No matter how naturally exuberant a happy person is, if you spend too long messing around with camera dials and switches you're going to end up with the wrinkled nose of impatience staring at your lens.

You can relax your subject by using a medium telephoto lens (typically the 35mm equivalent range of 85 to 135mm) to put a little distance between your camera and the subject's face. If you're in a friendly group and trying to catch candid faces, for instance, that focal-length range will let you work five or six feet (1.5 – 1.8 m) away, far enough that your camera might not even be noticed. The shallow depth of field of a telephoto lens will also help focus attention on the face and eyes. If your camera has an articulated LCD screen that lets you view it from odd angles, you might also be able to shoot full-frame face shots without lifting the camera to your eye—resting it on a picnic table while shooting one of your kids daydreaming, for instance.

Speaking of faces, if you plan on entering a portrait into a contest, it's important to research any model release requirements that might exist. The smaller photo-of-the-day contests are usually lax on this legal matter, but for bigger competitions—particularly those sponsored by publications with a large distribution—it is an absolute requirement. Whether or not a person is "identifiable" can sometimes be ambiguous and subjective, so you're best off establishing a habit of collecting releases whenever you take portraits, on that the same day. Generic releases are free to download from dozens of places on the Internet, and eventually using them will become second nature.

Finally, creating collections of faces is very popular these days, so contest or not, consider creating a gallery of the faces in your life, or even the faces you meet while traveling. It's comforting and inspiring to see all of "your" faces together.

people

Technical Note

Shot using a Canon EOS 5D camera with a Canon EF 28-135mm f/3.5-5.6 IS USM lens at 135mm. In studio with two JTL300 lights—a soft box for the main light with additional light from an umbrella. Levels adjustment; contrast increase; red saturation decrease; skin smoothed in post processing.

Why This Moment?

"During the session, her mother, sister, and I were working hard to get her attention focused on my camera. She was cooing at us, and created that bubble. It was just too cute, and I had to be quick to catch it before the moment passed."

—*Inspiration for* Baby Bubbles

no faces

Because the goal of a portrait is to reveal not just a likeness but also the character of the person (or people), there will be times when you should probe beyond the traditional face-first, eye-level perspective. It may even mean that *not* showing a face, or just concentrating on an interesting fragment of your subject, will make a stronger statement— for example, photographing your daughter's feet dangling over a stream or taking a close-up of your mother's hands knitting.

By eliminating the face you force the viewer to consider other important aspects of a person's physical appearance, and often these more isolated views tell a far more engrossing story than the whole. In Heather McFarland's shot of a fiddle player, she not only eliminated the face, but also photographed her subject from behind and only from the knees to the elbows. The hands holding the fiddle and bow, the crumpled jeans, and the relaxed pose tell a fascinating and insightful story about the subject—one that doesn't need a face or a smile to be complete.

Another reason for photographing isolated vignettes of people is that often you can do it without your subjects even knowing they're being photographed. By working with a medium telephoto lens you can isolate a portion of a person's body or a significant gesture candidly and from a distance (as McFarland did here). Even if your subject knows they are being photographed, by not forcing them to confront the camera face-to-face most people are far more at ease. If you ask a potter to pose at her wheel she may start to fuss with her hair or even wipe away smears of clay. But aim the camera at just her hands working the clay and she'll provide a far more confident, less-inhibited gesture.

Next time you're photographing another person, whether it's a close friend or a total stranger, ask yourself if there is a better interpretive story that can be told without including the face, or by working from an unusual angle. You might even consider making a portrait collage—shooting a figure study in six or eight shots rather than one, for example.

Why This Moment?

❝As I was listening to the music, I noticed this fiddle player talking to another musician in a beautiful, dappled light. He held his fiddle behind him as he chatted and I took the opportunity to capture this faceless portrait.❞ —*Inspiration for* **The Fiddle Player**

Technical Note
Shot using a Nikon D1x camera with an AF Zoom-Nikkor 80-200mm f/2.8D ED lens at 200mm. Tone curve adjustment in post processing.

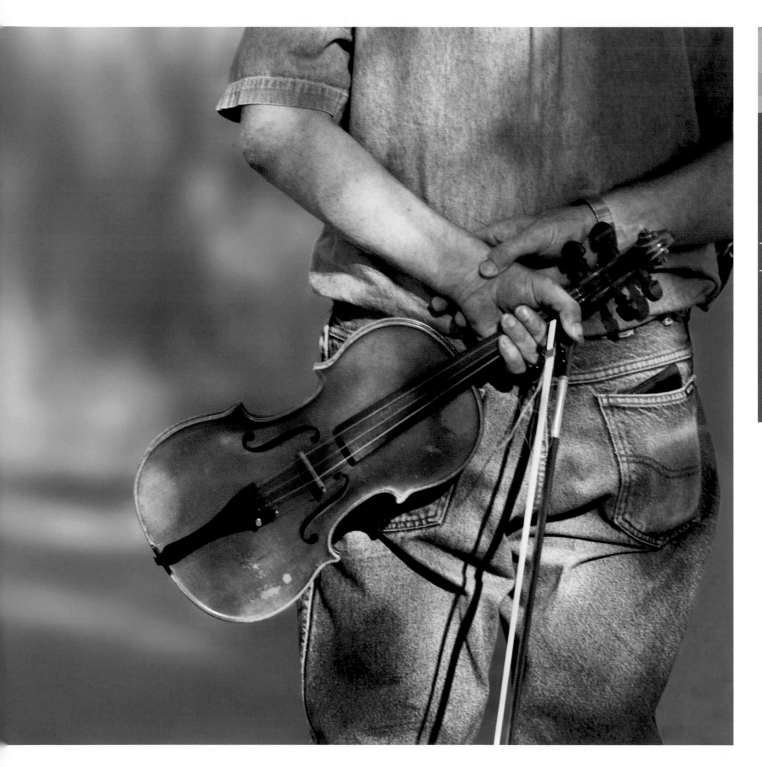

| Photograph: ©**Heather McFarland** | Title: **The Fiddle Player** |
| Contest: **Digital Image Cafe** | EXIF: **1/160 second at f/6.3, ISO 125** |

posed portraits

Although some of us have fairly horrid (and oddly universal) childhood memories of sitting for formal portraits in a developer-scented photo studio, much wonderful and deeply insightful portraiture is nevertheless done in a controlled or formal setting. Formal doesn't necessarily mean stodgy; planned portrait sessions can be fun, spirited, casual, quiet, or whatever type of mood you want to establish.

The primary difference between a snapshot and a planned portrait is control. By carefully planning the session and choosing things like setting, lighting, and even clothing, you are taking a far more proactive role in the outcome of the picture. Knowing what to expect, your subject will be ready, cooperative, and patient. Key to the success of such sessions is developing a level of trust and friendship with your subject. Photographer Marta Azevedo's pensive and penetrating portrait, for example, reflects an obvious rapport between photographer and subject.

You don't need a studio or a lot of expensive gear to shoot a good planned portrait; controlled environments can be created anywhere. The primary things you'll need are enough light and either thematically-related props (an artist in front of her easel, for example) or a very plain background. You can create a quick and inexpensive plain background by simply hanging a length of fabric or a roll of seamless photographic paper, available at most photo-supply shops.

When it comes to lighting there are several options, including using existing light, accessory flash, or the increasingly popular daylight-balanced fluorescent fixtures made specifically for photography (see www.fjwestcott.com). A large window provides a nice broad light that is flattering in portraits. By using a sheet of white foam board on the opposite side of the subject (facing the window) you can open shadows and control contrast, as well. With flash and fluorescent lights, use umbrellas or soft boxes to provide soft, more complimentary lighting.

One additional piece of equipment you should have is a tripod. By putting your camera on a tripod you can keep your camera steady in lower lighting levels, and also free yourself from hiding behind the camera. A cable release or wireless remote allows you can frame the scene once and then have a face-to-face interaction with your subject. In most cases your subject won't even know when you're shooting, which creates relaxed expressions.

66 Read, see other photographers' work, and photograph, photograph, photograph. 99 —Marta Azevedo

Photograph: ©Marta Azevedo	Title: A Woman from Uganda
Contest: Digital Image Cafe	EXIF: 1/125 second at f/9, ISO 200
Technical Note: Shot using a Nikon D70 camera with an AF Zoom-Nikkor 35-70mm f/2.8D lens at 62mm.	

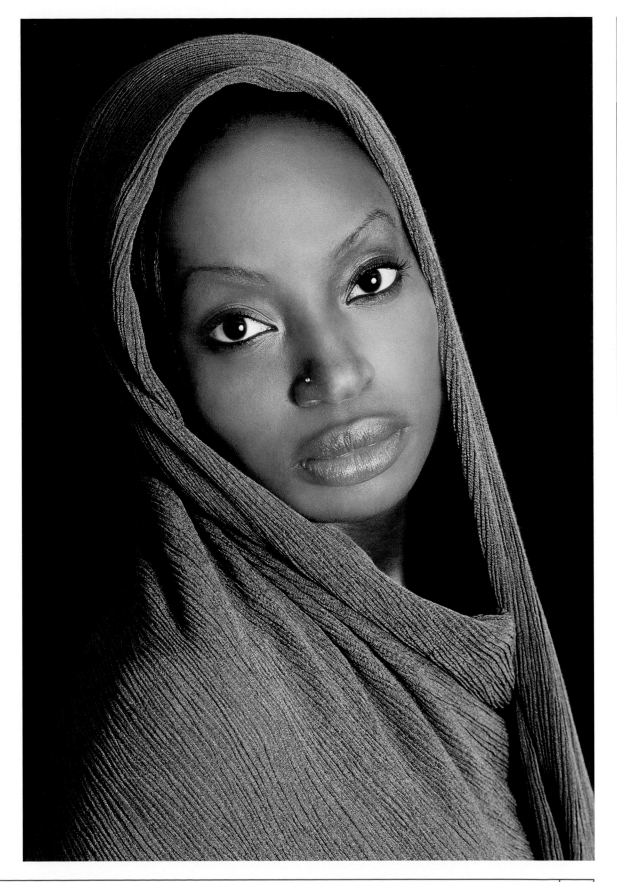

Technical Note

Shot using a Canon EOS 20D camera with a Canon EF 85mm f/1.4 USM lens. Converted to sepia in post processing.

Why This Moment?

"I was shooting Terri and her boys for a Mother's Day session. She was tickling her son Maddox and coaxing him into a good mood and I was just watching them interact. I love the way the wind was blowing through their hair and how natural they are with each other." —*Inspiration for* Emotion

Photograph: ©Michelle Frick	Title: **Emotion**
Contest: BetterPhoto.com	EXIF: **1/250 second at f/2, ISO 100**

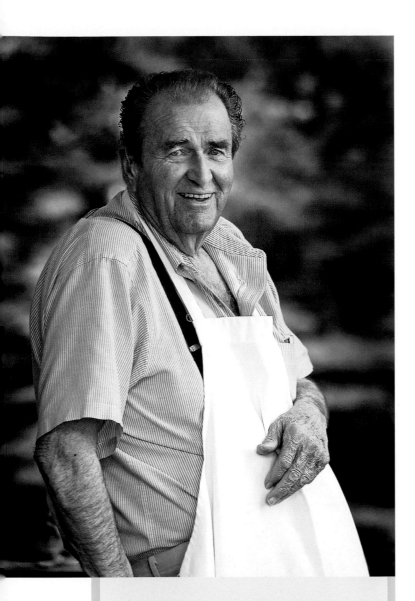

impromptu portraits

If planned or formal portraits are about preparation and strategy, then casual and informal ones are about awareness and anticipation. The moment for an impromptu portrait arrives and vanishes almost instantaneously. Capturing that moment requires a blend of both portraiture and photojournalistic skills. In other words, you have to be competent and quick.

A lot of informal portrait opportunities, like the one captured in photographer Ernie Aranyosi's warm portrait of a friend's father at a picnic, happen at family gatherings—and often when you're shooting something else (or worse, up to your elbows in potato salad). "I was shooting some photos of the lake and its surroundings, so I had my camera in hand," says the photographer. "I asked him if he would mind having his photo taken and then snapped four or five quick images. It was over in less than 30 seconds." Having the camera at the ready and being able to instantly shift gears from landscapes to portraits made all the difference.

Probably the two most important environmental concerns when you're shooting casual portraits (indoors or out) are the background and the lighting. The watchword for both should be *simplicity*. Since contrast and harsh shadows wreak havoc with facial features (and you want people to think it was a wise idea that they took a moment to pose for you), it's best to work either on bright overcast days or in areas of open shade. The lower light levels will cost you a stop or two, but that can actually work to your benefit if you open the lens to gather the extra light. Using a wide aperture limits depth of field so that focus is concentrated on the subject while also creating a pleasing bokeh (the out-of-focus area) behind your subject. Portrait lenses like the one Michelle Frick used for the photo at far left typically have very wide apertures, which can blur away distracting elements into a creamy and complimentary backdrop.

people

Technical Note
Shot using a Nikon D100 camera with an AF-S VR Zoom-Nikkor 70-200mm f/2.8G IF-ED lens at 150mm. Converted to duotone in Photoshop.

Photograph: ©Ernie Aranyosi	Title: The Patriarch
Contest: DailyAwards.com	EXIF: 1/100 second at f/2.8

people at work

Considering that we spend about a third of our waking hours working, it's surprising that we have so few photos of ourselves at our workplaces. My father, a photographer himself, worked in a visually fascinating research facility for about thirty years, but I don't recall ever seeing a photograph of him there. Photos taken in the workplace are engaging because they almost always reveal an interesting part of a person's life. When it's a parent or another member of your family, those photos also document an important part of that person's history. Photographing people at work is a great self-assignment and because the photos are so rare, they will often receive extra attention in a contest.

Part of the reason that more photographs aren't taken on the job is because we tend to take our workplaces for granted. In the age of unisex haircutting salons, few of us would think of a barbershop as a photographically intriguing venue. But in photographer Joshua Greer's gentle portrait of a barber in the small town of Arco, Idaho, the setting echoes Norman Rockwell's sweet portrayals of American life. In what other setting would this barber reveal such confidence and pride?

There are some other persuasive benefits to photographing someone in their workplace. Whether it's a blacksmith hammering out a hot iron form or a librarian telling a children's story, people are more relaxed in their own comfort zone, surrounded by familiar settings and objects. And those very objects make excellent props, giving the subject a place to put his hands, or a skill to demonstrate. Ask a fireman to pose in a studio (even in uniform) and you'll likely get an uncomfortable self-conscious subject that would rather be off fighting a fire. Pose him with fire hat in-hand and a foot on the bumper of a fire engine and the frame will burst with pride and confidence.

Keep in mind too that your subjects don't always have to be hard at work for it to be a telling environmental work portrait. In photographer Henry Hamlin's amusing silhouette of two cowboys playing poker in a chuck wagon, the setting and the hats provide all the information you need to figure out what these two do for a living.

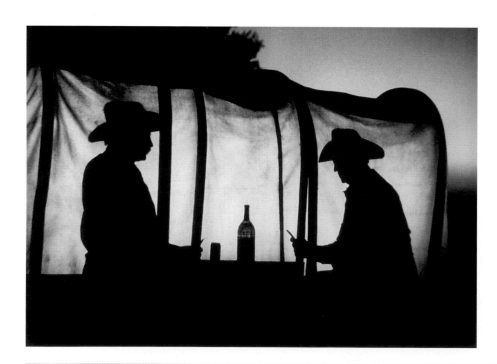

Photograph: ©Henry Hamlin	Title: **Poker in the Chuck Wagon**
Contest: **Smithsonian Magazine**	
Technical Note: **Shot using a Nikon 8008 camera with a Tamron 28-200mm f/3.8-5.6 lens and Fuji Velvia 50 film.**	

> **"**Initially I was taken by the barbershop itself, the frames on the wall, the chair, and the incredible window light that filtered throughout. When I saw Benny there, though, I couldn't take my eyes off of him. The combination of all those things really made the picture for me.**"**
>
> —*Inspiration for* A Barber About to Give a Haircut

Why This Moment?

Technical Note

Shot using a Calumet 8x10-inch view camera with a 300mm lens and Kodak Portra 160 film. Scanned to create a digital file.

Photograph: ©Joshua Dudley Greer	Title: A Barber About to Give A Haircut
Contest: Smithsonian Magazine	

| Photograph: ©Robert Ganz | Title: **Think** |
| Contest: **Digital Image Cafe** | EXIF: **1/125 second at f/2.2, ISO 100** |

Technical Note (both images)
Shot using a Canon EOS
10D camera with a Canon
EF 50mm f/1.4 USM lens and
natural light.

children: quiet moods

From moment to moment, kids experience an extraordinary gamut of raw and unfiltered emotions. And because they haven't yet developed the ability to subdue or mask their reactions to the world around them, they often wear these emotions on their sleeves—and on their faces—with a transparency that is both poignant and, for the sensitive of heart, at times difficult to watch.

Often, as with this pair of candid shots by Robert Ganz, emotional moments come as the result of everyday events, such as sibling conflicts. Here he photographed one of his sons who had just lost a battle over television rights. "The boys had been arguing about what to watch on our single TV," recalls Ganz. "Evan had lost out to his older brother and was a little bit upset about it. In the second shot I caught Evan's expression as he was coming out of the pout and beginning to be interested in what was on the TV."

To capture moments like these, preparation is everything. Kids ricochet from one emotion to another so fast that you don't have time to run and find the camera. Witness the second shot in this series (on the right), taken just moments after the first (to the left)—it reveals an entirely different reaction, one more focused on the camera and less on the uninhibited emotion of the previous incident. Because kids are fast to withdraw or turn away when they know they are being watched, accept that you are going to have to abandon some opportunities. You can just imagine the therapy bills if you didn't let those moments go: *I really needed to sit and cry but my dad wouldn't take the camera out of my face!*

On the other hand, kids also have incredible tolerance for cameras once they get used to your obsession and may ignore you completely. (And, after all, what good is having such emotionally deep creatures around you if you can't capture their human honesty before it's lost to adolescence?) Be careful not to upset the delicate balance between art and trust, because you need both for a good photograph.

Since a burst of flash during such pensive moments is the visual equivalent of a marching band parading into the room, it's far preferable to shoot with existing light. Whether it's from incandescent lamps, daylight coming from a window, or both, ambient lighting is a lot more attractive than the cold flat burst of light from a flash.

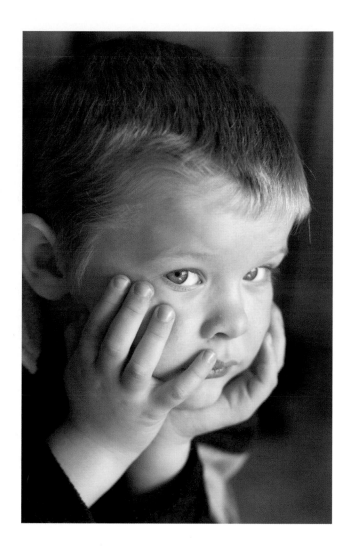

Photograph: ©**Robert Ganz**

EXIF: **1/125 second at f/2.5, ISO 100**

people

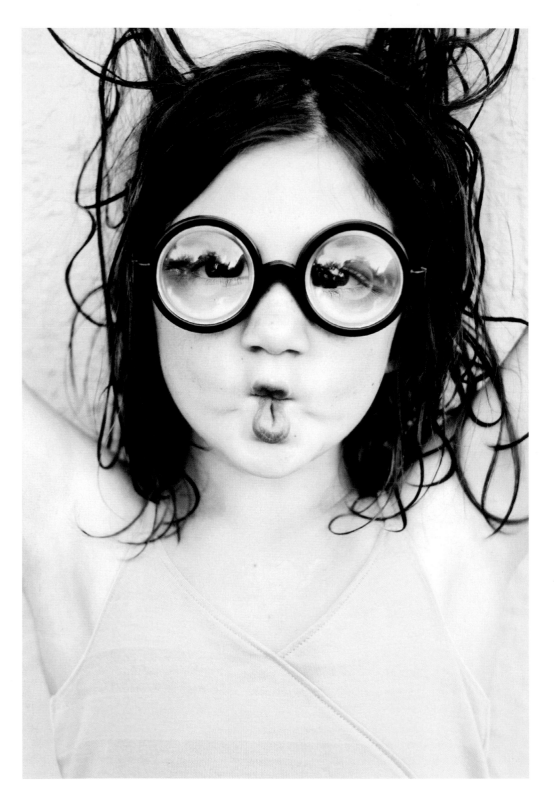

| Photograph: ©Karen Batal | Title: **Silly Glasses** |
| Contest: **Popular Photography** | EXIF: **1/400 second at f/2.2, ISO 320** |

silly moments, silly faces

You only have to watch a Jim Carrey movie for five minutes to understand a very basic Hollywood concept: silly faces sell. While Carrey has made a number of fine serious movies (*The Truman Show* comes to mind), if you ask someone who he is, they'll say, "Oh, he's the guy with the rubber face!" Go figure. When you've made a career out of distorting your face in ways most of us didn't think possible, people remember. Tragically, most of us don't have Jim Carrey hanging around the house to photograph or we'd all win a lot of photo contests. But fortunately, catching people inadvertently mugging with a preposterous face (a big yawn is a good opportunity), or getting someone to invent one for you is pretty easy.

A lot of silly faces and incidents happen naturally, and all they require is a ready camera and a quick trigger finger to capture—here, Robert Ganz's young son discovering his fingers for the first time is a good example. In fact, most young kids are so uninhibited they don't even realize how funny they're being.

If you can't catch them being silly on their own, most kids will gladly make silly faces upon request. It's not often kids get encouraged to act impishly for the camera, so they usually take full advantage of the opportunity. And if they won't cooperate, try a bit of reverse psychology: "Please don't make a crazy face in front of the camera this time!" will have them auditioning for the cover of *Mad* magazine.

Kids get the silliest when they're bored, so that's a good time to milk their funny side. If you're reaching the end of a more serious photo session—a long holiday greeting card shoot, for instance—just wait until the formal shots are done and turn them loose on a more fun challenge.

people

Why This Moment?

"I call this shot 'Digital Discovery' because my son had just noticed his fingers and was trying to track them as he lay on the bed. He actually crossed his eyes as he followed his fingers. I had been meaning to capture his expression while he did this, but the crossing of the eyes was just pure luck." —*Inspiration for* **Digital Discovery**

Photograph: ©Robert Ganz	Title: **Digital Discovery**
Contest: BetterPhoto.com	EXIF: **1/60 second at f/2.2, ISO 50**
Technical Note: **Shot using a Canon Powershot G1 camera with flash and spot metering.**	

children: siblings

Yuck! Hug my brother? Are you kidding?" We've all heard those reactions from brothers when they're asked to display a little affection in front of the camera (girls tend to cooperate more when it comes to hugging). You'd think you asked them to kiss a bug. But when you do get the rare shot of brothers in a warm embrace, it's priceless.

To capture these moments spontaneously you have to be vigilantly prepared. "Always have at least one camera with you at all times, and be so comfortable with it (and the controls, settings, etc.) that you don't have to stop and think about anything before you use it," says Robert Ganz. "My children are so used to seeing me with a camera, I can get away with taking shots at just about any moment."

Sometimes, however, you have to nudge their natural instincts. If you wait for such moments to occur on their own, you may end up with a pretty slim family album. And while you can't coax an embrace between brothers when they don't feel like sharing the love, you can at least foster

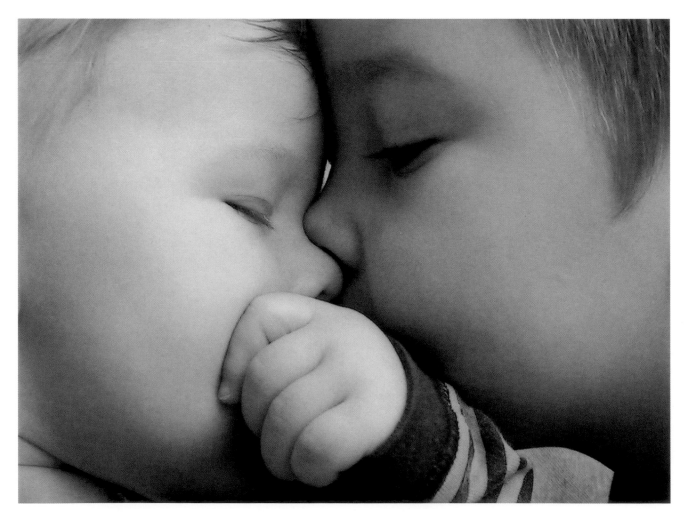

Photograph: ©Robert Ganz	Title: **Close**
Contest: **AgfaNet Photo**	EXIF: **1/60 second at f/2**
Technical Note: **Shot using a Canon PowerShot G1 camera with flash.**	

cooperation. The trick is in the timing. Don't yank kids off the swings, haul them inside, and tell them it's time to demonstrate their deep and abiding affection so that you can win a contest. (Not without some serious ice cream bribery, anyway.) Instead, wait until their affection rises naturally—just after their favorite bedtime story or during their quiet, sleepy times after a Sunday brunch.

Also, don't be afraid of documenting the occasional conflicts that erupt between siblings. Those "tears and fears" shots are just the kind of thing that you can use to torment during their high school years by whipping out the family album when they bring home dates. Ahh, sweet revenge!

In any case, it's important to be in the moment and occasionally pull the camera away from your face to enjoy these fleeting occasions of real affection or dissension. "Sometimes I wonder if I am missing the moments because I am watching through viewfinder," says Ganz. "But I have done my share of capturing magic moments that way and I am happy with the results."

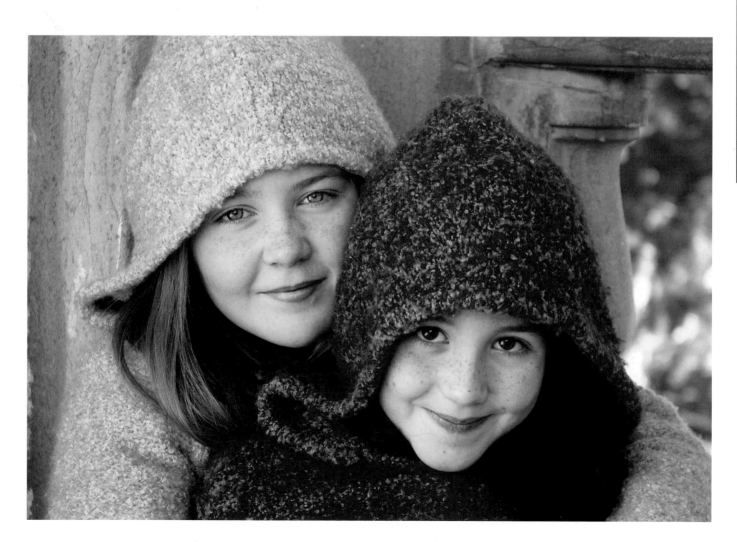

Photograph: ©Cindy Johnston	Title: Evie and Aisling
EXIF: 1/125 second at f/4.5	

ceremonies & rituals

Ceremonies and ritual gatherings have always been a part of human culture. Whether it's crowding around a hi-fi stereo and dancing, or a village community coming together to join hands and celebrate the arrival of a new tribal member, as in photographer Abhijit Dey's striking image on the right, we gather to mark significant rites of passage. Events like these have appeal to the universal rites of passage that all cultures share in one form or another.

Photographing such events, whether they are silly or solemn, private or public, is probably the single biggest reason that people own cameras. Why? Because life and milestones fly past so quickly that we need photographs to slow down for personal examination and reflection. Pictures become a frozen mirror into which we (and future generations) can gaze and witness our progress.

How you approach a particular ceremony or ritual with a camera depends on the nature of the event itself. Most religious ceremonies—a baptism or a wedding, for example—have sacred overtones that your photographs should reflect with a more removed or documentary style. For instance, in Dey's photo the only face shown is that of the baby. The other tribal members, their faces hidden, become an anonymous circle of hands and arms—quite a dramatic approach. Other events, like a Fourth-of-July picnic or an anniversary celebration, call for a more informal and interactive approach where happy faces, tables brimming with food, and colorful decorations reflect the fun of the event. Interestingly, too, some ceremonies that begin on a sacred tone (a wedding, for example), end up on a more festive note; so you get to photograph it from two very different emotional perspectives.

Before photographing rituals and ceremonies in a foreign country, ask for permission. If you don't speak the language, just follow the lead of the people around you. If no one else is shooting photographs, there is probably a reason.

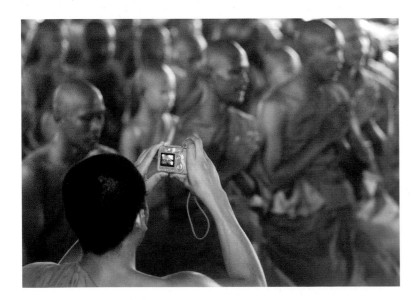

Above Photograph: ©**Paul Hilts**	Title: **Old World, New World**
Contest: **Smithsonian Magazine**	

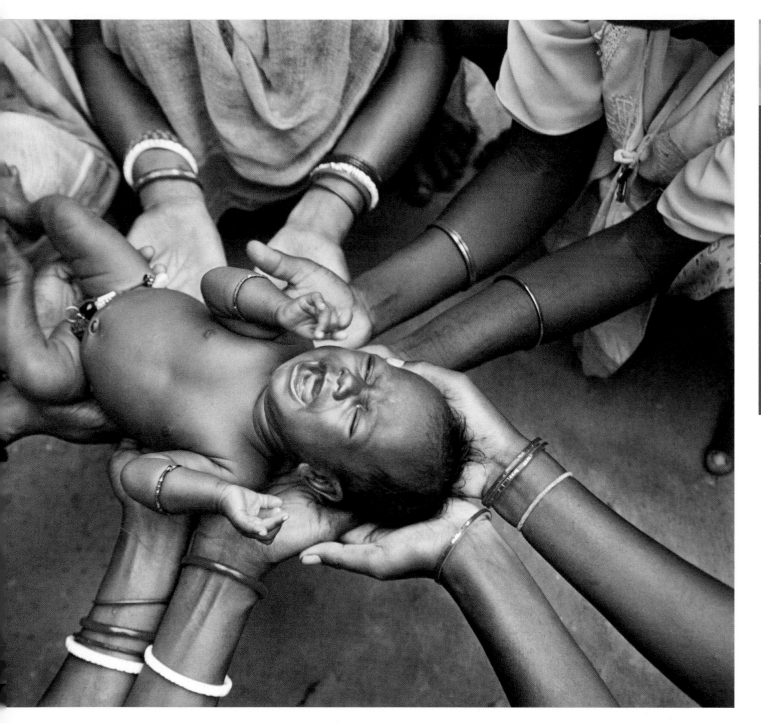

Photograph: ©Abhijit Dey	Title: A Tribal Birth in India
Contest: Smithsonian Magazine	EXIF: 1/60 second at f/8, ISO 100
Technical Note: Shot using a Nikon F90s camera with an AF Zoom-Nikkor 28-105mm f/3.5-4.5D IF lens at 28mm.	

" This photo was shot in Buenos Aires, Argentina. The couple dancing seemed to be in their own little world even though there were many people watching them dance. **"** —*Inspiration* *for* **The Last Tango**

Technical Note
Shot using a Nikon D200 camera with an AF-S DX VR Zoom-Nikkor 18-200mm f/3.5-5.6G IF-ED lens at 70mm.

Photograph: ©Kenneth Mucke	Title: **The Last Tango**
Contest: **Popular Photography**	EXIF: **1/10 second at f/4.5, ISO 200**

sports action

As the late, great Jim Mckay used to say, between the thrill of victory and the agony of defeat lays the human drama of athletic competition. Between those emotional bookends you will find a wealth of great photographic endeavors—breathtaking action, deep passion, and comical performances as well. Best of all, no matter where you live or what your lifestyle is like, sports are always easy to find and photograph—whether it's kids skateboarding down your street, a Saturday beach volleyball league, or the Red Sox from atop the Green Monster at Fenway.

One of the challenges of photographing many (but not all) sports is that they usually happen at quite a distance from spectators. Since you can't just walk out onto the playing field to shoot, you have to rely on long telephoto or zoom lenses to get close. Interestingly, several digital compact cameras on the market today boast up to 24x zoom lenses (often called superzooms). This 35mm-equivalent focal length range of 26-624mm offers approximately the same optical reach that professionals enjoy. But while such powerful lenses come in handy with distant subjects, there are plenty of sports that provide closer access and can be shot at more moderate focal lengths. If you position yourself under the hoop at a high school basketball game, for instance, you can probably shoot with a normal or even a wide-angle lens.

Because so many sports involve bursts of high-speed action, you need to anticipate when and where that action will take place. At a baseball game, for instance, a lot of action takes place around first and third bases. Positioning yourself nearby one of these will bring the action to you, which is a lot easier than randomly chasing it all over the field. This way you can frame your shot ahead of time and prefocus on just the right spot, which will reduce shutter lag and greatly increase your chances of getting a great action shot that is well-composed and tack sharp.

When you want to freeze the action, keep this in mind: all other things being equal, subjects moving parallel to the focal plane (left, right, up, down, or diagonally) require faster shutter speeds than subjects moving perpendicular to it (toward or away from the camera). The subject in this dynamic shot of a rower exhibits characteristics of both kinds of motion, because photographer Madeleine Guenette was shooting from a bridge looking down at a roughly 45° angle. She was therefore able to use a moderate shutter speed (1/160 second) to freeze the action.

Finally, don't forget that most of the drama of sports isn't only in the action, but also in the human reactions to winning and losing. Emotion-filled faces, like Michelle Frick's smiling daughter at the edge of a pool, are far simpler to capture and often provide the most meaningful images.

Above Photograph: ©Madeleine Guenette	Title: **Early Morning Water Spider**
Contest: **Digital Image Cafe**	EXIF: **1/160 second at f/6.7, ISO 200**
Technical Note: **Shot using a Nikon D200 with an AF-S DX Nikkor 18-135mm f/3.5-5.6G IF-ED lens at 135mm.**	

Why This Moment?

❝I often go on this bridge around 6:00 a.m. waiting for these athletes to train because I know they like the calm water. The light and the calm of the lake were perfect. I waited until she was just in the frame.❞

—*Inspiration for* Early Morning Water Spider

Left Photograph: ©Michelle Frick	Title: **Water Baby**
Contest: **BetterPhoto.com**	EXIF: **1/125 second at f/10, ISO 500**
Technical Note: **Shot using a Canon EOS 5D camera with a Canon EF 85mm f/1.8 USM lens.**	

historically-inspired portraits

Does studying the great master painters from centuries gone by, collecting or creating vintage costumes, and inventing historically inspired characters appeal to the history buff in you? If so, you should find the work of fine artist and photographer Juliana Kolesova inspiring. Before I began researching this book, I'd never even heard of anyone attempting this unique visual challenge. After seeing her wonderful portraits, I'm fascinated by the concept and awed by the level of skills and dedication involved.

The two photos shown here are from Kolesova's historically inspired series called "Unknown Masters." While these photos are not meant to be exact replicas of specific paintings, their goal is definitely to evoke the look of certain classical painting styles and time periods. The challenge of creating such portraits is, to say the least, mind-boggling. Kolesova, an artist of many talents with a background in portraiture, not only captures the final photos, but she also creates every element that goes into each image.

Sound like a fun challenge? Much of the beauty of these portraits, of course, is derived from the varied talents with which the artist has been blessed. But the example of someone having a singular vision and then working hard to take complete control over its materialization is something you can imitate. Her portraits serve as a great reminder of what inspiration, talent, and dedication to an idea can create.

Few of us possess the talents to design and sew costumes or style hair, but we can all study various social periods and analyze what created the unique look of that period—and then apply those ingredients to portraiture. The images of pop-culture icon Peter Max, for instance, are marked by psychedelic colors and intense saturation—something you can recreate in post processing. You might even try hitting the thrift shops for vintage 1960's clothing, and find willing models to help you create the hippy look (just look at my old high school yearbook for some genuine character studies).

Photograph: ©Juliana Kolesova	Title: George Gordon Junior
Contest: DailyAwards.com	EXIF: 1/200 second at f/16, ISO 400

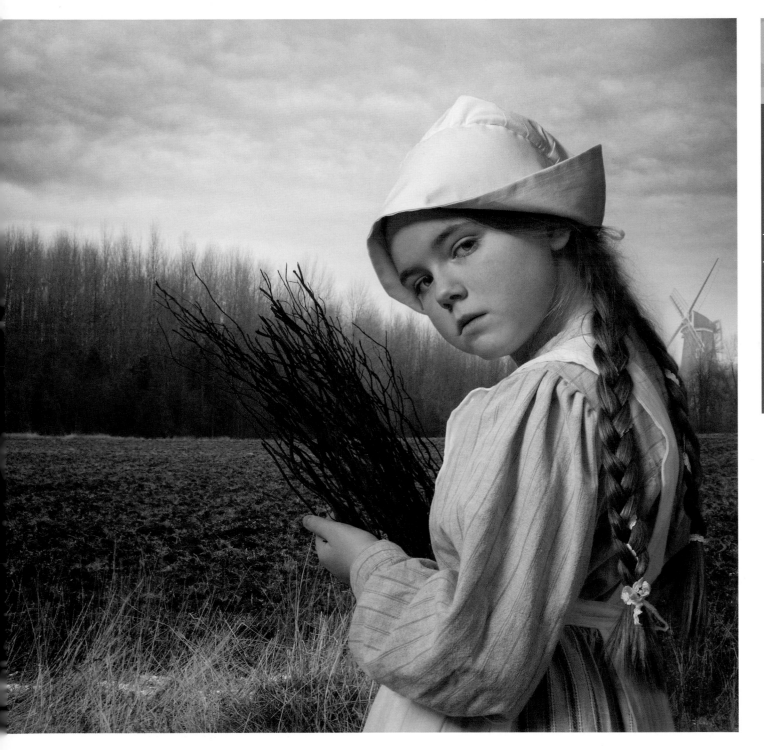

| Photograph: ©Juliana Kolesova | Title: **The Peasant Girl** |
| Contest: DailyAwards.com | EXIF: **1/200 second at f/14, ISO 400** |

Robert Ganz
Photographer

I first became aware of the amazing photographs of Robert Ganz while I was a teacher at BetterPhoto.com; it seemed that I was always running into his photos in the galleries there. I was so impressed by them that when I wrote *The Joy of Digital Photography* for Lark Photography Books, I asked Robert to contribute several of his wonderful images. He has an eye for great shots, and can ferret out unusual pictures from seemingly ordinary situations. I've been teasing Robert for years that he should give up his day job and become a professional—he's still resisting my advice.

Robert has worked in the customer service field for the past 17 years, living on both the east and west coasts of Canada. Currently employed by a software company, he now lives in Montreal with his family. Among his favorite subjects are his children, who are becoming a little camera shy—or perhaps just camera wary—as they grow up. In addition to taking pictures, he likes to read, play computer games, hike, watch birds, and spend time with his wife and sons.

Although he's been photographing for a number of years, his interest and success in photography only truly blossomed when he began shooting digital. In the past seven years he has won numerous contests and a bundle of prizes—some of which have been quite glamorous. I interviewed him in order to give you some insider information on how to win the big ones.

Regarding his participation in photo contests, Robert says "there is amazing talent out there, and I can learn something every day." But today, we're the ones that are going to learn something from this talented and prolific contest photographer:

> ❝I think that we all perceive the world around us a little differently, and that this is reflected in our photography.❞

How did you get started entering contests?

About nine years ago I started shooting digital, using a Casio QV2000UX. I remember researching cameras at StevesDigiCams.com, where I joined in discussions, and eventually won a Picture of the Day.

Do you keep track of all your wins?

I have a scrapbook of congratulatory letters, emails, and prize notifications. The wins in online daily contests have been in the hundreds; as for more formal mail-in or annual contests, I've received enough awards (honorable mentions, first or second places, and a couple of grand prizes) to keep me interested in entering more.

What are some of the more impressive prizes you've won?

Over the years, I have won cash (always nice), cameras, binoculars, printers, magazine subscriptions, electronic flashes, memory cards, and software programs. The most memorable prize package was a Fuji D-SLR package and an all-expenses paid trip for two to the Yukon for a week of dog sledding.

Well I have to ask, did you go on the dog sledding trip?

I did, and it was amazing. I remember that as I was entering the contest, I joked with my wife and told her that since the grand prize was a week of dog sledding in the Yukon, she should start thinking about what to pack. After we found out that I won, she half-heartedly asked why I couldn't win a trip to Hawaii! In the end, we had the trip of a lifetime, away from the kids for a whole week and in one of the most beautiful locations on earth.

You won the Grand Prize in *Popular Photography's* 10th Annual International Picture Contest in 2004. What was that experience like?

In a word, awesome. I was on vacation in Nova Scotia when I got the following email [excerpted here]:

August 27, 2003

Dear Robert:
Congratulations! Your image of a small child pointing his finger at what appears to be an ant has been awarded Grand Prize in Popular Photography and Imaging's *2004 Annual International Picture Contest. Your image, along with the other winners, will be published in the January 2004 issue of* Popular Photography and Imaging.

I was literally shaking as I typed my response back to him. To top it all off, this was on my birthday.

| ©Robert Ganz | Grand Prize Winner of Popular Photography's 10th Annual International Picture Contest |

Any advice for photographers with ambitions to win contests?

Never give up! Don't give up on a photo you believe in. Re-enter photos that have not won anything. If they are good they can win. So much is at the mercy of the judges, and it pays to be persistent. I have some photos that have won major prizes without winning any other, smaller contests. You never can tell what will win and what won't. So just don't give up.

How do you process images intended for contests, and what software are you using?

If you are entering contests for publications, be sure to print and save at the highest resolution file that you have, and be sure to read the contest instructions carefully as to permitted sizes, required labeling, and mailing deadlines. The same goes for online submissions: pay careful attention to the rules about file size, ppi requirements, print sizes, captions, and watermarks. A violation of any of these can get you disqualified.

As far as post processing goes, I do not have any special technique for contest submissions; I prepare them following the same workflow I follow for making prints for myself. I use Adobe Lightroom to index and convert my RAW files; Adobe Photoshop to crop, adjust color, touch ups, and any special effects that I want to add; Picasa to index, mail, or otherwise organize my photos; and Qimage to do all my printing.

Do you shoot with contests in mind or is that a secondary thought?

I try not to. There have been times, when a contest has a particular theme or category, that I have attempted to create photos that fit. But these have never been as successful as the candid, unscripted, taken-on-the-fly shots that characterize my photography.

What do you like to shoot the most?

People and bugs the most, with animals and birds close behind. Landscapes and still life studies are probably my favorites—though I will try anything once.

©Robert Ganz | Title: **Two for Tea**

You photograph your kids quite a bit—are they always such willing subjects?

When they were younger it was much easier and I could capture them being very natural. As they've gotten older it is more work for me, as they are more self-conscious. Still, I think they know that taking photos is just something their Dad does for fun. Maybe someday they will appreciate having all these photos to look through; but maybe not. I pretty much shoot for myself anyway.

How much time do you spend shooting?

Not as much as I would like to. In some ways it is seasonal—I shoot more in the spring, summer, and fall than I do in the winter. But I always at least have my Canon PowerShot G9 with me.

What's your favorite camera/lens combination?

I currently shoot with a Canon EOS-1D Mark II that I purchased used three years ago. I love that camera! My favorite lens changes all the time, but the Canon EF 70-200mm f/4L IS USM is small, light, and the perfect focal length range for people shots on the fly.

Any thoughts or advice to others about taking pictures?

I think that we all perceive the world around us a little differently, and that this is reflected in our photography. I can't help but put something personal into a photo.

©Robert Ganz | Title: **Baby Blue**

If I manage to capture a feeling or a scene that also appeals to lots of other people, then chances are it will be a successful photo. But having said that, I think it is important to shoot for yourself. Don't shoot for other people; don't shoot for contests; don't shoot because you have to. Shoot what you want, when you want, because you want to. If you can do this, and follow basic techniques, then you will be happy with your work. With some luck, others will appreciate your vision as well. But don't sweat it if they don't.

If you can open your eyes and your imagination
wide enough, the photographs you create will help
you present an engaging world in your own light.

6

sharing your travels

While most professional photographers will tell you that you should be able to take interesting and creative photographs in your own backyard—and they're right— there is nothing quite so fun as peeking over the fence with your camera and taking pictures in the neighbor's yard. Whatever is there surely must be more fascinating than what's in your own yard—or so the travel brochures promise. And that's essentially what travel photography is all about: looking over the fence (or across the ocean, or up on a mountain) to see how other places look and how other people live.

What you find depends on what you're looking for (like the old saying: "No matter where you go, there you are"). For some of us it's a view back into yesterday— perhaps to see where we (or our ancestors) came from, or just to see the world at a simpler or more elegant time. For you it might be a journey of comparison: how do we look now compared to how we looked in the past? How much progress have we really made? And for others, it may be a more spiritual journey: to look more closely into the faces of those who immerse themselves in the mysteries of life.

The questions you ask and experiences you seek will imbed your travel photos with a competitive edge.

Just showing a distant place isn't enough win you a contest—the globalized modern world is deluded with images from all around the world. Like Jim Richardson said on page 37, now people crave for more, for "the feeling of what it's really like to *be there*."

Whatever your purpose or goal, and however much you've planned each detail of your itinerary, there is one thing that travel will always do, without fail: it will surprise you. No matter how many guidebooks you read or how many photos you research online, nothing compares to standing there, feet in their yard, their sun on your back, their views in front of you. Around every corner is a sight that you've never seen before, a sound you've never heard, and smells that you've never breathed in. And it is the unveiling of those surprises that will attract the attention of contest judges, because ultimately, that is what judges want so desperately—to be surprised. They want and need to be brought into the moments of discovery, your moments of discovery, to experience your travels *with you.*

If you can open your eyes and your imagination wide enough to bring home your travel experiences on the miracle of a memory chip, the photographs you create will help you take down those fences of cultural, linguistic, and geographic differences, and present an engaging world in your own light.

Technical Note

Shot using a Canon EOS 30D camera with a Sigma 18-50mm f/2.8 EX DC Macro lens at 18mm. Minimal processing with Apple iPhoto and Adobe Elements 6.0.

Photograph: ©F. M. Stephens	Title: Antelope Canyon
Contest: Wilmington International Exhibition of Photography	EXIF: 1/4 second at f/4, ISO 400

timeless views

n traveling, people seek a connection to the past, propelled by the idea that when modern life seems too close, the remnants of history are still there for us to touch, explore, and visit. For most of us, the world today seems to speed along, reinventing itself faster than the seasons (and not often for the better); so finding islands out of time is a refreshing experience. Views like this striking scene of the Grand Canal in Venice, Italy, captured by photographer David Michael, are a bit like stepping into the pages of a history book.

Since the modern world works so hard at intruding into the past, it's tougher to find places where the beauty of old towns and cities remains unspoiled. Not surprisingly, of course, the older the places are, the more likely you will find untouched views. It's much easier to find a pristine old town center in Europe than it is in America, simply because European civilization is a few thousand years older. (Not to say the United States and Canada don't offer their own unique histories, in the form of haunting ghost towns of the Wild West, for example.)

One method is to scour the postcard racks when you first arrive in a new city or town, and research the places that other photographers have discovered. A concierge or cab driver also can easily guide you to a particularly good locale or vantage point. Also consider the timing of your trips; the off-seasons tend to offer much less-crowded experiences. Even some of the most popular destinations in the world are nearly empty in late autumn and early spring. Exploring early in the day or on rainy days will also help cut down the number of tourists dramatically.

Once you find a subject, you have to find angles that eliminate hints of the twenty-first century—signs of commercialism and tourism, not to mention the tourists themselves. Nothing takes away the antiquity of the Pyramids at Giza like a Hard Rock Cafe t-shirt. With fast-food franchises and tour-bus parking lots dotting almost every popular landscape, discovering virgin views is not an easy task. Naturally, the farther off the beaten path you go, the further from the 21st century you'll be. Photographer Freeman Stephens captured this shot of Antelope Canyon while traveling through Navajo tribal lands in Arizona. Untouched by history, geologic exposures like these are an extreme form of escape from the modern world, and the immense scale of geologic time they communicate make them an excellent and worthwhile addition to any travel portfolio.

Photograph: ©David Michael	Title: **Springtime in Venice**
Contest: **Smithsonian Magazine**	EXIF: **f/9 at ISO 200**
Technical Note: **Shot using a Nikon D50 camera with an 18-135mm lens at 18mm.**	

Technical Note
Shot using an Olympus Camedia
C-770 camera (which was won in
another photo contest).

Why This Moment?

"The photo was taken in Kowloon, China looking toward Hong Kong Island. I saw the old-style fishing boat approaching and waited for it to get into position. The lighting was very unusual, with low clouds casting a greenish color on the water.**"**
—*Inspiration for* **Hong Kong Harbor**

past versus present

Some of the most photogenic scenes illustrate the contrast between the old and the new. These perspectives embody the inner conflict felt by many cultures that wish to embrace the present while still honoring the past. We like riding the bullet train from Tokyo to Kyoto, but we still want to see Geishas walking along the streets when we get there.

Spiraling into the future faster than rural and suburban areas, urban districts readily reveal the paradox of past and present existing simultaneously. In European cities, modern business and banking centers often surround the the old town centers. This regrettable result of economic development often seems crass and intrusive to travel photographers seeking pristine perspectives. Just when you think you have a great image of an ancient city block framed, you notice there's a Starbucks peaking out between two antique buildings. Rather than give up on the shot, use these elements to make an interesting architectural comparison—framing a Gothic cathedral spire against a modern skyscraper, for example.

In order for images like this to be effective you must show a clear and uncluttered juxtaposition. In Doug Mauck's scene of Hong Kong Harbor, for instance, the old market boat sitting alone in the harbor seems overshadowed and cast aside by the glittering city across the bay, and yet its very isolation is what romanticizes the past.

Often, too, you can find the old versus the new contrasted in people's costumes. In Germany, for example, it's still not uncommon to see men wearing traditional Lederhosen (and if you do, don't stare, just point to your camera, smile, and ask them to pose). Traditional clothing is seen in almost all corners of the world, and generally the older a culture is, the more you will notice it.

While the dynamic relationship between today and yesterday is more obvious in cities, you can find it everywhere. Modern farmers may plow their fields with shiny new tractors, for instance, but it's rare that you can go to a farm and not find leather-and-wood remnants of the draft-horse days. Where I live in New England, I often see modern street signs erected next to original King's Highway stone mileage markers.

Photograph: ©**Doug Mauck**	Title: **Hong Kong Harbor**
Contest: **Digital Image Cafe**	EXIF: **1/500 second at f/4, ISO 64**

Technical Note

Shot using a Canon EOS 40D camera with a Canon EF-S 10-22mm f/3.5-4.5 USM lens at 10mm.

Above Photograph: ©Geoff Stamp	Title: **Medieval Times**
Contest: **DailyAwards.com**	EXIF: **1/125 second at f/16, ISO 320**

Right Photograph: ©**Jeff Wignall**	Title: **Chenonceau**
EXIF: **1/250 second at f/8, ISO 200**	

royal dwellings

Castles, palaces, chateaus—the very words conjure such a powerful aura of mystery and intrigue that we willingly endure long lines at the airports, expensive hotels, and hours spent trying to figure out the navigation thingamajig in the rental car, all for the opportunity to gaze upon them. Steeped in history and built in an age of splendor and opulence that we'll likely not see again, these royal dwellings are worth all the hassle it takes to get to them. Photographically, they present both a fun challenge and a subject rich with visual possibilities. (They also make you wonder why you can't sleep *there* instead of back in the hotel.)

Because they are often so overwhelmingly beautiful, such places challenge your ability to break from a traditional perspective. The tendency is to include as much of the building as you can, hoping for the power of the architecture to carry the picture. The main problem is that this approach is entirely predictable and pedestrian; a few thousand other people have already beaten you to it—and contest judges have seen them all.

Since your time is usually limited when visiting royal digs, it's usually worth starting your explorations with a short tour. Then, once you know more about the place, use your free time to wander freely and discover less-photographed scenes. From a purely visual perspective, these tours often present angles and vantage points that you might never discover on your own. While you might not have the time (or permission) to shoot during the tour, it will provide you with ideas that you can pursue later.

Since these places are dripping with so much history, hearing a short lecture will also help you find interesting approaches. Many castles, for instance, were designed not just as posh royal getaways, but also to intimidate and fend off the jealous neighbors. Knowing this might lead you to an interesting shot of a moat, for instance, or a keyhole view from a viewing port high in a turret. In photographing Château de Chenonceau in the Loire Valley of France, for example, I was struck by the series of moats and towers created to protect the chateau, and decided to use one of these moats as a foreground device, leading the eye to the main tower.

As you explore for compositions, try looking for thematic combinations that reveal the marriage of history and architecture. To get his winning photo of Leed's Castle in England, photographer Geoff Stamp used an ultra-wide-angle lens to create a powerful foreground from a sundial. "I liked the chronological significance of the timepiece in relation to the age of the castle," he says. Not only does the composition enhance the ancient feel of the castle, but also its closeness to the front of the frame gives the shot a good sense of immediacy, and helps lead the eye into the scene.

| Photograph: ©Robert Mann | Title: **To Infinity** |
| Contest: **DailyAwards.com** | EXIF: **1/640 second at f/14, ISO 100** |

modern architecture

They may not be as inviting or romantic as a French château or an English castle, but emotional coldness aside, modern urban buildings can be fascinating temples to strident industrial design, and quite fun to photograph. As much as we might decry the displacement of older, more time-honored buildings, some urban towers are so jazzy-looking they'll nevertheless have you standing on the sidewalk, craning your neck upward, mouth agape like, well, a tourist.

Because most (though not all) modern architecture exists in a dense urban environment, you'll probably have a limited range of vantage points from which to work, and most of the time you'll be looking up at a sharp angle. In that situation you're inclined to shoot at a steep angle using a wide focal length. The problem with this viewpoint is that it creates an effect known as keystoning that makes the building appear to be falling backward in space. If you own a D-SLR, there are lenses called either PC or TS (perspective control or tilt-shift, respectively) that are designed to fix this problem. These lenses allow you to move (or "shift") the front lens elements in relation to the focal plane, and fit tall vertical subjects in the frame without keystone effect.

These lenses can be quite expensive, so fortunately there are other solutions. For instance, many different software programs can digitally correct for the distortion in post processing; some employ data about the lens used, while others calculate and project a new image based on a crop of the building from the original shot (Filter>Distort>Lens Correction>Transform in Photoshop). However, keep in mind that no matter how advanced the software may be, there is always some loss of the original image quality.

An alternate approach is to embrace the distortion: move even closer, so you're shooting at an even more extreme angle, intentionally exaggerating and distorting the building for artistic effect. That is exactly what photographer Stefan Neilson did in the striking shot on the next page of the famous Turning Torso skyscraper in Malmö, Sweden. By exploiting the keystoning effect, he has turned the building into an almost abstract obelisk piercing the sky—a dramatic image reflecting the building's own theatrical posture.

Another option is to switch to a longer lens and isolate sections of the building. Often by entirely removing the context of the superstructure and focusing only on collections of lines and shapes, you can transform segments of the building into bold, graphic patterns. By eliminating all points of reference and instead concentrating on just the design of the steel skeleton and glass plates, photographer Robert Mann (who, incidentally, has won over 3,500 photo of the day/month/year contests in the past six years) transformed a piece of modern architecture into this pattern that, oddly enough, resembles a spiral found in nature—the center of a sunflower perhaps, or or the sections of a chambered nautilus.

Sometimes a good photo won't even require having the camera aimed at the building. I spent hours one afternoon photographing the Iowa state capitol in downtown Des Moines without liking most of my shots. After turning away from the building and packing up my gear, I spotted a rippled reflection of the capitol in a modern glass tower across the street, and that's where I found my best shots. Keep an eye out for these kinds of reflections, as they offer an excellent way to turn an ordinary snapshot into a winning image.

| Photograph: ©Christina Seuser | Title: **Count the Squares** |
| Contest: **DailyAwards.com** | EXIF: **1/60 second at f/18, ISO 200** |

Technical Note

Shot using a Canon EOS Digital Rebel XT camera with a Canon EF 17-40mm f/4L USM lens.

Why This Moment?

"I do quite a lot of architectural photography and I find the different shapes very interesting. With this building, called Turning Torso, it was the combination of the shape, colors, and clouds that attracted me."

—*Inspiration for* **With a Twist**

Photograph: ©Stefan Nielsen	Title: **With a Twist...**
Contest: **DailyAwards.com**	EXIF: **1/100 second at f/13, ISO 100**

66 This is one of the many shots I've taken in and around the Michigan State Capitol building. Its fascinating architecture is well suited to grand wide-angle shots, close up interior details, and everything in between. 99

—*Inspiration for* Up

Photograph: ©Eugene P. Tatroe	Title: Up
Contest: Daily Awards	EXIF: 1/2 second at f/6.3, ISO 80
Technical Note: Shot using a Kodak EasyShare DX7590 camera on a tripod.	

the building within

One aspect of looking at or photographing architecture is that you can rarely tell from the outside what the inside will look like. Very often buildings that seem like spectacular works of creative design on the exterior (modern office buildings, for example) fade into caverns of long hallways and anonymous doorways once you pass through the foyer. On the other hand, many older buildings like temples and churches, older town halls, and even public schools that seem sedated and lackluster from the outside, are rich with both decorative design and ornate architectural details within. It pays to poke your head inside a few public buildings when you're traveling.

Obviously buildings are much dimmer on the inside than outside under the sun, which presents an immediate question: are you going to have enough light to take a well-exposed photo? To be honest, I've photographed in some of the dimmest buildings you can imagine, including dark mission churches in southern Arizona and during a candle-lit mass at Notre Dame in Paris. I've always been able to get a good exposure by simply raising the ISO speed (typically to ISO 800 or 1600). Flash is rarely allowed in most buildings and even if it is, it won't supply enough light—especially if you're photographing large rooms or ornate ceilings, stairways, etc. Tripods are also usually frowned upon, so while they would be the ideal solution, it's rare that you can use one (though it is certainly worth asking—there's nothing to lose).

Interestingly, while the quantity of light in many interiors is not great, often the quality of the lighting design is quite good and as long as you can make a long-enough exposure, the look of the lighting will be excellent. In Eugene P. Tatroe's wonderful shot of the Michigan State capitol dome, for instance, a combination of natural and artificial lighting has been used to reveal vibrant colors and exquisite architectural detailing (and he was allowed to use a tripod).

Finally, if daylight coming through windows represents a significant part of the interior illumination, you're usually better off working on cloudy or rainy days since the lighting will be far more uniform. In Juliana Kolesova's shot of a stairwell in the Louvre, a combination of soft window light and artificial light from wall sconces creates a gentle and natural-looking ambience. So next time you're traveling and the skies get cloudy, look for a building interior to photograph.

Photograph: ©Julianna Kolesova	Title: Louvre Staircase
Contest: Daily Awards	EXIF: 1/30 second at f/3.5, ISO 320
Technical Note: Shot using a Canon EOS Digital Rebel camera.	

Why This Moment?

❝We were exploring the old Red Fort of Agra in India, and I spotted this scene through a window, which I used as a frame. I saw that misty light, so classically identified with India, framed by shadows, and it just had that 'wow' feeling. I made sure to line up the center of the window with the top of the tower.**❞**

—*Inspiration for* **Agra Red Fort**

Technical Note
Shot using a Nikon D70 camera with an AF-S DX Zoom-Nikkor 18-70mm f/3.5-4.5G IF-ED lens at 22mm.

Photograph: ©**Daniel Kohanski**	Title: **Agra Red Fort**
Contest: **Popular Photography**	EXIF: **1/500 second at f/16, ISO 800**

find frames within the frame

When seeking out a competitive travel shot, bear in mind the legions of tourists that have passed by these same famous locations, snapping away with their disposable cameras. The difference between your winning image and their snapshot is the degree of effort you put into finding just the right angle, frame, and perspective. Judges are adept at recognizing a thoughtful composition, and will reward you for your efforts.

A good travel photo (or any photo for that matter) arranges the elements in a scene in order to feature and highlight its subject. Like a centerpiece in a formal table setting, the main subject needs to echo the place settings around it, yet still be bold enough to stand on its own as the focal point. One device that many professional travel photographers use to design this unified look is to position the intended subject within a naturally occurring frame in the scene. Tree limbs, doorways, windows, gates, or even the legs of a table (or a cow if you're careful and have a change of clothes) all make good foreground frames.

Frames-within-frames can serve several purposes. For one, they act as visual signposts that draw attention to your main subject by physically isolating it from its surroundings. For another, they subdue or eliminate peripheral clutter that you can't otherwise exclude. If you're photographing a street musician in New Orleans, for example, and there is just too much chaos on the streets around him, framing him through a bit of wrought-iron fencing lets you focus attention on him, while de-emphasizing the outlying clutter.

When photographed with a wide-angle lens, frames-within-frames can establish or exaggerate a sense of depth and distance. If you're photographing a sailboat in a harbor at sunset, you can frame it through an old ship's anchor to stretch the sense of space in the scene (while reinforcing the nautical theme). Conversely, to contract the space between the frame and the subject you can switch to a longer focal-length lens (or zoom in) and use the inherent compression of the telephoto effect to squeeze them together—making them seem closer than they actually are.

Regardless of how you use a frame, choose one that links visually or thematically to the subject. In his photo of the Agra Red Fort in India, photographer Daniel Kohanski carefully framed one of the fort's towers through an arched window that echoes the architectural style of the historic building it encloses. Similarly, in his photograph of a church on the remote Pribilof Islands in the Bering Sea (between Alaska and Russia), photographer Bill Yeaton used the homey curtains of a hotel's kitchen window to reinforce the rural and quiet atmosphere of the locale.

sharing your travels

Why This Moment?

❝The church is a very interesting architectural piece and I was looking for a unique way to portray it. I thought the window and the curtains made an interesting frame because curtains are important in the Russian Orthodox Church, and must be changed every so many weeks. ❞
—Inspiration for **Church Through the Curtained Window**

Photograph: ©**Bill Yeaton**	Title: **Church Through the Curtained Window**
Contest: **Smithsonian Magazine**	

carnivals, festivals, and special events

For sheer fun, color, and pageantry, you won't find many subjects as visually inspiring as carnivals, festivals, parades, and other big public celebrations. Unlike most travel subjects that require a lot of time and energy spent pursuing and getting to them, festive events like these bring all the excitement to you. Better still, the people that participate in them are usually uninhibited and camera-friendly, so they expect and want you to take lots of pictures.

There's hardly a town or region in the world that doesn't have some kind of festival or event during the year. These can range from tiny local harvest celebrations to huge carnivals drawing hundreds of thousands of visitors. The toughest part about photographing events like this is timing your travels to coincide with them—though sometimes you get lucky and just stumble onto one. Late one night while driving around Europe, I pulled over to sleep in a small Bavarian town that seemed abandoned. When I woke up the next morning, I found my car surrounded by dancers, singers, fiddlers, and jugglers—the entire town had been taken over by a festival!

As you plan your trips, make sure your Internet research includes event schedules; try to pick travel dates that coincide with events you'd like to see. Many, like The Day of the Dead, are related to religious celebrations (though it would be pretty tough to spot the religious aspect of Mardi Gras in New Orleans); others have agricultural or historical significance.

Since you'll be shooting a lot of pictures during such events, be sure to bring along more memory cards and batteries than you normally would. You'll also probably want to take along a wide-range zoom lens so that you can catch the dancers shimmying in your face and then quickly zoom in on costumed princesses waving from a distant float. If you want wide shots of a parade or festival, scout the locations ahead of time and see if you can find a high vantage point—a street hill along the route, or a balcony or rooftop from which you can shoot without being swept up in the crowd.

With festival activities often stretching from midday to midnight, you should come prepared to photograph in both bright and

Why This Moment?

66 I like the diagonal line created by the two faces and shot a few frames until I got the perfect composition. 99

—*Inspiration for* **Carnival Couple**

Photograph: ©Stefan Nielsen	Title: **Carnival Couple**
Contest: **DailyAwards.com**	EXIF: **1/200 second at f/8, ISO 400**
Technical Note: **Shot using a Canon EOS Digital Rebel XT camera with a Canon EF-S 18-55mm f/3.5-5.6 IS lens at 55mm.**	

dim light (and bring not only extra batteries but also some energy drinks for when you need to be recharged). During the bright daylight hours you can shoot almost without worry, and hone in on interesting costumes or faces. Stefan Nielsen's terrific photos of participants in full regalia at the annual Venice Carnival are beautiful and colorful mementos you could never get elsewhere—perfect entries for portrait contests. As an added bonus, if the costume conceals the person's identity, you don't even have to worry about model releases!

As much as I prefer to work with a tripod at night, when it comes to working in a festive environment you're better off relying on wide apertures, high ISO settings, and (if your camera or lens has one) an image stabilization system—though the latter won't help freeze action in rapidly moving subjects. Alternatively, try abandoning the idea of sharp photos altogether. Instead, switch to the Shutter-Priority mode, set a shutter speed of 1/4 second or slower, and try to capture the motion and color of the event—the photos will be far more evocative anyway.

| Photograph: ©Stefan Nielsen | Title: **Lady in Pink** |
| Contest: **DailyAwards.com** | EXIF: **1/200 second at f/7.1, ISO 200** |

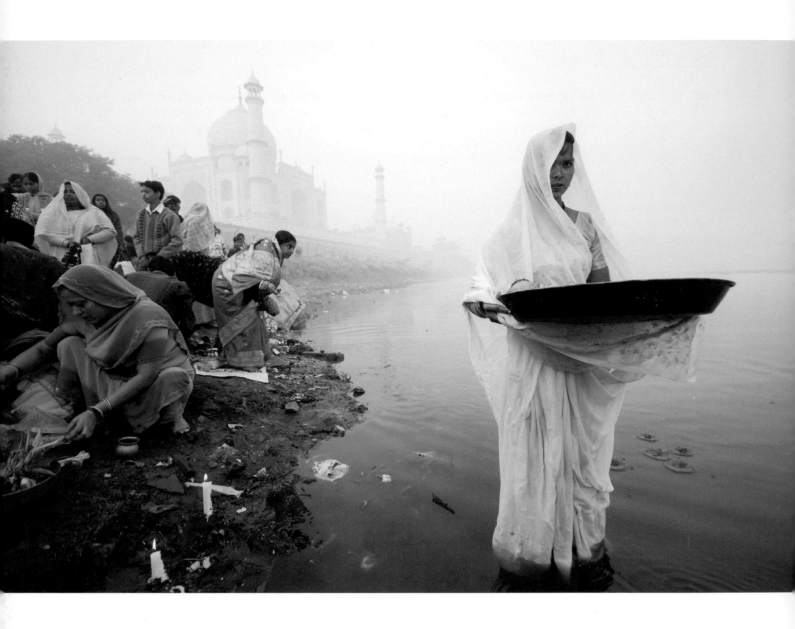

Photograph: ©Indranil Sengupta	Title: **Woman Praying at the Chhath Festival**
Contest: **Smithsonian Magazine**	EXIF: **1/80 second at f/4.5, ISO 200**
Technical Note: **Shot using a Nikon D80 camera with a Sigma 10-20mm f/4-5.6 EX DC HSM lens at 10mm.**	

spiritual journeys

When visiting a country where religion is a visible part of daily life, you'll find that pictures of religious activities reveal cultural insights better than photographs of landmarks and landscapes. Rituals, festivals, and people dressed in religious garb personalize faiths otherwise unfamiliar to us. In terms of photo contests, pictures like this are uncommon and always interesting, so they are well worth pursuing.

You must be tactful when photographing religious events; exercise discretion and always show respect. Even at large public events, like the colorful shot of the Chhath Festival photographed by Indranil Sengupta beside the Taj Mahal in India, you have to use diplomacy and always defer to the spiritual nature of the subjects or activities. Ask someone at your hotel if it's acceptable to photograph the event, and even then, follow the lead of others around you. If you see your subjects taking pictures of one another or if other tourists are shooting, the odds are that photography is accepted.

Although language may be a barrier, by offering a warm smile and pointing to your camera, you're likely to get permission to take someone's photo—or it may get you waved off and then at least you'll know. The worst thing to do in a situation like this is to try to be surreptitious. As you can probably imagine, strangers with cameras at religious events or at holy sites could easily be viewed with mistrust or suspicion, and at the very least, if you shoot at the wrong moment or against someone's wishes, you might be viewed just as another ugly tourist.

If you want to photograph inside a church or mosque and you aren't sure about the rules for picture taking, it helps to have a local guide secure permission for you—although most houses of worship post rules about photography in multiple languages. Or you might just ask a friend (or a concierge) to write you a simple note that asks permission in the local language. Taking these extra steps can gain you access to photographic subjects that your competition will assume to be forbidden. In this way you will differentiate your photos from the masses, and the judges will reward your dedication to (and interest in) the subject.

Also, if you are working from a distance or with a long lens, as photographer Dilip Kumar Ganguly was in his shot of two young lamas, it's best to be very obvious with your camera. It's not likely that those two happy faces would object to being photographed, but being up front will make you feel more confident and your smile might even help start a conversation or get you invited to areas that might otherwise be off limits.

Why This Moment?

"I took this photo at Tawang Monastery which is located in a small hamlet in India's Arunachal Pradesh state, high in the Himalayan Mountains."
—*Inspiration for* **Happy Lamas**

Photograph: ©Dilip Kumar Ganguly	Title: **Happy Lamas**
Contest: **DailyAwards.com**	EXIF: **1/1000 second at f/5.6, ISO 200**

Technical Note: **Shot using a Nikon D80 camera with AF-S DX VR Zoom-Nikkor 18-200mm f/3.5-5.6G IF-ED lens at 150mm.**

people in their element

Butcher, baker, candlestick maker—people at work can lead to some very interesting and unusual photographs. I pointed out in Chapter 5 (see pages 136-137) that the workplace makes an excellent background for portraits; when traveling, work comes up again as gesture that can communicate volumes about a particular culture and lifestyle. We're all curious about how people in foreign places earn a living, particularly in societies or settings that are markedly different from our own.

And sometimes those unique photos can identify a country instantly. You don't see a lot of tulip pickers outside of Holland, so Bill Yeaton's lush and graphic photo clearly announces the picture's location in the Netherlands. Images likes these connect the viewer with the subject (we all have to work) and have a much more authentic feeling.

Finding people at work is rarely a problem since almost everyone around you is doing something to earn a living, from the doorman at the hotel to the fisherman on the docks. And it's surprising how easy it is, especially if you are very open-minded and curious, to turn an ordinary job into a visually interesting photograph. Photographing a traffic cop might not seem like it would lead to any interesting visuals. But if you find an energetic and entertaining cop waving hordes of cars swirling through an intersection you might come up with some colorful and even comical photos. In fact, the traffic cops in Hamilton, Bermuda have become so famous that they're often immortalized on postcards and travel brochures.

Unless you're a total extrovert (which some of us are), most people find it awkward to just walk up to a stranger at work and ask them to pose for a picture. One solution is to start with the people you're already dealing with on a daily basis. In his wonderful book *Spirit of Place: The Art of the Traveling Photographer* world-renowned travel shooter Bob Krist recommends precisely that: "If you're still reluctant to approach potential subjects cold, try photographing the people you naturally interact with during your travels. Waiters, doormen, taxi drivers, street vendors, shopkeepers, and street artists are all used to request from travelers and are usually happy to pose for a picture or two." Terrific advice.

Crafts people and artists are usually more than willing to pose for photos not only because they're hoping you might buy something (you don't have to, though it doesn't hurt) but also because just having tourists pay attention to them draws in more business. Most crafts people are justifiably proud of their work and their studios are usually quite distinctive and interesting. While working as an assistant at an Arizona Highways Photography Workshop, Colleen Miniuk-Sperry shot this dramatic photo of a Navajo silversmith in a traditional Navajo Hogan in Chinle, Arizona. "We had the opportunity to photograph Andrew Henry in his Hogan as he created his silver bracelets," she says. "We placed him underneath the smoke hole so that his face and workspace would be better illuminated."

By the way, if you plan a return visit, it's worth taking people's addresses and sending them a print. As long as you follow through on the promise, they'll be sure to remember (and welcome) you next time.

Why This Moment?

66 The color, the leading lines, the geometry of the background, and the interestingly yellow flower in a field of red—it just seemed right. 99
—*Inspiration for* **Tulip Picker**

Photograph: ©Bill Yeaton
Title: **Tulip Picker**
Contest: **National Geographic Traveler**

Technical Note
Shot using a Contax 645 medium format camera with a 45mm lens and Velvia slide film, mounted on a tripod.

❝As a travel photographer, I look for opportunities to photograph people actively engaged in their environment in the best possible light. I love being able to tell a person's unique story through my photographs.❞
—Colleen Miniuk-Sperry

| Photograph: ©Colleen Miniuk-Sperry | Title: Enlightening Traditions |
| Contest: Smithsonian Magazine | EXIF: 1/60 second at f/5.6, ISO 100 |

The more you know about the types of contests that are out there…the more you can psyche yourself up for the tips and techniques that you'll pick up in the rest of the book.

choosing and entering contests 7

Now we come to the most fun (and perhaps most important) chapter in this book: how to find, choose, and enter specific contests. While this is the last chapter in the book, no doubt many of you flipped to these pages first. And why not? The more you know about the types of contests that are out there and what their requirements (and rewards) are, the more you can psyche yourself up for the tips and techniques that you'll pick up in the rest of the book.

We are reward-driven creatures. Whether those rewards mean seeing our pictures published online or on the cover of a photo magazine, or perhaps even winning an exotic prize, having your creative talent recognized is a great feeling. But there are a few guidelines to locating photo contests well suited to your particular photo skills and interests that will maximize your chances of winning.

And remember, as they say in lottery lines all over the world, you can't win if you don't play. The only way to win photo contests is to enter them. At the end of this chapter I'll introduce dozens of specific contests and provide you the details to evaluate which ones might be right for you.

a winning philosophy

Winning photo contests, like winning any type of contest, is largely a numbers game: the more contests you enter, the better the odds are that you'll win one. If you enter one picture in one contest per year, you stand a far less chance of seeing positive results than someone who enters, say, a photo each month in twelve different contests every year. Not only will more of your photographs pass in front of more judges' eyes, but also you'll become more experienced at entering contests—i.e., understanding the rules, staying within the categories, learning which pictures attract the eyes of judges, and so on. Besides, since most contests don't charge an entry fee, you may as well spread your talents around.

How do you find contests to enter? Well, there is certainly no dearth of opportunities. Start with the listings at the end of this chapter. Then do a simple web search with terms like "online photo contests" or "picture-of-the-day contests." You'll get enough leads to fill your free evenings for months to come. You'll also find contest listings in your favorite photo magazines and even in the arts section of your local paper. It's rare that I pick up a periodical these days, from home-improvement magazines to travel publications, without seeing at least one contest advertised. Some of the contests are editorially based (that is, the magazine itself is sponsoring the contest), and some are commercially driven (by advertisers). If you're a prize hound in search of a trip to Tahiti, scan the commercially sponsored contests since they typically offer more valuable prizes.

You'll find contests in places that will probably surprise you, too: I've found them on seed and garden websites, state tourism websites, and even in hotel brochures. Keep your eye on photo-sharing sites like Flickr as well, because you'll often find informal competitions on specific themes or subjects. These are good practice for entering other types of contests, and they'll net you some great feedback that can be very handy when it comes to editing your work.

Photograph: ©André Viegas	Title: **Vasco da Gama**
Contest: **Kodak Picture of the Day**	EXIF: **30 seconds at f/10, ISO 100**

tracking contests

Photograph: ©**Michelle Frick**	Title: **Jellies**
Contest: **BetterPhoto.com**	EXIF: **1/125 second at f/4, ISO 3200**

While I'd hate to see you become overly devoted (a kind word for obsessed) to keeping track of new contests, there is a lot of value in an organized approach. Unless you develop a method for tracking deadlines and themes, you're likely to miss out on some great opportunities. I, for one, have a great talent for seeing a contest that I'd really like to enter only to find the perfect photo in my collection the day after the contest has closed.

To avoid this kind of disappointment, keep a folder or notebook of contests you might like to enter. Print out online contest announcements, tear them out of magazines, and either shove them into that folder or pin them to a bulletin board near your workspace. Of course, if you happen to have some skill at creating spreadsheets or interactive calendars on your computer, then feel free to take the high-tech road.

The hierarchy for your contest listings should probably begin with the deadline (and if you're like me, you'll give yourself a personal deadline about a week prior to the real one, as protection against procrastination). For ongoing contests, you can create a more subject-driven approach that might include specific topics: Landscapes, France Photos, Kid's Portraits, Dog Shots, etc.

Collecting and organizing contest notices has another advantage: it can serve to inspire ideas when your creativity hits the doldrums or when you can't think of anything to shoot. Over the years one of the most frequent frustrations I've heard from students is, "I never know what is important enough to photograph." (Please, don't get me started on that topic.) Having contests with specific themes and subject requirements provides a good creative challenge and will keep you focused on consistently finding new ideas.

Having plenty of time and some decent organization is particularly useful when it comes to travel and vacation photography because, obviously, it helps to know about a destination-specific travel contest before you plan a trip. It would be pretty discouraging to vacation in London for a week, unaware that a major "London at Night" photo competition was underway. Many regional tourism contests feature specific categories; Florida's on-going state parks contest is a good example. And if you happen to be making an autumn trip to Maine, it might be worth knowing that the official Maine website happens to have an autumn-travel category.

So as part of your trip research, check for relevant photo contests. If you're traveling to Paris, for example, do an online search with terms like "Paris photo contest" or "travel photo contests." Results too broad? Try narrowing your search terms a bit to "Eiffel Tower contest" or "Seine at night photo contest." Or, if you're not getting any hits, broaden the terms to "European travel photo contest." You will find contests for almost any major destination. Holiday and seasonal themes also make good search terms (and good creative goals). Websites often announce these well ahead of the holidays so that you have time to think about the challenge and stir up some creative juices.

monitor your submissions

You should also devise a simple method of remembering what contests you've entered and when the judging dates are (or if they are ongoing). This can be particularly useful when you're entering picture-of-the-day type contests, just to be sure you're not entering the same photos over and over again. If you're anything like me, 20 minutes after you submit an image to a contest, you'll forget which one it was.

My suggestion is to create a visual notebook of your entries. For each image, create a simple document (in Microsoft Word, for example) that has thumbnail and all of the related info; something like this:

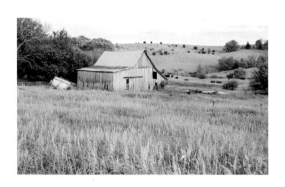

Contest: Digital Image Cafe, Picture of the Day

Date posted: January 1, 2009

Deadline/judging: Ongoing

Prizes? Yes

Entered contest before? No

Entry fee? No, just membership

If you keep a visual reference system, you'll always know where your photos are and when you can expect delivery of all your grand prizes. This is very similar to the filing system I use for tracking what photos I've sent to potential clients; so if at some point you start to also market your photos to paying customers, you'll be in the good habit of keeping close tabs on your image submissions.

types of contests

A contest is a contest is a contest, right? Well, yes and no. Yes, they are all about judging photographs based on creativity, technical merit, and relevance to the contest themes. But different types of contests have different technical standards and different submission methods. It's important that you match your images to the type of contest you're entering.

With magazine contests, for example, your images will have to meet much higher reproduction standards—typically high-resolution image files of 300 ppi at the printed dimensions with minimal post-processing enhancements. Online contests have much lower reproduction standards and can handle more extreme enhancements (like excessive color saturation). Also, by their very nature, some contests offer a lot more chances to win. Online picture-of-the-day contests, for instance, pick at least 365 winners a year; an annual magazine competition might only choose a handful of prize-winning photos.

Online Picture of the Day (POTD)

These contests are the simplest to enter, generally not too technically demanding (at least in terms of reproduction quality), and they offer the highest odds of winning. Entering them is very simple: typically you just upload a screen-resolution (72 ppi) image through a very basic interface, and you're entered. Virtually all POTD contests are free, though some may require membership, either free or paid, in the host site.

Often POTD-winning photos are subsequently advanced to a higher level of competition—a picture-of-the-week or picture-of-the-month. In fact, some contests randomly choose the daily pictures out of all the submissions that day; only then are they reviewed for weekly and monthly prizes by human eyes. Don't let the thought that a computer is picking your winning POTD photo discourage you from entering, though, because a win is a win is a win in terms of getting your photo recognized; and it still has to compete to move up through the ranks. With some POTD contests, it's not at all clear how the daily image are chosen, so it's worth reading site forums or FAQs (frequently asked questions) to find out more.

Peer-Review & Voting Contests

Several websites base awards on the votes of fellow site members. Entries rise in the standings as they gather more votes, when the voting period ends, those with the highest number win.

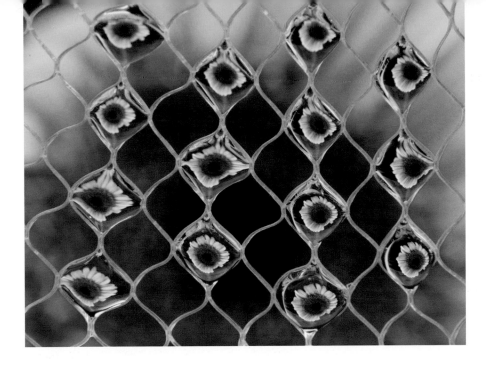

| Photograph: ©Robert Mann | Title: **Net Shot Gerbera X** |
| Contest: **Kodak Picture of the Day** | EXIF: **1/10 second at f/8, ISO 200** |

Some competitions have rather complex voting mechanisms where votes from individual photographers are weighted by their particular standing on the site—usually based on how many contests they've won themselves. A good example of this type is DailyAwards.com, where all winning images are decided by member voting. The judging is a somewhat complicated procedure at first glance, so it takes a few reads to get the rules down.

One gentle warning about these voting sites is that, as a result of the cold, impersonal nature of the online world, the voting can range from warm and fluffy, to cool and distant, to downright sadistic. These sites tend to attract photographers with strong opinions, little shyness about expressing themselves, and thick skins. On the other hand, sites like these also tend to attract photographers of very high skill levels. (You'd better be pretty good yourself if you're going to do any trash talking, right?)

If you like to have your photos critiqued by others, then voting sites might be for you. The best of these contests will inevitably make you a better photographer. In truth, because many of the contests do weight the voting in favor of photographers who have proved their photographic worth, both criticism and praise is usually genuinely and generously guided.

Basically, while your grandmother (and your cat) may love your pictures, regardless of their genuine creative quality, you can count on other photographers to point

out your failings—and your successes—without inhibition or reservation. So be brave, dive in, and you may find yourself being praised for your improvements on a regular basis.

State Tourism Contests
Tourism contests exist in both the online and print world. They can be seasonal, annual, or ongoing. The great thing about travel contests is that they help you focus and narrow down your pool of potential photos. Instead of pouring over the thousands of nice images in your collection, you have to restrict yourself to your Maine vacation photos, for example.

I love tourism contests because they provide a bit of mental and creative stimulus for me when I'm planning a new trip, even if I have no intent to actually enter the contests. Knowing that the state of Maine, for example, has a seasonal online competition is something I keep in mind when I'm photographing a lighthouse after a dusting of fresh snow. How would other photographers approach this? How would my photos stand up to photographers who actually live in Maine? It's a good mental nudge.

The important thing about taking photos for regional contests is to keep good notes on where you shot the photos (your camera's metadata will keep track of when, in case it happens to be a seasonal contest). It's really helpful, for example, if you photograph a moose in a river in Maine, to be able to narrow down the location to "Moose in bog in Rangeley, Maine." (And trust me, if you hang out in Rangeley, you will find yourself some good moose photo-ops.)

Magazine Contests
These contests, especially from legendary journals like *Smithsonian* and *National Geographic* (see listings below), are at the zenith of photo competition. Often the main allure is the prize of publication in the magazine itself. And while getting published is an exciting (and sometimes life-changing) reward, most magazines contests also offer the best material prizes.

The competition, as you can well imagine, is brutal in such contests. Let's face it; if you're competing for publication in *National Geographic* and a trip to an exotic destination, you're going to be butting elbows with some fiercely talented competitors. From a creative perspective that's a good thing, because it forces you to improve your own game. And that, ultimately, is what entering contests should be about: not just showing your best work, but being pushed to a whole new level.

Here, more than in any other type of contest, it's imperative that you follow the rules closely, review previous years' winners, and enter images of superb technical quality. In particular, it's important to review and meet the magazine's print publication standards in terms of sharpness and resolution. If you are entering a low-resolution image online but are required to submit a high-resolution image for publication, be sure that you have an exact match at 300 ppi (standard offset print resolution—also the resolution of every photo in this book). And protect that image with your life; back it up at least once, preferably multiple times.

Local Contests

Local newspapers and community organizations are another great place to find contests. To promote community spirit, local contests often culminate in an exhibit of winning pictures. Since most of these contests are run by local volunteers (or the editors of the local paper), you may have to submit your entries as prints, as opposed to digital files. That means your ability to make high-quality prints is important.

Some local contests are created to publicize a local park or historic site, and if you happen to live in that area, you have the advantage of being able to visit at different times of year, in lots of different weather and lighting conditions. If you're an aspiring professional photographer, entering local contests is a good career move since you'll be showing off your best work to your community's editors, business owners, and civic leaders. I got a lot of my early photo assignments based on having my winning photos published in local newspapers—and 30 years later, some of those people are still my clients.

rules, rights and other legal considerations

Photograph: ©Kevin Hedquist	Title: **Grand Mesa**
Contest: **Digital Image Cafe**	EXIF: **1/200 second at f/13, ISO 400**

To win any contest (and, more importantly, to be eligible to accept prizes) you must follow the rules; that means it's very important that you read and understand all of them. Some contests seem informal about the images you select and how you enter them, but can nevertheless declare your images ineligible if you fail to follow the guidelines. Virtually all contests have clearly stated submission protocols. It's your job to read and understand them. Most of the contests also have a FAQ page that you should read.

The rules are put in place not only to protect the contest holder's rights, but also to keep them from pulling their hair out in large clumps and having to hire a lot of extra staff just to keep the process going forward. You can imagine how annoyed the editorial staff of a magazine might become if you keep mailing them prints when the contest rules clearly state all entries are to be made via their website.

You Have Rights Too

In any discussion of image use, the subject of photographer's rights has to be addressed. In the United States, copyright law states that unless you formally transfer in writing the copyright to your images, you are the owner of that copyright. (Outside of the United States you'll have to consult that country's own copyright laws.) If you click on that familiar button that says, "I agree to the terms" of this contest, you'd better know the terms. Read them; don't just click blindly.

Some contest hosts want to own your images if you win a prize. Don't enter those contests. Under no circumstance should you enter a contest where your rights as the copyright owner are not protected in stone. Never give away "all" the rights to your images. Never. Don't do it.

Most contests will ask for broad rights usage when it comes to publicizing their contest winners (and to promote future contests), and this is perfectly legitimate. After all, you probably made the choice to enter the contest after being inspired by seeing the other photos that had won awards in the past. And the contest hosts have an obvious need to use winning images to promote their contests. The key thing here is that you should only be asked to provide "limited use rights" that specifically relate to that contest and its promotions. If they choose to use your image(s) beyond that realm, you are probably entitled to some form of compensation. For example, if a nature magazine holds an online contest and you win first prize, you can expect that they'll want to use that image to promote the contest online and even in their magazine. But if they also want to later use your image in a subscription flyer to try and get new subscribers to their magazine, you are probably within your rights to ask for additional compensation, as that image use is not related to the contest.

Virtually all contests that I've studied come down firmly and openly on the side of photographers' rights, so really this won't be much of an issue. But it is something to keep in mind when you're reading the contest rules and guidelines. If you feel uncomfortable with the rights they are asking for, ask for clarification. Often these things are written in obtuse legalese and the hosts are more than willing to clarify their stance.

The bottom line with rights is to be aware, but not paranoid. The copyright laws are weighted heavily on your side, and contest owners are usually only trying to protect themselves when they claim certain publication rights. (See www.copyright.gov/eco for information on digitally filing a copyright registration for your work.)

to pay or not to pay

Another question that you will find yourself pondering is whether or not to pay for entry into certain contests. The vast majority of contests are free, but some of the higher-end contests do charge a nominal fee.

Why do they charge fees? One obvious reason is that they are taking on a substantial financial burden to host a contest. Someone has to be paid to organize entries, communicate with photographers and sponsors, and to administer the prize process. Also, often the entry fees go to offset the cost of prizes—particularly when the prizes are substantial. And finally, I think that some contests charge entry fees just to keep the window-shoppers out. They are looking for serious entries and trying to keep the quality level of entries as high as possible. Nothing thins out the masses like charging upfront.

My feeling is that if the contest is a major event, offering substantial notoriety and lavish prizes, then yes I will pay a reasonable fee to participate. In some cases you don't have to pay to enter the contest specifically, but do have to pay an annual fee to belong to the site (such as with Digital Image Cafe). In that case it's largely a matter of whether or not you think you'll benefit from joining the site—even if it didn't have any contests. I don't think I would join a pay site just for a contest, but I have no objection to paying a small annual fee to belong to worthwhile community sites—and by the way, I am a paying member of Digital Image Cafe, and other such sites.

Is the Contest a Scam?

While almost every contest I've researched online (and certainly those mentioned in this book) is legitimate and run by a credible organization, there is always the chance that you'll stumble upon a contest or related offer that is a scam. Hey, it's the Internet—an absolute haven for scam artists.

Fortunately, most rip-offs are easy to spot. If you run across a contest that wants you to pay a fee to be published in a book, for example, and the only way that you can be published in that book is to pay the fee, move on. If the contest fee seems exorbitant and you've never heard of the organization (or can't find them mentioned anywhere else online), move on. If anyone tells you they can make you rich and famous if you just send them a photo and a hefty fee, run. And hide the kids.

In short, if any alarm bells go off in your head, they are probably going off for good reason. Do your research before you get involved. With tons of great contests out there, there's no reason to get into anything remotely shady.

directory of contests

BestFoto Digital Photo of the Day Contest

Type: Daily and monthly; by category
Eligibility: No restrictions
Fee: n/a
Prizes: Featured on the website
Submissions: Digital (email attachment)
Website: BestFoto.com

Daily Awards Photo Contests

Type: Daily, weekly, monthly; by category and
 peer voting/critique
Eligibility: No restrictions
Fee: Free membership required
 (paid subscription offers additional benefits)
Prizes: Featured on the website;
 photo/camera equipment
Submissions: Digital (upload)
Website: DailyAwards.com

Digital Image Cafe Photo of the Day

Type: Daily; weekly; monthly; quarterly; categories;
 peer voting/critique
Eligibility: Open to all
Fee: $29/year membership required
 (includes many additional benefits)
Prizes: Featured on the website;
 photo/camera equipment
Submissions: Digital (upload)
Website: www.DigitalImageCafe.com

Earth Shots

Type: Daily
Eligibility: No restrictions
Fee: n/a
Prizes: Featured on the website
Submissions: Digital (upload)
Website: EarthShots.org

Imaging Resource Photo of the Day Contest

Type: Daily and monthly
Eligibility: No restrictions
Fee: n/a
Prizes: Featured on the website;
 photo/camera equipment
Submissions: JPEG only (upload); limit two entries
 per month
Website: DailyDigitalPhoto.com

Kodak Picture of the Day

Type: Daily
Eligibility: No restrictions
Fee: n/a
Prizes: Featured on the website; displayed on the
 Kodak Times Square Gallery in New York City
Submissions: JPEG only (upload)
Website: www.Kodak.com/eknec/PageQuerier.
 jhtml?pq-path=2549&pq-locale=en_US&_
 requestid=746

National Geographic's Your Shot Photo Competition

Type: Daily, monthly; magazine
Eligibility: No restrictions
Fee: n/a
Prizes: Featured in print or online
Submissions: Digital (upload)
Website: ngm.NationalGeographic.com/Your-Shot

PhotographyVoice Photo of the Day Competition

Type: Daily
Eligibility: No restrictions
Fee: Free registration required
Prizes: Featured on the website
Submissions: Digital (upload)
Website: PhotographyVoice.com/PotD

Steve's DigiCams Digital Photo of the Day

Type: Daily and monthly
Eligibility: No restrictions
Fee: n/a
Prizes: Featured on the website; photo/camera
 equipment (monthly winners)
Submissions: JPEG only (email attachment);
 one entry per month
Website: www.Steves-Digicams.com/Daily_DPotD.html

Birder's World Photo of the Week

Type: Weekly
Eligibility: No restrictions
Fee: Free registration required
Prizes: Featured on the website; publication in the magazine; one-year subscription
Submissions: JPEG only (upload or email attachment)
Website: BirdersWorld.com/brdcs/Photos

Daily Awards Photo Contests

See listing under Daily Contests section

Digital Image Cafe Photo of the Day

See listing under Daily Contests section

DPChallenge

Type: Weekly; by category (theme) and peer voting/critique
Eligibility: 13 years of age or older
Fee: Free registration required; paid memberships offer additional benefits
Prizes: Featured on the website
Submissions: Digital (upload)
Website: DPChallenge.com

Nature's Best Picture of the Week

Type: Weekly; magazine
Eligibility: No restrictions
Fee: n/a
Prizes: Featured on the website; magazine subscription
Submissions: Digital (email attachment)
Website: www.NaturesBestMagazine.com/PotW_Guidelines.htm

National Wildlife Photo of the Week

Type: Weekly; magazine
Eligibility: No restrictions
Fee: n/a
Prizes: Featured on the website
Submissions: Digital (upload to Flickr group)
Website: NWF.org/PhotoZone/Photo_of_the_Week.cfm

Photo Friday

Type: Weekly; peer voting
Eligibility: No restrictions
Fee: n/a
Prizes: Featured on the website
Submissions: Hyperlink and title only (must first be uploaded to your own website)
Website: PhotoFriday.com

SOAphoto

Type: Monthly and quarterly; by category and peer voting
Eligibility: No restrictions
Fee: Free membership required
Prizes: Samsung digital compact cameras
Submissions: Digital (image files with valid EXIF data only)
Website: SOAphoto.com/Contest

WetPixel Photo of the Week

Type: Weekly; peer voting
Eligibility: No restrictions
Fee: Free registration required
Prizes: Scuba-related gear; One grand prize per year
Submissions: Digital (upload)
Website: Wetpixel.com/Competition

©Neil Shapiro | Title: **From the Top of the Rock** | Contest: **Kodak Picture of the Day**

choosing and entering contests

bi-monthly contests

Apogee Photo

Type:	Bi-monthly
Eligibility:	No restrictions
Fee:	n/a
Prizes:	Free online classes; photo/camera equipment
Submissions:	Digital (email attachment); three images per entrant
Website:	ApogeePhoto.com/Contest.shtml

JPG Magazine Photo Contest

Type:	Bi-monthly
Eligibility:	No restrictions
Fee:	Free membership required
Prizes:	Publication in the Magazine; Free one-year subscription; $100
Submissions:	Digital (upload)
Website:	JPGmag.com

monthly contests

BestFoto Digital Photo of the Month Contest

See listing under Daily Contests section

BetterPhoto Contests

Type:	Monthly; peer voting/critique
Eligibility:	No restrictions
Fee:	$4.08/month for Basic Membership; $49/month for Masterpiece Membership (both offer additional benefits beyond contest participation)
Prizes:	Deluxe BetterPholio™ Web Site ($199/year value); photo/camera equipment
Submissions:	Digital (upload)
Website:	BetterPhoto.com/Contest.asp

Daily Awards Photo Contests

See listing under Daily Contests section

Imaging Resource Photo of the Month Contest

See listing under Daily Contests section

©Patricia White | Title: **Red Umbrella** | Contest: **Smithsonian Magazine**

Pampered Puppy Monthly Dog Photo Contest

Type:	Monthly
Eligibility:	Over the age of 18 in Canada and the United States, excluding Hawaii and Alaska
Fee:	n/a
Prizes:	Dog toys and accessories; gift certificates
Submissions:	Digital (CD via mail); no more than three images per contest entry; minimum image resolution is 800 x 600
Website:	PamperedPuppy.com/Contest

National Geographic's Your Shot Photo Competition

See listing under Daily Contests section

The Nature Conservancy's *Great Places* Photo of the Month

Type:	Monthly
Eligibility:	No restrictions
Fee:	Free newsletter registration required
Prizes:	Feature placement on website (photo and interview)
Submissions:	Digital (upload)
Website:	Nature.org/eNewsletter/

Steve's DigiCams Digital Photo of the Month

See listing under Daily Contests section

©Donna Eaton	Title: **Eagle Trio**
Contest: **Steve's DigiCams**	

The Everyman Photo Contest

Type:	Annual
Eligibility:	Separate amateur and pro categories
Fee:	$50 for three images
Prizes:	$1,000 grand prize; $250 first place category winners; featured on the website
Submissions:	Digital (upload)
Website:	TheEveryman.com

Hey, Hot Shot!

Type:	Annual
Eligibility:	No restrictions
Fee:	$60
Prizes:	$500 and a two-week exhibition at the Jen Bekmen Gallery to five winners; one Ultra winner is featured in a solo exhibition; contenders featured daily on Jen Bekman's blog
Submissions:	Online (registration and upload)
Website:	HeyHotShot.com

International Garden Photographer of the Year

Type:	Annual (Garden and Landscape Photographic Arts Ltd.)
Eligibility:	No restrictions
Fee:	£10 for four images; £20 for a portfolio of six images
Prizes:	£5,000 grand prize; featured and exhibited in print; extensive press coverage
Submissions:	Digital (email attachment)
Website:	www.igpoty.com

International Photography Awards

Type:	Annual; by category
Eligibility:	Separate contests for professionals, amateurs, and students
Fees:	Professionals—$35; amateurs—$25; students—$15 (discount available)
Prizes:	International Photographer of the Year—$10,000; Discovery of the Year—$5,000; Deeper Perspective Photographer of the Year—$5,000
Submissions:	Digital (upload) or print (via mail)
Website:	PhotoAwards.com

annual contests

Amtrak Picture Our Train Contest

Type:	Annual
Eligibility:	No restrictions
Fee:	n/a
Prizes:	Featured in print; $1,000 voucher grand prize
Submissions:	8x10 inch (20x25 cm) prints via mail
Website:	Amtrak.com/PhotoContest

Appalachian Mountain Photography Competition

Type:	Annual; regional
Eligibility:	No restrictions
Fee:	n/a
Prizes:	Cash and store credit
Submissions:	Registration and digital upload
Website:	www.VirtualBlueRidge.com/Contests/app-mtn-2008/

B&W Single Image Contest

Type:	Annual; magazine; by category
Eligibility:	No restrictions
Fee:	First image is $25; additional images at $10 each (no limit)
Prizes:	Featured in a special edition of *Black & White* Magazine; first place is the cover image
Submissions:	300 ppi, 8-bit, grayscale image files; burned to CD and mailed in
Website:	BandWmag.com/Contest

©Rob Palmer

Title: **Hovering Kestrel**

Contest: **National Wildlife**

National Geographic International Photography Contest

Type: Annual; magazine
Eligibility: No restrictions
Fee: n/a
Prizes: Feature publication; significant publicity; trips; camera equipment
Submissions: Digital (upload)
Website: ngm.NationalGeographic.com/Photo-Contest

National Wildlife Photo Contest

Type: Annual; magazine; by category
Eligibility: Separate entries for youth, amateur, and pro
Fee: n/a
Prizes: $5,000 grand prizes; featured on website and in the magazine
Submissions: Digital (upload)
Website: NWF.org/PhotoZone

The Nature Conservancy's Annual Nature Photography Contest

Type: Annual
Eligibility: No restrictions
Fee: n/a
Prizes: Featured in print; free calendars
Submissions: Digital (email or via Flickr account)
Website: Nature.org

Our World Underwater

Type: Annual; by category
Eligibility: No restrictions
Fee: $10 per image
Prizes: $50,000 in prizes; travel; photo/video/diving equipment
Submissions: Digital (upload or CD/DVD via mail)
Website: UnderwaterCompetition.com

Smithsonian Magazine Annual Photo Contest

Type: Annual; magazine
Eligibility: No restrictions
Fee: n/a
Prizes: Featured in print; lavish travel packages; cash
Submissions: Digital (upload)
Website: PhotoContest.SmithsonianMag.com

Travel Photographer of the Year

Type: Annual
Eligibility: No restrictions
Fee: £10, £15 for portfolio of two images; free under the age of 16
Prizes: Expeditions, photo/camera equipment, exhibitions, significant publicity
Submissions: Digital (email attachment)
Website: TPotY.com

Popular Photography Annual Photo Contest

Type: Annual; magazine; by category
Eligibility: No restrictions
Fee: n/a
Prizes: High-end electronics and camera equipment; trips; featured on website and in the magazine
Submissions: Digital (upload)
Website: PopPhotoContest.com

Windland Smith Rice International Awards

Type: Annual; magazine (*Nature's Best*)
Eligibility: No restrictions
Fee: £10, £15 for portfolio of two images; free under the age of 16
Prizes: $10,000+ in cash prizes, publication and exhibition
Submissions: Digital (email attachment)
Website: NaturesBestPhotography.com

magazine contests

B&W Single Image Contest
See listing under Annual Contests section

National Geographic International Photography Contest
See listing under Annual Contests section

National Geographic's Your Shot Photo Competition
See listing under Daily Contests section

National Wildlife Photo Contest
See listing under Annual Contests section

National Wildlife Photo of the Week
See listing under Weekly Contests section

Nature's Best Picture of the Week
See listing under Weekly Contests section

Popular Photography Annual Photo Contest
See listing under Annual Contests section

Ranger Rick's Photo Contest

Type:	Quarterly; magazine
Eligibility:	Must be 13 years of age or younger
Fee:	n/a
Prizes:	Publication in *Ranger Rick* magazine and on the website; a Certificate of Recognition; five copies of the magazine.
Submissions:	Print only (up to 8x10 in; 20x25 cm); original image file or negative must be supplied if selected for publication.
Website:	NWF.org/kidZone/kzPage.cfm?siteID=3&departmentId=80&articleId=956

Smithsonian Magazine Annual Photo Contest
See listing under Annual Contests section

Windland Smith Rice International Awards
See listing under Annual Contests section

©Robert Ganz | Title: **Under the Bow** | Contest: **Digital Image Cafe**

regional contests

Appalachian Mountain Photography Competition
See listing under Annual Contests section

Florida State Parks Photo Contest

Type:	Regional
Eligibility:	13 years of age or older
Fee:	n/a
Prizes:	Park entry fees; trips
Submissions:	Digital (CD via mail)
Website:	www.FloridaStateParks.org/PhotoContest/default.cfm

Maine.gov Photo Contest

Type:	Regional; seasonal
Eligibility:	18 years of age or older
Fee:	n/a
Prizes:	Featured on the website
Submissions:	Digital (upload)
Website:	Maine.gov/portal/Photo_Contest

For an updated directory and additional resources, visit www.LarkBooks.com/digital

index